CHILDREN'S PLAY SPACES
From sandbox to adventure playground

Marguerite Rouard/Jacques Simon

Translated by Linda Geiser

CHILDREN'S PLAY SPACES

From sandbox to adventure playground

The Overlook Press
Woodstock, New York

We wish to thank Jean-Louis Bernard for his collaboration.
M.R./J.S.

First published in the United States in 1977 by
The Overlook Press
Lewis Hollow Road
Woodstock, New York 12498
SPIELRAUM FUR KINDER
Copyright © 1976 by Verlag Gerd Hatje, Stuttgart
English language translation copyright © 1977
by The Overlook Press, Inc.
Library of Congress Catalog Card Number: 76-57882
ISBN: 0-87951-056-0

CONTENTS

A PAGE OF WRITING

Two and two is four
four and four is eight
eight and eight is sixteen
Repeat! says the teacher
Two and two is four
four and four is eight
eight and eight is sixteen
But the dreambird flies by
in the sky
the child sees it
the child hears it
the child calls it
Save me
play with me
bird!
Then the bird swoops down
and plays with the child
Two and two is four . . .
Repeat! says the teacher
and the child plays
the bird plays with him
Four and four is eight
eight and eight is sixteen
and how much is sixteen and sixteen?
Sixteen and sixteen is nothing
and surely not thirty-two

in any case
and they disappear
The child has hidden the bird
in his desk
and all the children
hear its song
and all the children
hear the music
and eight and eight in turn are fading
and four and four and two and two
in turn are off
and one and one is neither one nor two
and one by one they disappear
And the dreambird plays
and the child sings
and the teacher shouts
When will this nonsense stop?
But all the children
listen to the music
And the walls of the classroom
collapse quietly
And the window panes become sand again
the ink becomes water again
the chalk becomes a cliff again
the fountain pen becomes a feather.

Jacques Prévert

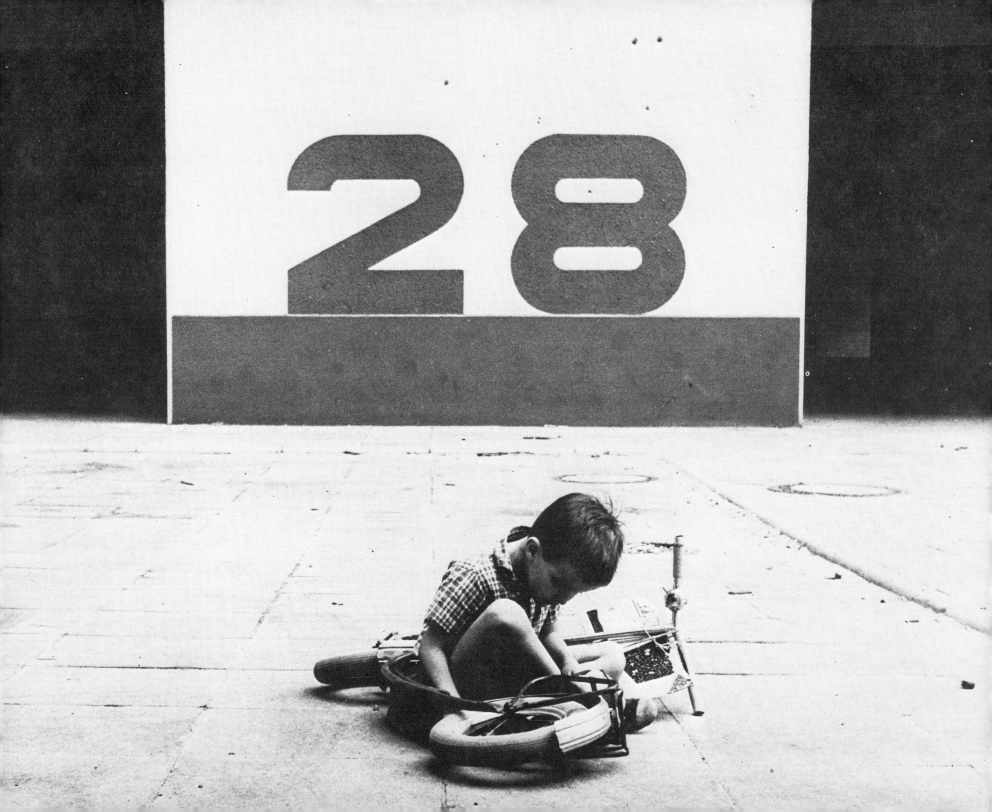

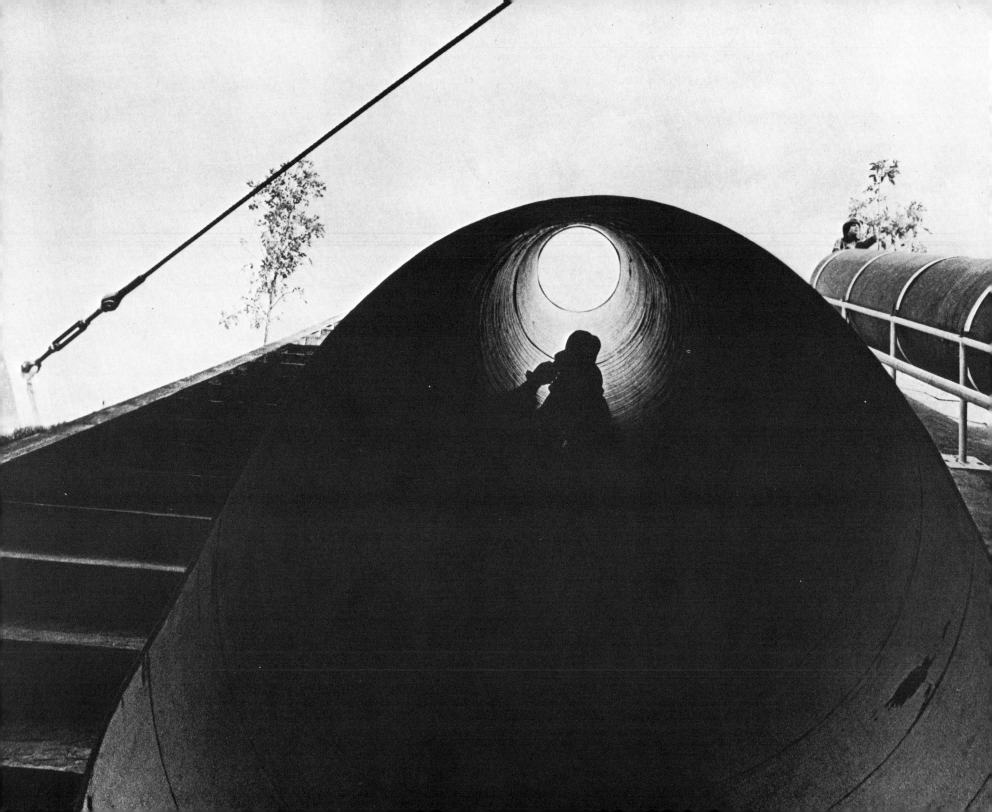

It is self-evident that the education of our children is too important to be left to specialists. Play is an integral part of education; its conception goes far beyond the mere arranging of space.

The UN Bill of Rights for children recommends that "governments should orient the child toward a healthy education on the physical, intellectual, moral, spiritual, and social levels and guarantee his freedom and dignity. The child should have every opportunity to indulge in recreational activities directed toward educationally desirable goals."

It seems, however, that recreational facilities for children are regarded, more or less paternalistically, as a way to help defenseless beings become persons.

The unequal aptitudes of children reflect, in part, the different material, moral, and intellectual conditions of their family life. One could try to put an end to these inequalities by radically changing the fundamental conditions of a child's life, by questioning the methods and content of education. Education and recreation cannot be separated arbitrarily. Leisure time is usually believed to be only an additional aspect of life's efforts and development. It is looked upon as a luxury and privilege. Yet in reality, for the child as well as the adult, leisure time is an essential part of education and cultural development. The specific activities are not as important as the media and the environment in which they are experienced. Psychological studies have shown that the child does not really distinguish between work and play.

Children are the victims of the conditions of life in modern cities. How can their imaginations be stimulated in the face of the architectural monotony of housing projects made of glass and concrete? How can children feel free when they are constantly exposed to the dangers of traffic?

What positive experience can be gained inside the tedious structures of dormitory-like cities? How can children satisfy their need to play out-of-doors where there is virtually no greenery, where ball-playing and stepping on the grass are forbidden, and where there is no place to play hide and seek?

There isn't a city in the world that provides enough play space. It is not practical to refer to the normal needs of children or to raise the issue of their rights. Their portion of the overall space budget is too small an allotment, for the economy of the cities is structured so that the children are given only a modest amount of play space.

It is unrealistic to think that this will change, since the child is neither consumer nor producer. But this is no excuse. We must realize that increasingly the streets—overcrowded as they are with every kind of vehicle—are humiliating and degrading play areas.

In seminars and meetings, good intentions are expressed, dismal statistics quoted, the situation of one city compared with another and then compared with the overall realistic needs. Programs are drawn up and standards are set. Specialists are brought in to negotiate for real estate and calculate the financing. Then more specialists are called in to work out the problems from a sociological, medical, cultural, and educational point of view. It is virtually impossible for such a large group of experts to be in agreement. Little of consequence ever happens; although well-intentioned, these groupings do not confront the real issues.

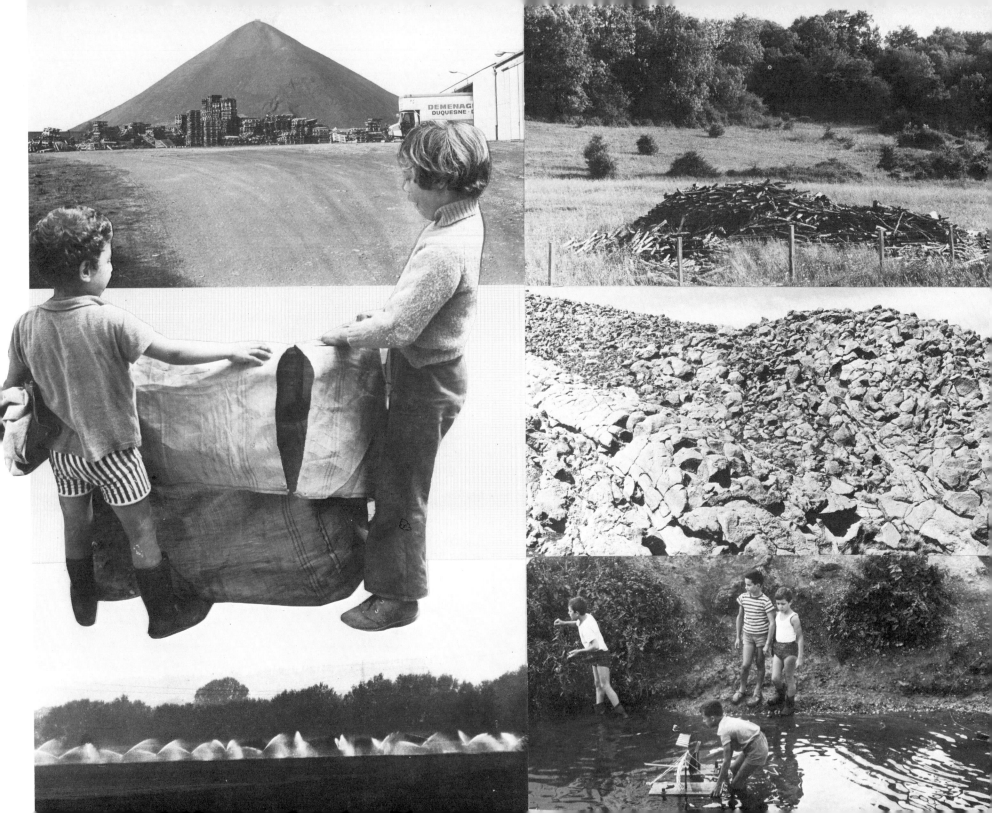

Playing is a liberating activity and has little to do with sports, culture, or party games. Playing is a necessity. No child should be deprived of it. Playing is liberating in that it moves the child into socially constructive directions. Playing is a stimulant. It doesn't need doctrines or principles. The need to play is like an epidemic: it spreads and fades and suddenly flares up again; it is extremely contagious, for it removes constraints and produces joy.

Home, street, and school at their best contribute unconditionally to the spirit of play as the most important expression of life. They should not be places where a child has to adapt to standardized values and where play is technically manipulated.

With most prefabricated playground equipment, children are forced to conform to the ideas of others. When the assembly line overpowers the play area, children are cut off from their creative sources with disastrous consequences.

Any child, in order to develop normally, needs a certain amount of satisfactory experiences. Instincts are freed when movement acts as an escape valve. These moments of freedom lift the child out of everyday life. Although urban planners, parents, and teachers know about these needs, there are insufficient opportunities for children to satisfy them. Wishes, needs, hopes, and fantasies are not adequately addressed during the hours of "education" or "leisure," although we know that physical enjoyment of games is important for harmonious and creative development.

Since education is so far-reaching and leaves permanent imprints, adults must meet children's needs more creatively.

Children cannot be looked upon purely as "leisure-time consumers." Leisure time is the vehicle through which a child interprets the world. It is not relaxation, but a serious and necessary occupation. Needs must be differentiated: the need for isolation in order to pursue individual desires, such as reading, writing, painting, and solitary games. The need to interact with playmates of the same age group. The need to prove one's self and one's independence. And finally, the need or, better, the urge to discover things.

The leisure-time occupations of children balance the other lifetime realities. A strongly independent child confronted with society's rules will imitate heroes in order to act out and learn to cope with his own anxieties. During leisure time, the child develops personality, learns expression, discovers self through others, and by communicating with people and nature gains the knowledge and insight into life so necessary for further development.

Within a time budget of several thousand play hours per year, a child has a right to fresh air, sun, relaxation, physical safety, and various activities and possibilities to express himself.

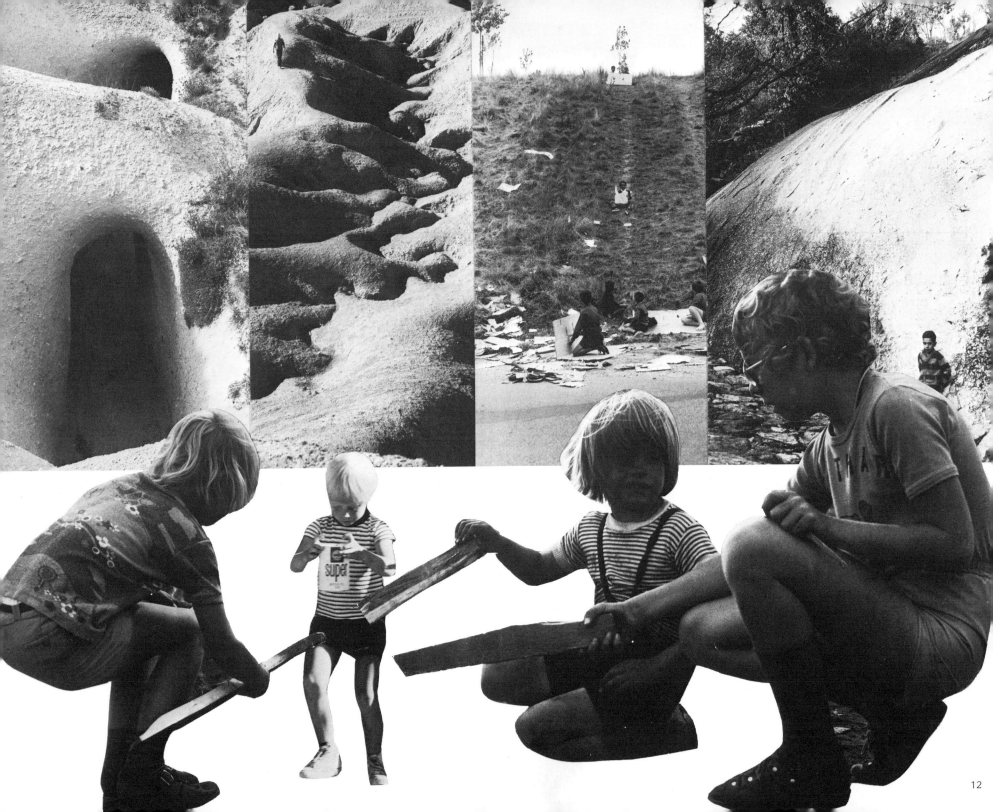

Formerly, children were able to play almost anywhere in relative safety. When it became necessary to provide specific play areas for them, children were banished into small spaces not used for more lucrative purposes, such as housing and parking lots. Architects and contractors commissioned to build playgrounds thought them secondary problems and installed the usual paraphernalia of slides, sandboxes, and monkeybars which has formed the commonplace concept of the playground.

The outcome was forseeable: the children rejected insufficient and unimaginatively arranged areas. They scorned the charity bestowed upon them by a commercial society. Hundreds of research programs have demonstrated the following requirements: children must have dynamic, stimulating places filled with opportunities to exercise their sense of discovery, individually or communally. This is a major element in the development of their personal abilities.

While waiting for the weekend to come, a child may use his room as a bicycle track. But inevitably the day comes when this child cries: "I don't want to pretend anymore. I'm going outside with my bike and nobody can stop me."

As play impulses change, the toys, the toy trains, the box with beads, the tin soldiers, the building blocks are brought outside to be shared with other children. And it becomes more and more apparent that they develop a need for freedom. Everything explored outside becomes familiar, but disenchantment soon follows—after houses, streets also become too small.

The responsibility of designers is therefore clear; they must assign play spaces to areas well-protected from traffic where there is plenty of sunshine and where landscaping is most attractive and dynamic. Playgrounds must be shaped in such a manner that there will be areas for relaxation, activity, surprise, encounter, isolation, or group work. If playground equipment is planned, it should blend into the landscape and not stifle the development of the imagination. On the contrary, it should offer a variety of useful possibilities.

The layout of playground equipment should take into account the ages of the children who will use them. The growth cycles of nature must also be considered, since they are a vital reference point for the learning child.

A constructive policy giving top priority to the welfare of children can contribute greatly to helping them adapt to their environment and also provides an important adjunct to education at home and in school.

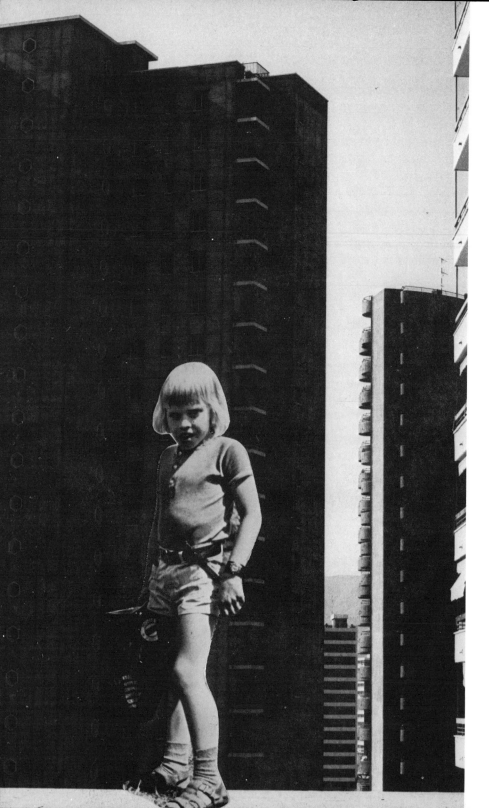

The arrangement of a playground should be planned initially for all age groups and offer a number of different activities taking place simultaneously and one after the other. The playground should be a meeting place and provide stimulation. It should teach the children tolerance and consideration for each other's needs.

Streets must be reclaimed for play activity, temporarily or for good. There should be an area of 200 to 500sq. m in every part of a city laid out with care to avoid deterioration and costly maintenance. These precious, empty spaces within the density of the city should not be planted, but reserved instead for play.

Larger, landscaped area of 500 to 10,000sq. m contribute to the embellishment of the cities. Their arrangement would have to depend on the number of persons enjoying them, and on their natural condition. In any case, such areas should be neither totally "mineral" nor "vegetable." A combination of both elements would allow for relaxation and activity.

A supervised and possibly covered area of 500 to 2,000sq. m should be provided in every part of the city so children can roam freely and do as they please. Their activities could include breeding small animals or building a shack. Parents should be excluded from this area so as not to dampen the high spirits of the children.

Finally, it would be desirable to have many planted areas with trees and shrubbery. Empty lots could be used in this manner, as could spaces that have not yet been designated for other use. Agreements can be reached between owners and interested associations on a temporary basis.

Depending on the size of the city, public parks take up from 1 to 20 hectares and sometimes more. Even if trees and grass predominate, they can be arranged so that a large area is reserved for play. Usually there is ample space available and nature will be left unharmed. Through careful thinning of wooded sections, some parts can be made into wilderness, swampy or rocky areas, or places scattered with all sorts of building materials, as well as botanical sections, grassy areas, hills and dales.

In addition to the common schoolyard, schools, of course, should have fields for sports and open-air activities.

The banks of a river or stream passing through town may provide useful play space and can be made suitable for that purpose at small cost. With a little imagination, even condemned properties, shut-down factories, the roofs of buildings, gravel pits and quarries, or dead-end streets can be converted appropriately.

It is essential for children to have the opportunity to "get out of themselves" two or three times a week and into an environment where they can get back in touch with the earth, water, grass, and rocks, renewing their creative potential.

Faced with the problem of insufficient play space, cities should consider converting sections of their town squares and shopping malls into playgrounds. Playmobiles are an alternative. These are motorized playgrounds— automobiles or trucks carrying all sorts of mobile playground equipment which can be installed temporarily in parks, squares, and pedestrian crosswalks.

Premises are available as play spaces even in the hearts of cities with hardly any parks: warehouses, sheds, gymnasiums, auditoriums and lobbies, shopping centers, schools, etc. Play hours can be scheduled according to the size of each place. With adult guidance, a wide variety of games can be planned.

This kind of program, without a specific set of rules, can be arranged by any tenants' committee, union, community, or company. The wide range of activities available enables every age group to participate according to its ability. The success of makeshift play areas depends on the number of children frequenting them and the quality of the equipment. In any case, they improve the situation for children enormously at a minimal cost.

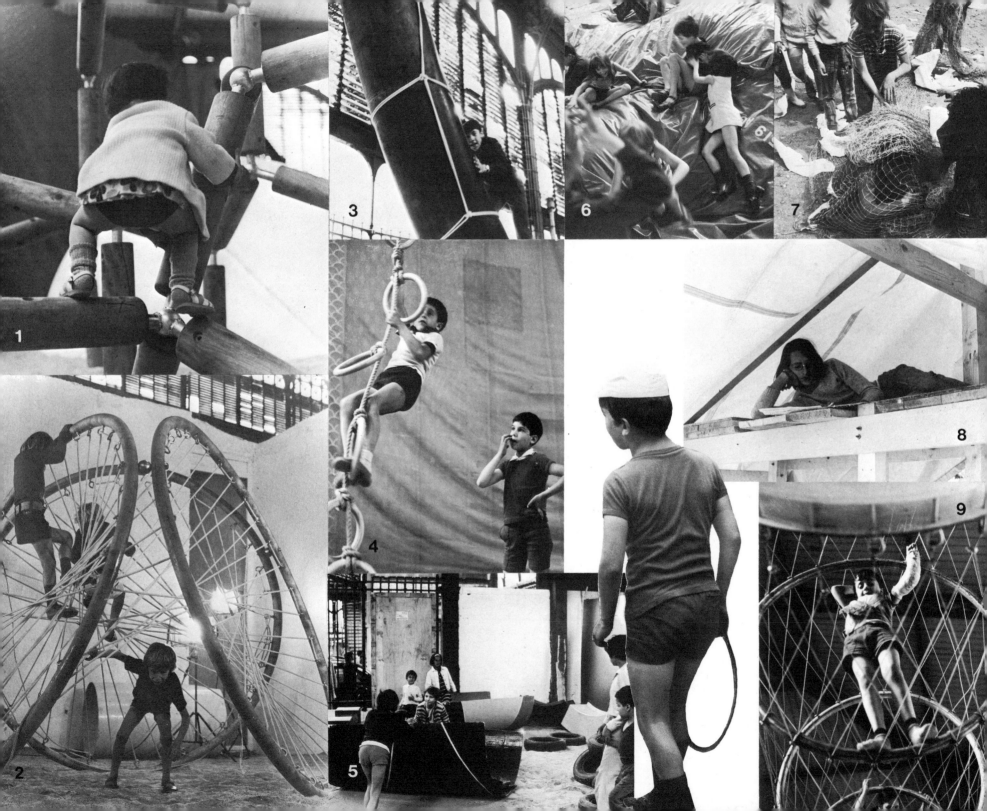

Children's city, IGA '73, Hamburg, Germany

Design: Hilde Richter
Completion: 1973

The planning of this playground was entrusted to a manufacturer of wooden play equipment. There are numerous companies that specialize in the complete installation of children's playgrounds: excavations, paving, assembly of playground equipment, as well as the planting of trees, shrubs, and grass.

Wooden logs are very popular because they are solid and can be used for all kinds of forms and structures. Also, they blend much better with nature than steel, plastics, or concrete materials which have been overused in playground design.

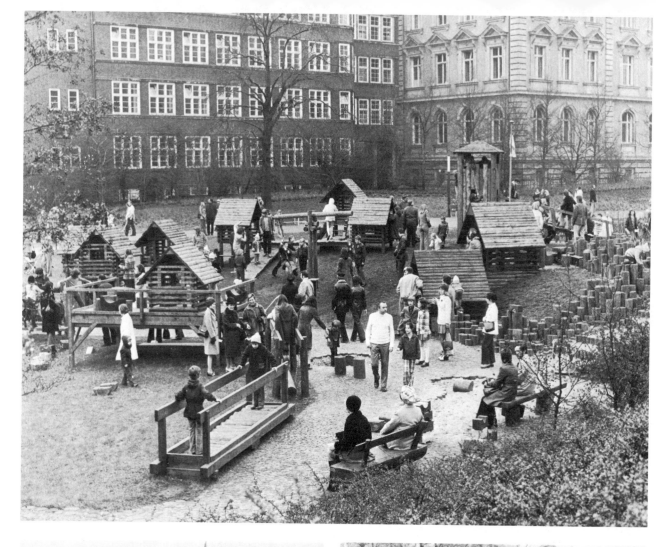

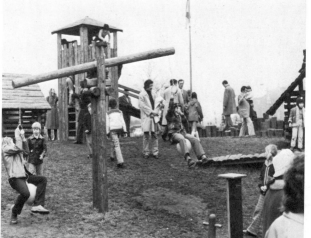

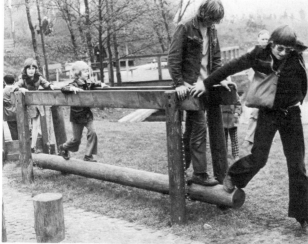

Lozziwurm

Design: Iwan Pestalozzi
Year of design: 1972

The Lozziwurm—assembled here in a schoolyard in
Zurich—is a structure for climbing, crawling, and
sliding, made of polyester tubes 90cm in diameter.
Only two types of tubing are used—straight pieces
and pieces bent at an angle of 90 degrees—and their
assembly yields numerous possibilities of form. The
elements are connected by coupling rings that were
originally closed by tension mechanisms and today
are fastened with screws.

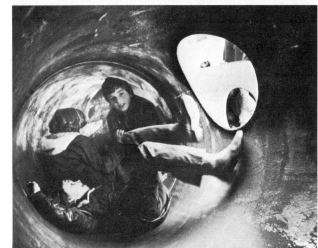

	1
2	

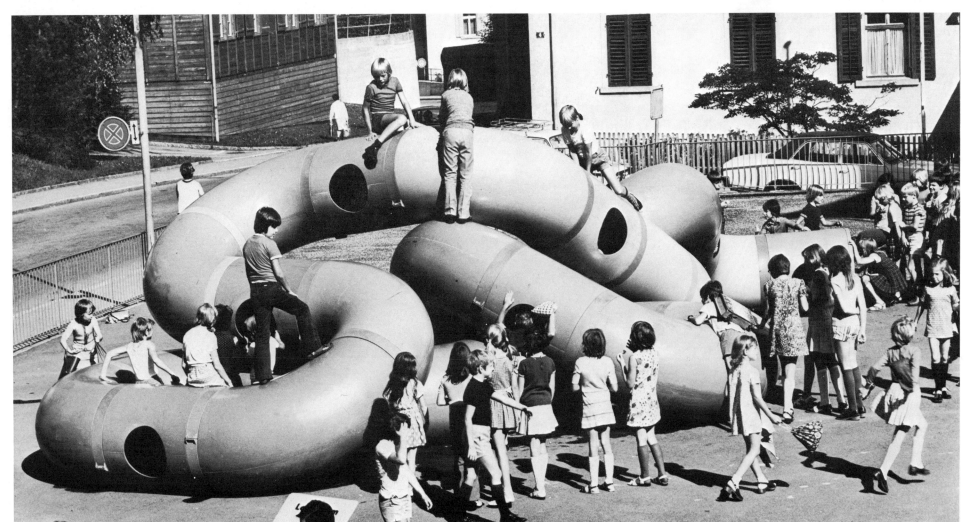

9

Giant rope circus, Revierpark, Vonderort near Oberhausen, Germany

Design: Conrad Roland
Completion: 1973

This is a remarkable example of a prefabricated product. Because of its lightness and uncomplicated assembly, it can be put up anywhere—at a children's fair or at other special events.

The climbing construction is recommended for all ages except, of course, toddlers and infants. This industrial-looking structure is suitable for both artificial and natural surroundings.

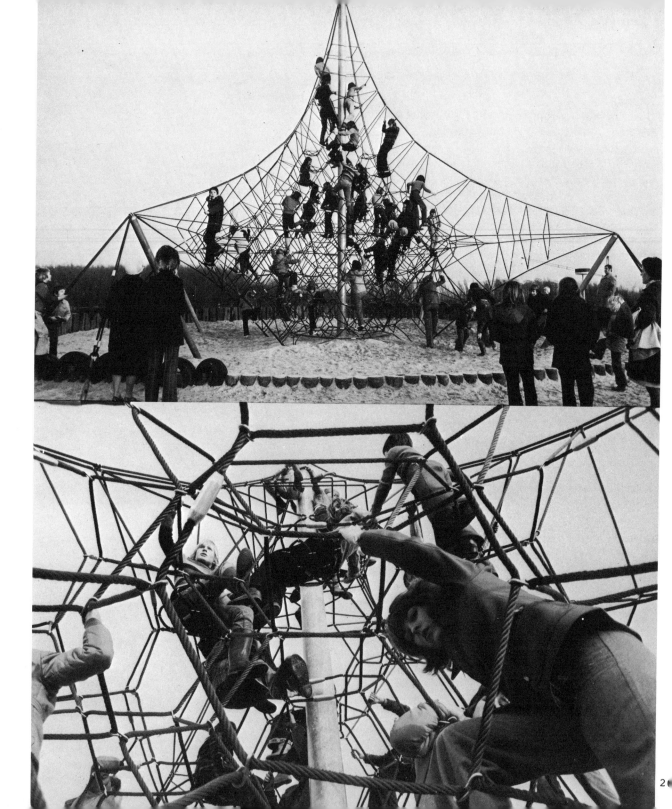

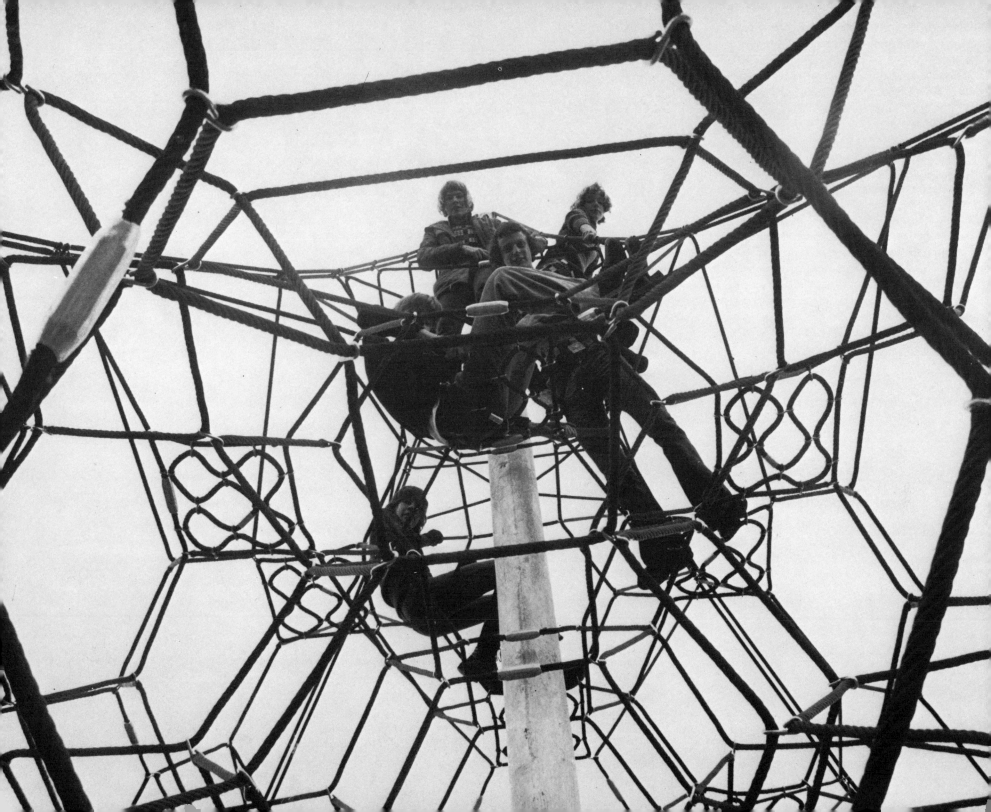

Climbing net in the Hillside Adventure Playground, Islington, London, England

Design and Execution: Students of the Architectural Association School of Architecture under the direction of Mark Fisher, Don Gray, Erik Millstone, and Paul Green Armytage.
Completion: 1974

This collapsible climbing net (2) has been integrated into an already existing adventure playground.

It was manufactured in a nearby shed owned by the community. The work took about two months. Sixty children showed up to test it out over a period of two days. They were very enthusiastic; it was a great success. Unfortunately, the manufacturing cost, due to the very expensive special materials used here, were so high that the residents of the community were unable to participate financially.

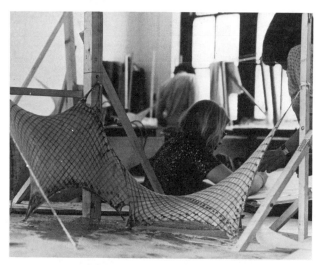

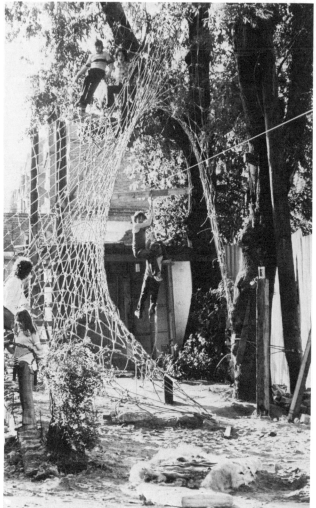

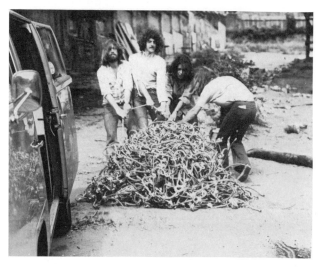

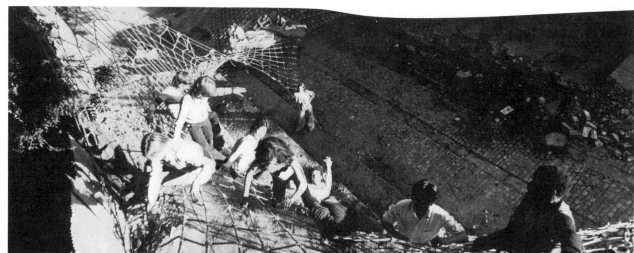

1	3	5
2		
4		

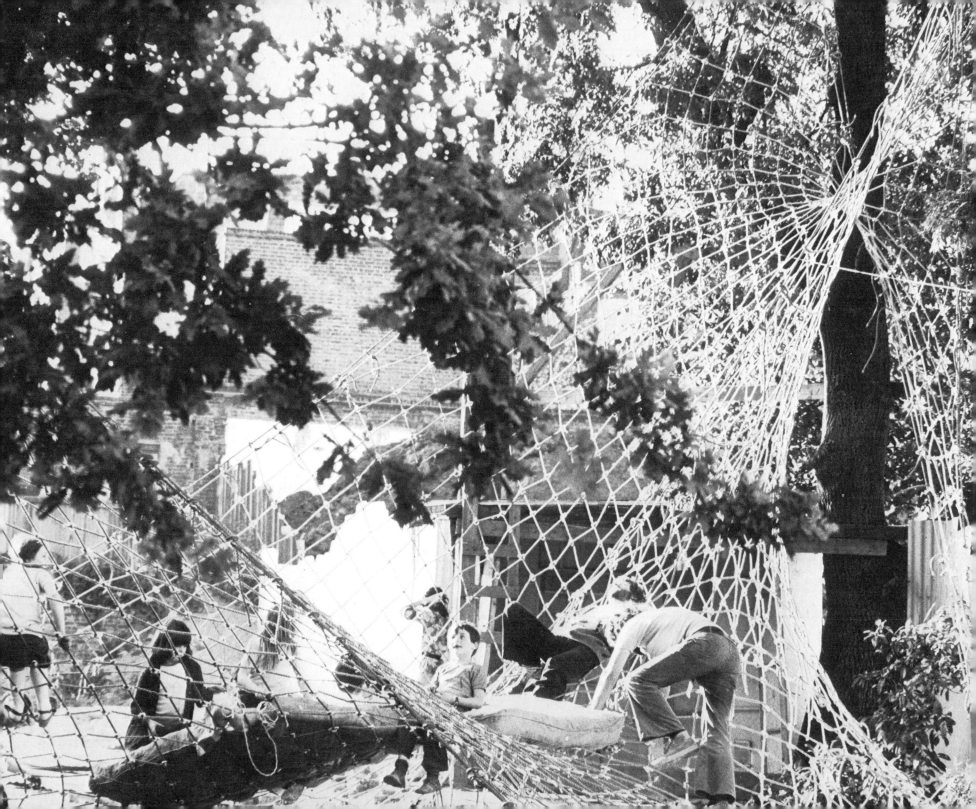

Textile Playground, IGA '73, Hamburg, Germany

Design: Roman Antonoff
Completion: 1973

This playground was sponsored by the Textile Industry Association of the Federal Republic of West Germany in order to demonstrate the range of possible uses of textiles for playground equipment that can not be achieved with rigid materials. Ten "floating" tents were installed, 300 textile building blocks, a swing, a climbing apparatus (Tarzaneum), two treehouses, and a "spiral" house.

The "floating" tents (1) are hooked on massive wooden tripods and can be set in a rotating or pendulum-like motion. The textile building blocks (5), about the size of a suitcase, are made of colorful weatherproof fabric and filled with a lightweight synthetic granulated substance. The flat surfaces of these blocks make it easy to stack them into all sorts of compositions. The Tarzaneum (7), inspired by the Tarzan films, is made of 300 hemp ropes hooked on a giant grid of steel and wood. Children swing from the ropes as from vines. The basic structure of the treehouses (4, 6) and "spiral" house (2, 3) is a wooden frame shaped like an eight-sided cube. The treehouse frame is filled with ropes and nets; the "spiral" house frame contains a giant 15-ton spiral of rope.

		3	4	5
1	2	6	7	

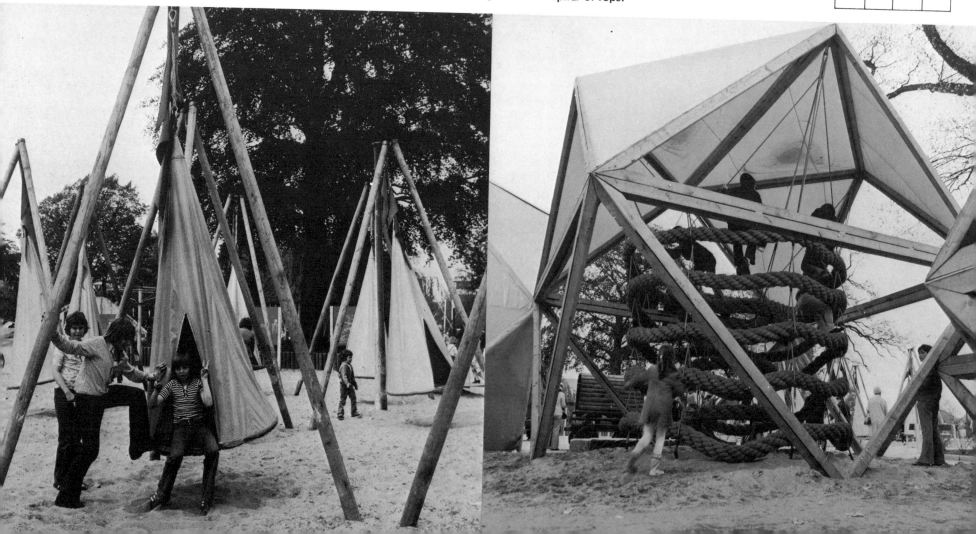

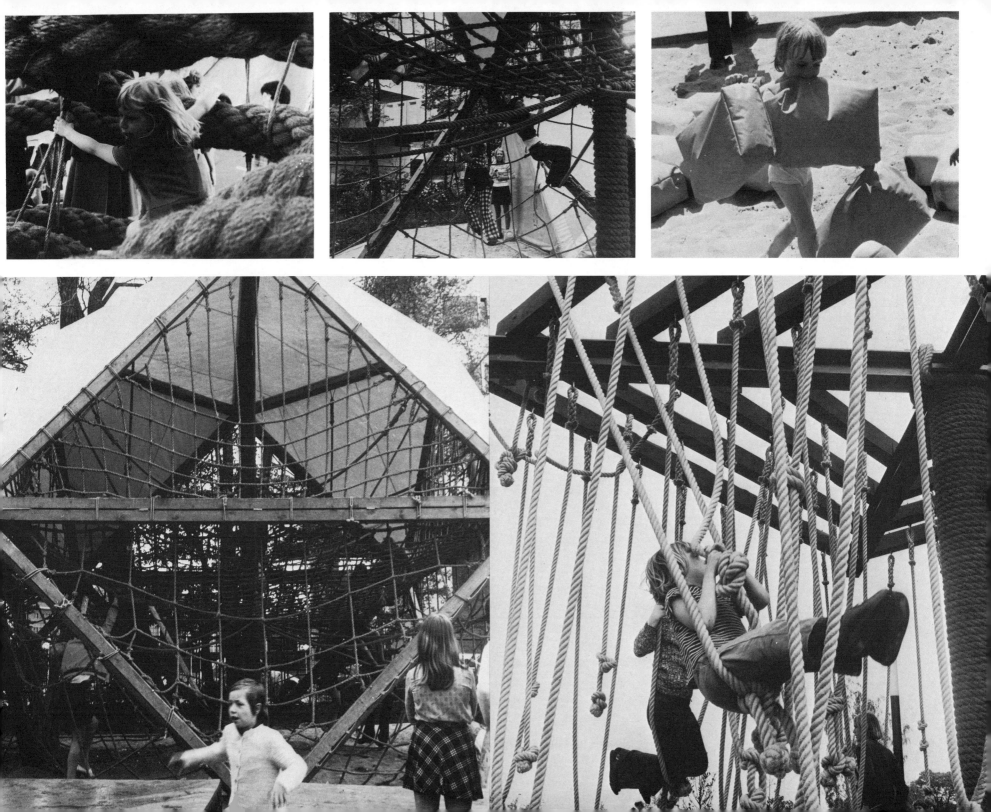

The introduction of plastics into playground equipment was an important development. Objects made of synthetics can be produced at relatively low cost. The disadvantage is repetitive forms which become monotonous. Many manufacturers therefore offer a combination of elements which can be arranged in a variety of ways. Plastics offer countless possibilities that no other materials can equal; even large objects are so light that children can move them with ease. An even more important characteristic is durability and brightness of color. Besides prefabricated objects, numerous other forms can be realized with plastic: artificial hills, grottos, simulated volcanic eruptions, etc.

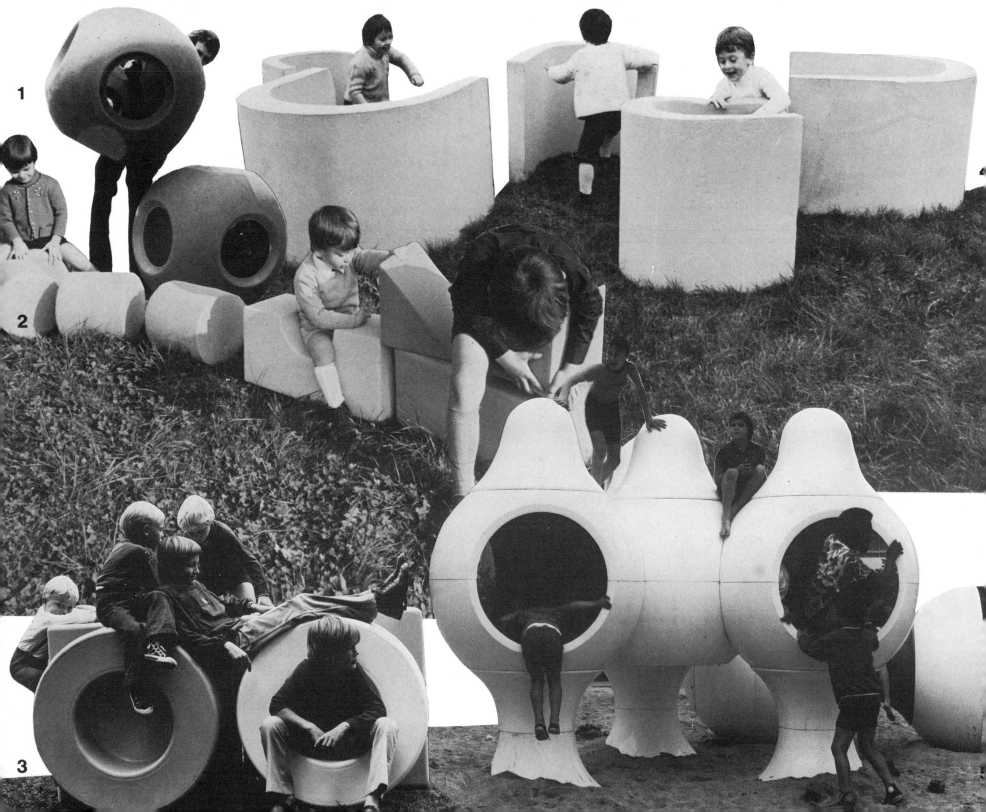

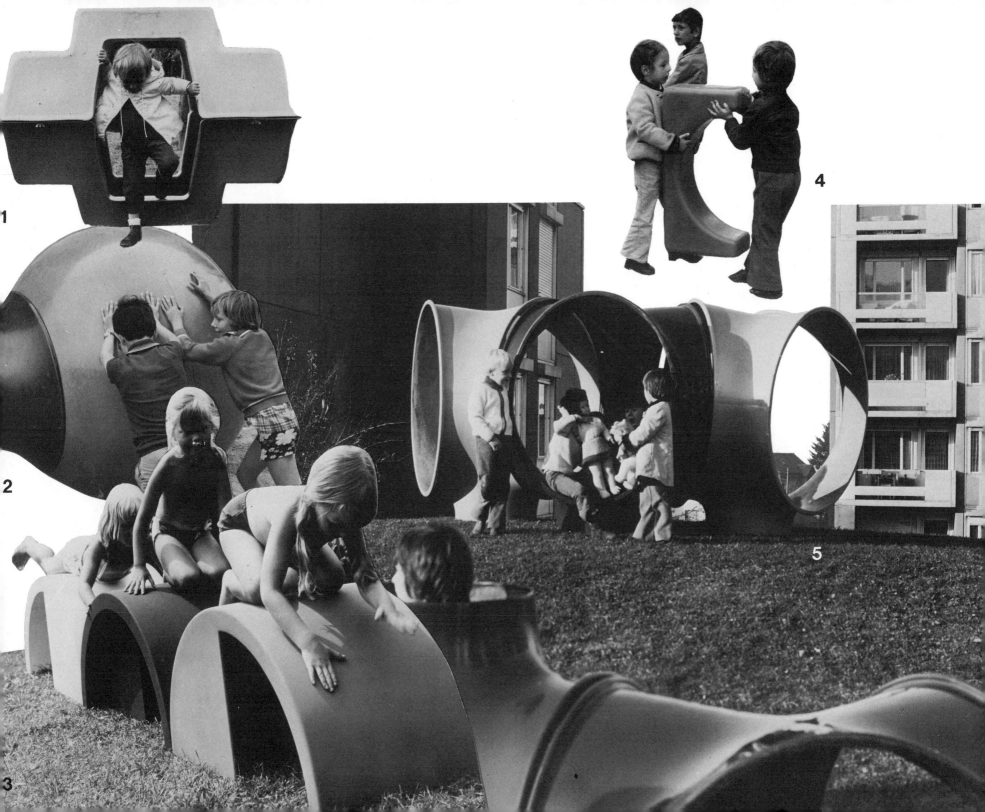

1

2

3

4

5

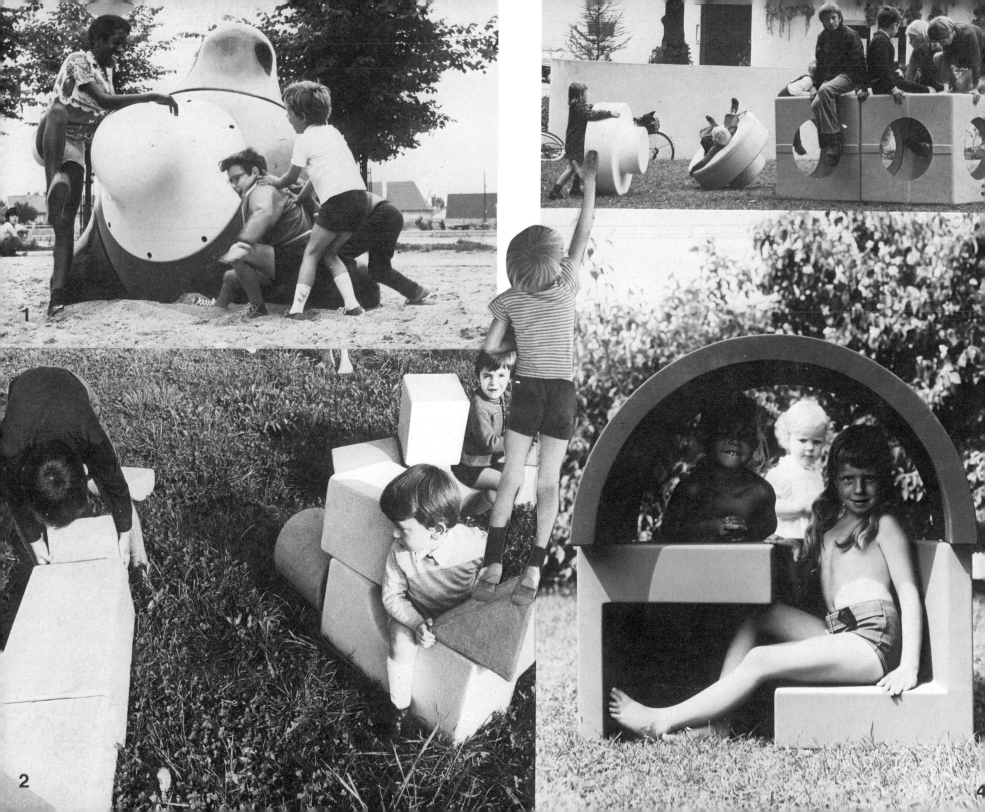

1

2

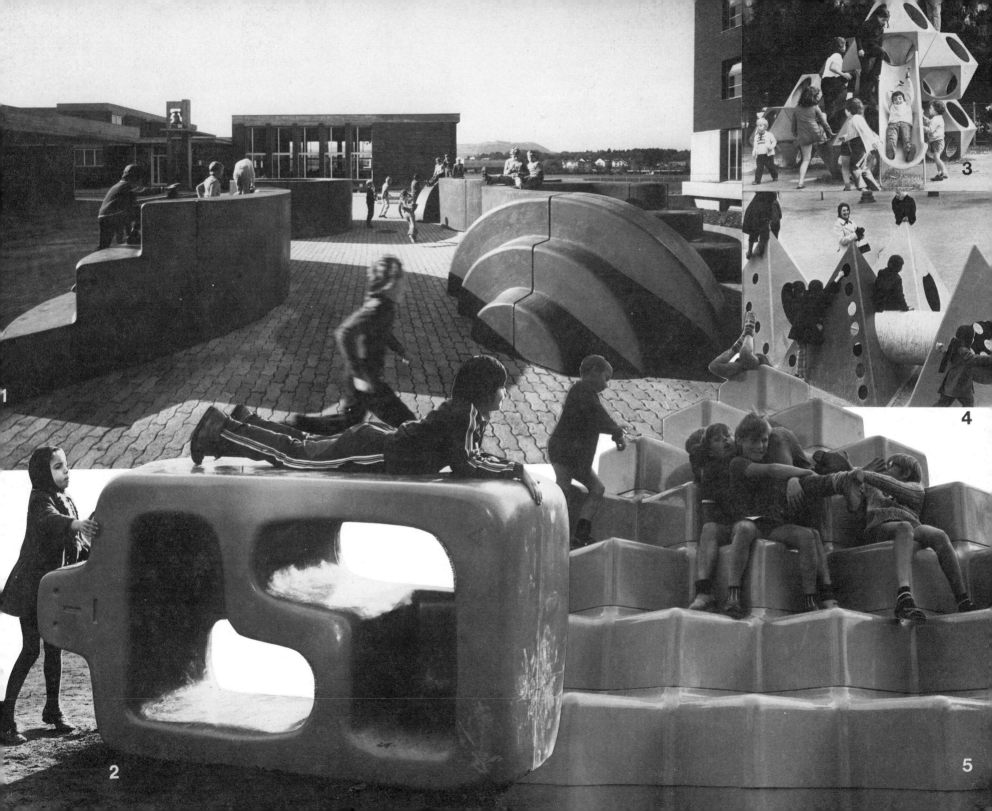

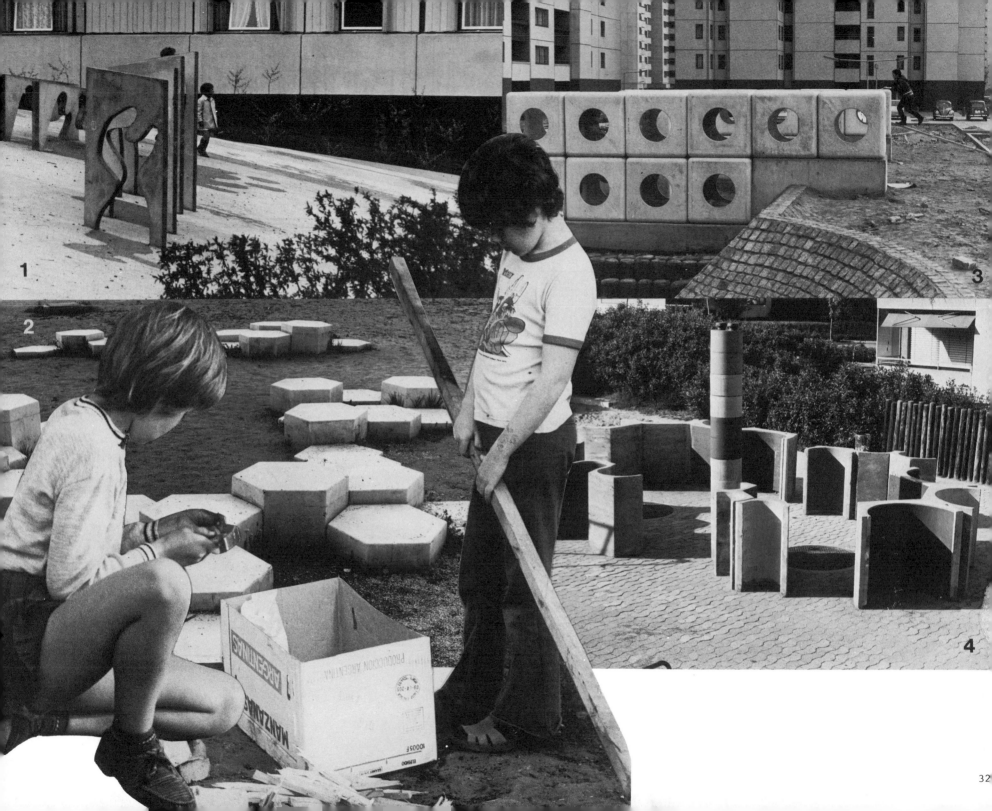

Concrete is even cheaper than synthetic materials and therefore often used in playgrounds. It can be mixed and poured on the spot or prefabricated. The surface can be smooth or rough; it can be painted or left in the raw. Finally, its weight makes it easier to erect solid structures.

Prefab elements are cheap enough that extensive areas can be generously furnished. Concrete is especially recommended for ground equipment, because of its versatile practical applicability and because of its resistance to exposure. It is especially useful for solid structures which are not supervised. However, because of the hardness of this material, sharp edges should be avoided on all equipment used for climbing or jumping.

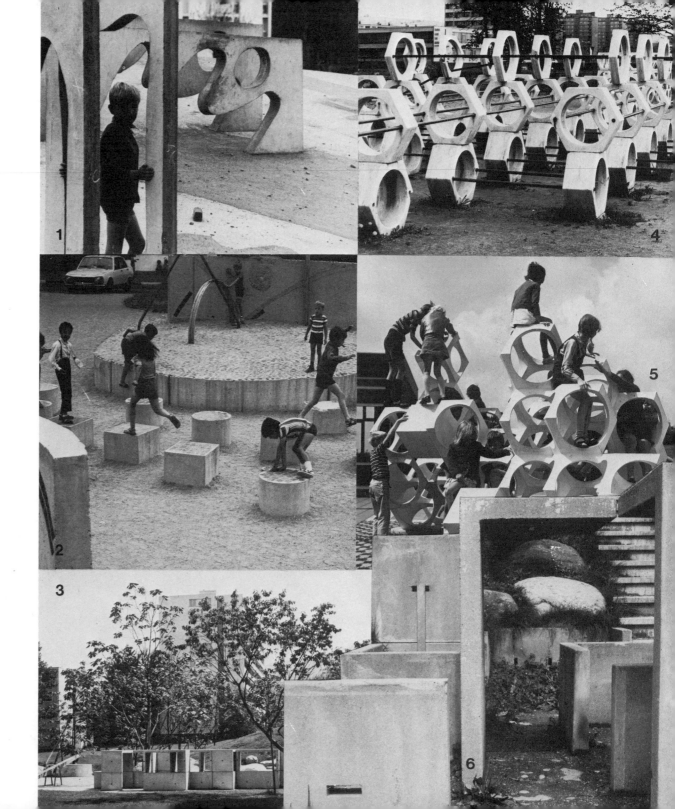

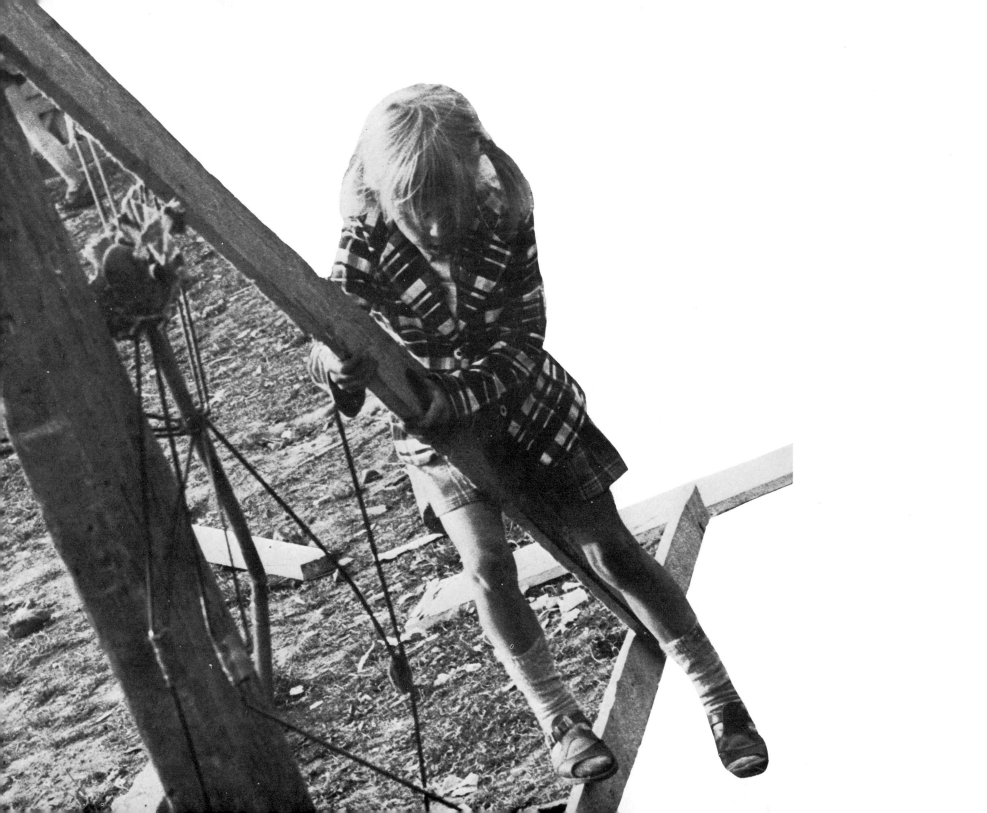

Wood is without a doubt the material most loved by children, for its stability, and because it is easy for them to work with it.

Wood can be found almost anywhere: to build a fire or cabin, for carving, or for any other woodworking hobby. A bow is made of green wood; pine bark is extremely suitable for small boats; scraps from construction sites (framing boards, plywood, molding, etc.) are ideal for building shacks and other structures. The possibilities are endless. New forms and functions can be invented, constructed, and combined.

Wood is also easy to transport.

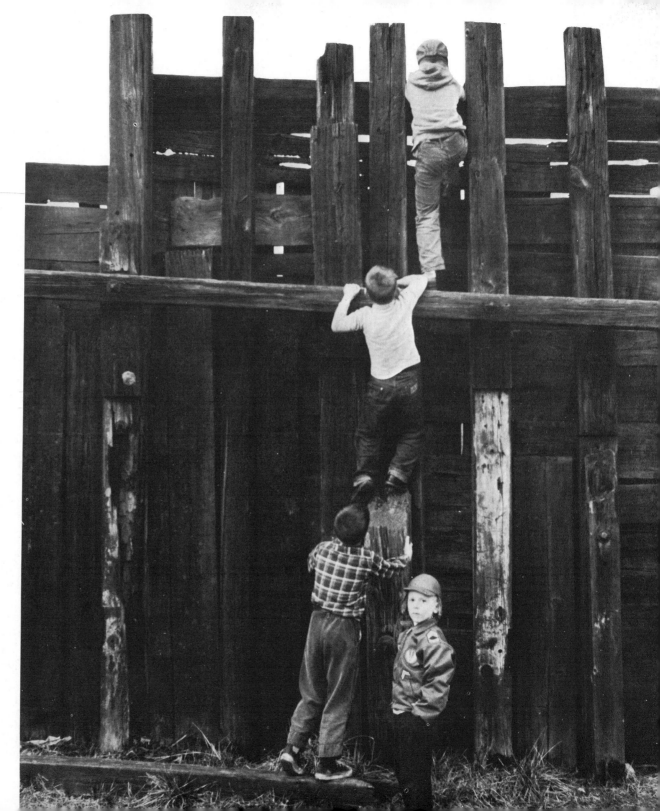

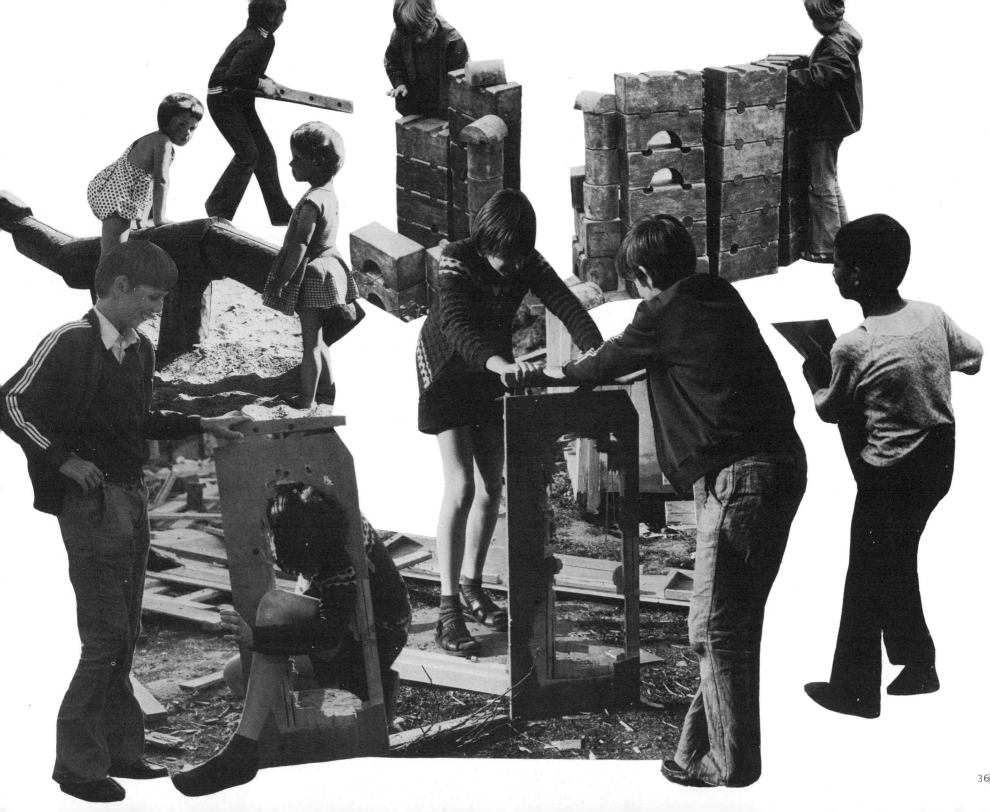

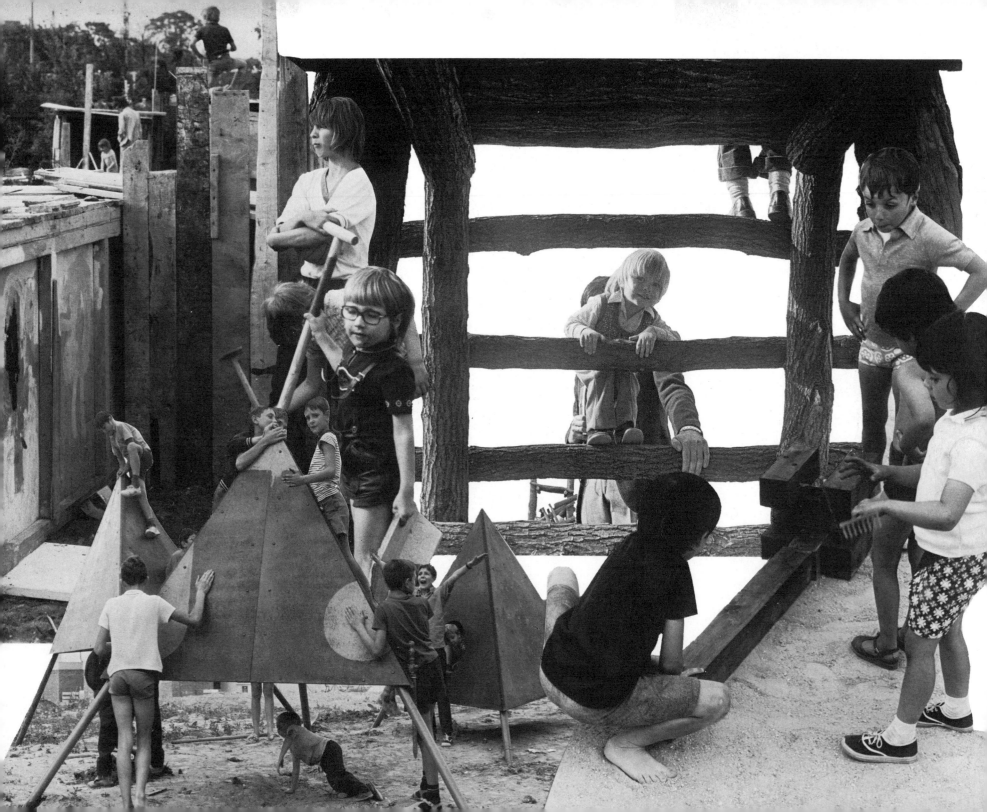

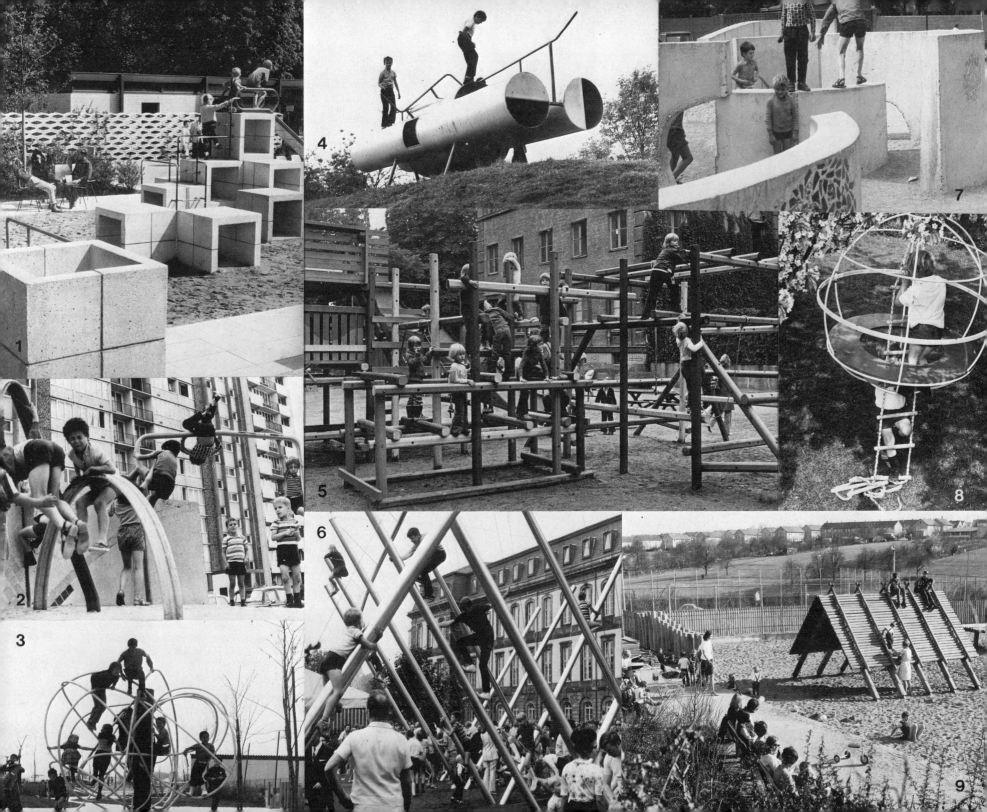

1

2

3

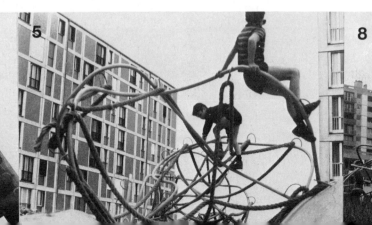

4

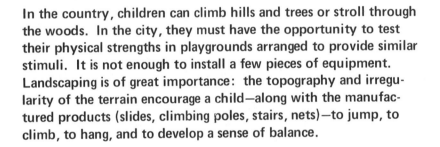

6

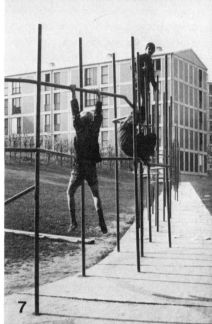

7

In the country, children can climb hills and trees or stroll through the woods. In the city, they must have the opportunity to test their physical strengths in playgrounds arranged to provide similar stimuli. It is not enough to install a few pieces of equipment. Landscaping is of great importance: the topography and irregularity of the terrain encourage a child—along with the manufactured products (slides, climbing poles, stairs, nets)—to jump, to climb, to hang, and to develop a sense of balance.

5

8

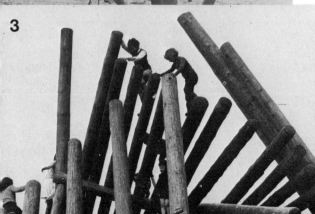

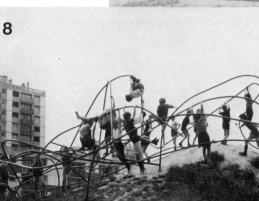

Joseph Weinstein Neighborhood Park, Lefferts Place, Brooklyn, New York City, USA

Design: M. Paul Friedberg & Associates
Completed: 1966

This small playground is located in a rather poor neighborhood. Surrounded by houses, it is a place of recreation for residents who have no opportunity to go to the country.

These "pocket" playgrounds are usually built on empty lots where two or three dilapidated buildings not worth saving have been removed. The real estate is bought by the city and the playground project supervised by an office of urban development. The construction is usually done by private contractors, or, in this case, by the Department of Labor, the work being distributed among the local unemployed.

The photographs show the empty lot before the work began (1) and how it looked on the day the playground opened.

1
2

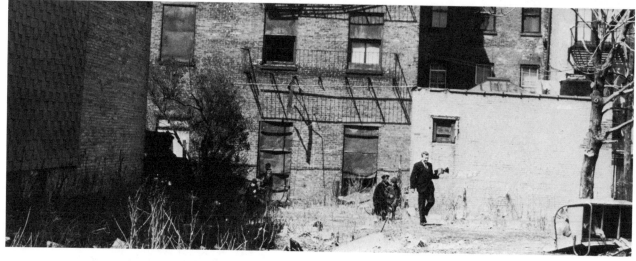

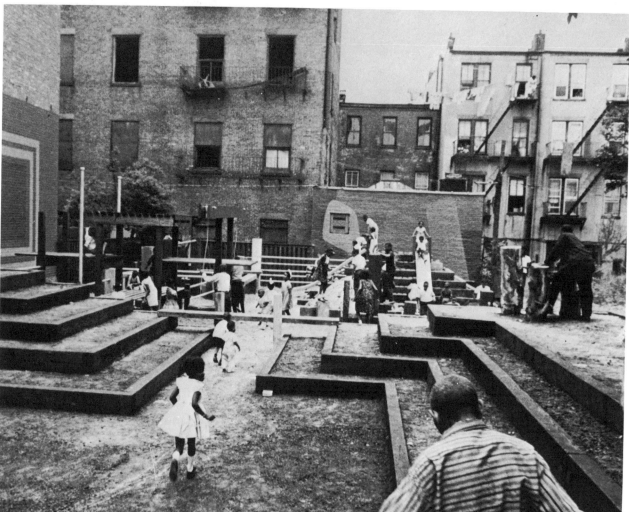

PS 166 Playground, Manhattan, New York City, USA

Design: M. Paul Friedberg & Associates
Completed: 1968

With the financial help of the Astor Foundation in conjunction with the Department of Parks, it was possible to convert this previously reconstructed piece of real estate into a "pocket" playground in a very short period of time. Originally a traditional schoolyard was planned, but then it was decided to create a recreation area for the children of the whole neighborhood.

The area is furnished with benches so that parents may watch over their children or wait for them after school without disturbing their play. There is an amphitheater which converts into a pool during the summer months, and a fountain with water jets shooting out from under the steps to the center of the square.

The architects have hidden the toilets and the water sources ingeniously inside a concrete hill, at the same time creating sloped areas for slides and other games. The architects also created a special playground for toddlers. The landscaping and the equipment are in accordance with that age group. For safety as well as an aesthetic effect, this space has been set one meter below street level.

This playground proves it is not necessary to wait for the rehabilitation of an entire neighborhood. A small financial outlay can create a play area.

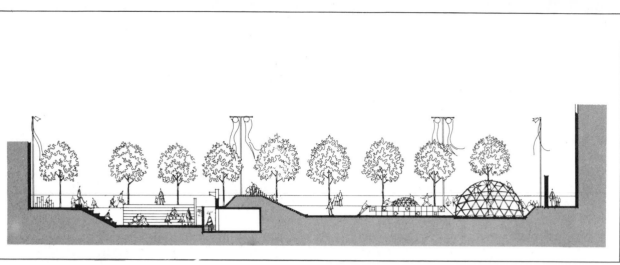

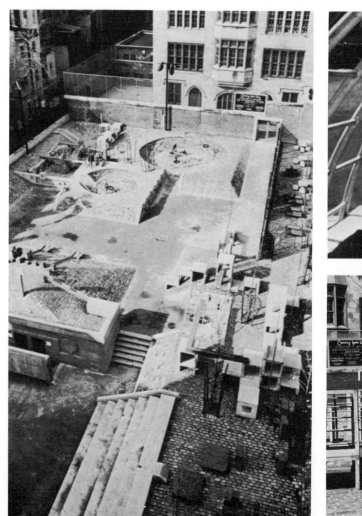

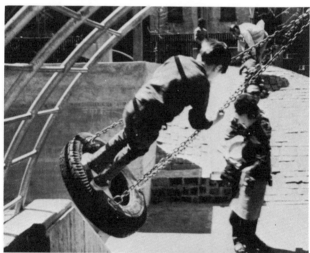

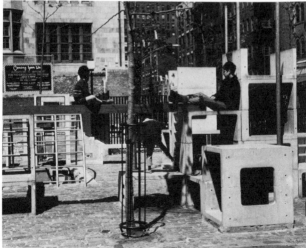

Sidewalks in Roubaix, France

Design: Jacques Simon
Completed: 1966

All the sidewalks on the south side of the streets (4 to 10m wide) were remodeled as play spaces. Crosswalks were covered with rippled concrete slabs and the originally planned patches of grass replaced with a black and white stone pattern: an interesting graphic effect facilitating the installation of concrete or steel playground equipment.

Play areas under apartment windows usually disturb tenants; the conventional solution is to plant grass, bushes, and flowers which don't co-exist well with children's activities.

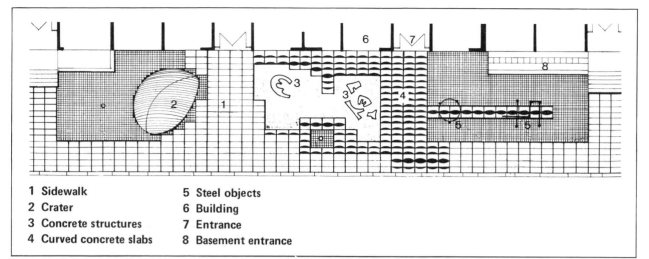

1 Sidewalk
2 Crater
3 Concrete structures
4 Curved concrete slabs
5 Steel objects
6 Building
7 Entrance
8 Basement entrance

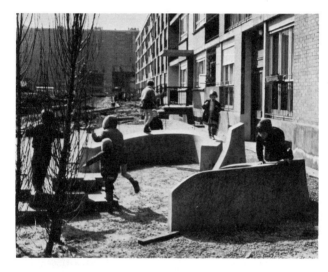

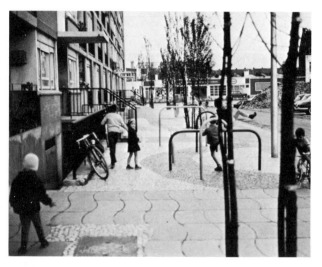

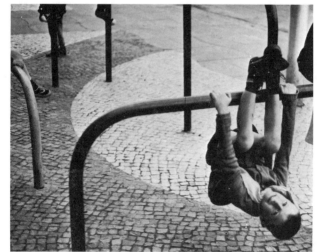

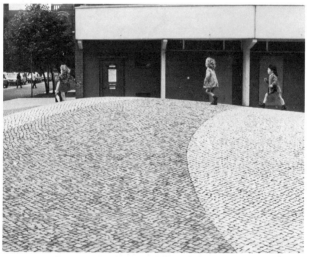

1	
2	3
4	5

42

Sidewalk with play area in the Cité d'Almont, Melun, France

Design: M. Saint Maurice
Completed: 1972

This designer was striving to counteract the extreme distance between the street and the buildings. The circular center allows for free access to the entrances; its curves and slopes offer an ideal space to play hide-and-seek and other physical action games. The grounds along the side and in front of the entrances are sloped in a similar manner. Constructions made of railroad ties are mounted upright in convenient places so as not to disturb the pedestrian traffic.

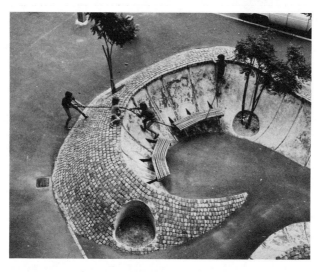
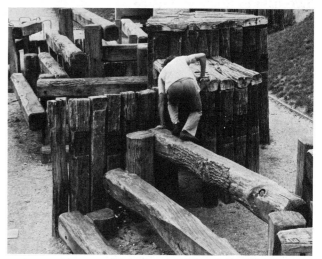
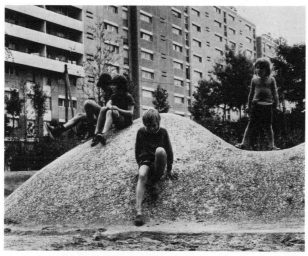
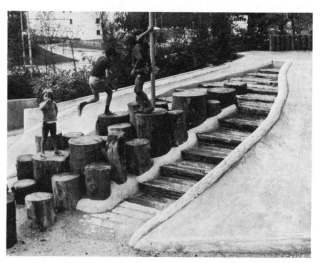
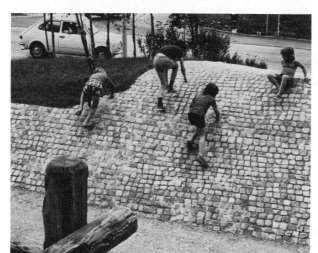
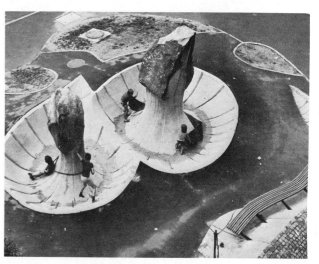

1	2
3	4
5	6

3

Layout of a pedestrian mall in Amiens, France

Design: Bernard Gogois
Completed: 1971

This central mall is surrounded by buildings of different heights. The pavement in between is narrow in some places and wider in others. A walkway leads over a small bridge into a tunnel beneath a building, around a corner, up on a ramp, to a space paved with flagstones overlooking the playground.

It is almost like walking through a maze of concrete elements. These elements serve the children as platforms, steps, benches, edges of sandboxes, and painting easels.

The streetlights are orange-colored spotlights installed on top of the buildings. Lighted in this way, the playground appears to be a theatrical set—confusing and reassuring at the same time.

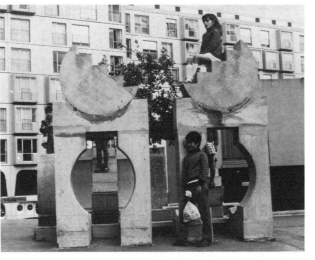
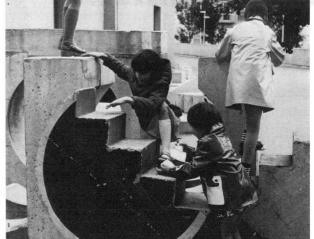
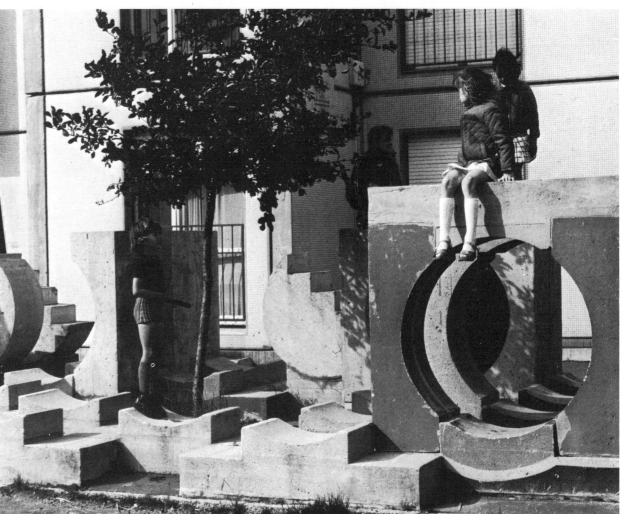

1	2
3	

Playground in Bedford-Stuyvesant, Brooklyn, New York City, USA

Design: M. Paul Friedberg & Associates
Completed: 1970

This is a street where cars were banned in order to create space for a recreation area. This ghetto neighborhood had only benches and stoops to sit on, but now there are many places for sitting, strolling, jumping, running, and climbing. By creating different ground levels, monotony was successfully avoided.

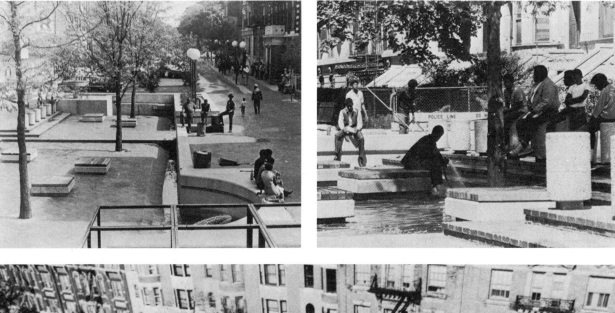

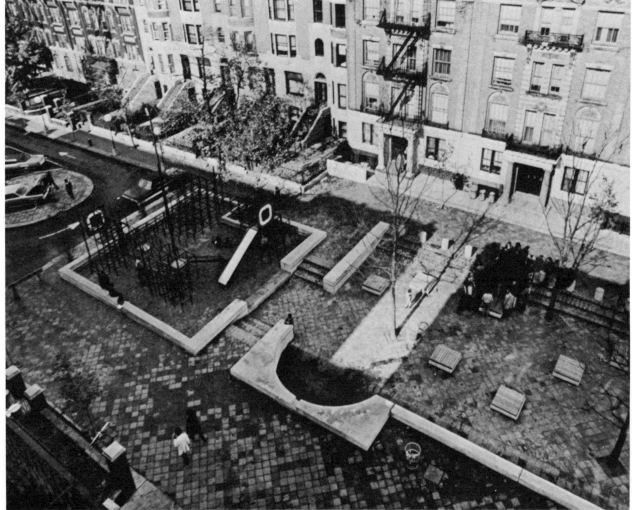

Playground on Vaandrig and Hoogerwerffstraat, Rotterdam, Holland

Design: Department of Urban Development, Rotterdam
Completed: 1973

These play areas closed off from any kind of traffic make it possible to convert a space back to its original purpose. The two streets are once again meeting places for the people of the neighborhood. The trees were incorporated into the design of a new arrangement composed of sandboxes fenced in by palisades (3), lightweight climbing elements (monkey cages) (2), and a chessboard (4).

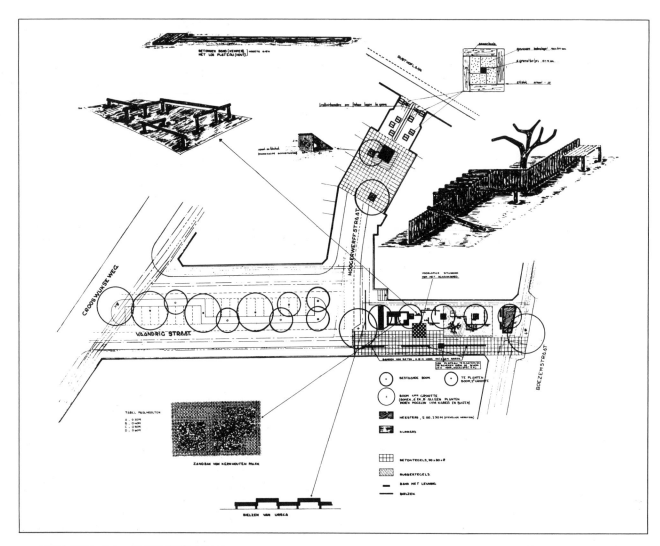

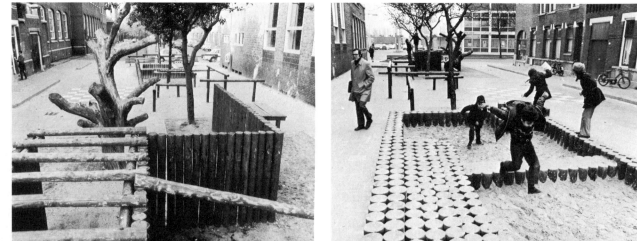

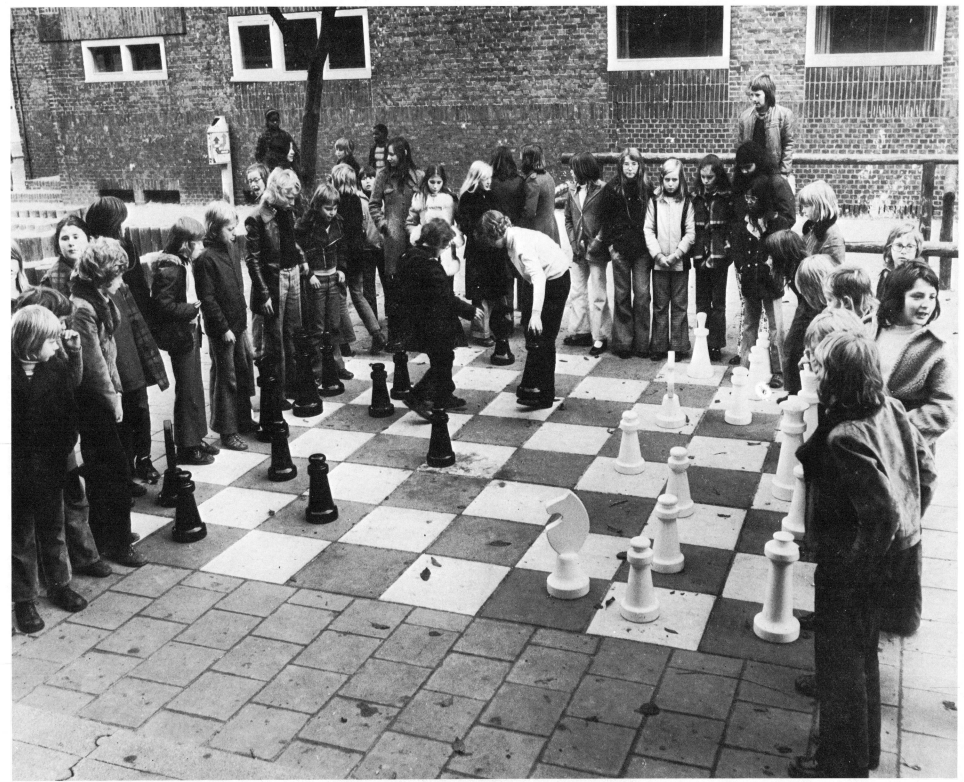

Playground on the Ravelijnplein, Rotterdam, Holland

Design: Department of Urban Development, Rotterdam
Completed: 1971

Instead of having recreation areas incorporated within the schools, the city resolved to create an open play space. This can be used before classes begin, during recess, and for after-school activities. All the playground equipment is placed on synthetic rubber mats to cushion possible falls. For greater safety, the edges of the sandboxes are rounded off.

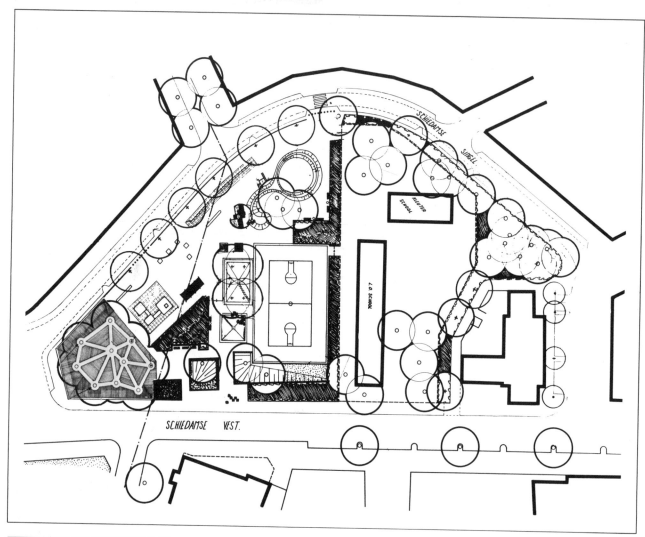

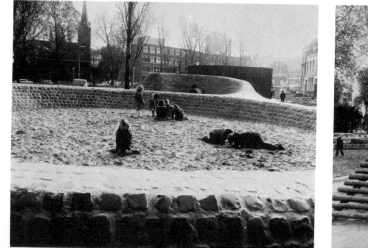

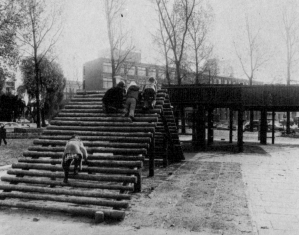

Pijnakerplein, Rotterdam, Holland

Design: Department of Urban Development, Rotterdam
Completed: 1971

This square was divided into two areas as part of an urban renewal project.

One half is reserved for special events with a raised music pavilion in the center. The trees remain as the only tall plantings in the area.

The other area, slightly below street level, is a space for play and recreation with wading pool, sandboxes, wall-benches, a shelter, a giant caterpillar made of yellow plastic, etc. The ground is paved with scrap material saved from demolition in the neighborhood. The area is protected from traffic by brick walls and other structural devices.

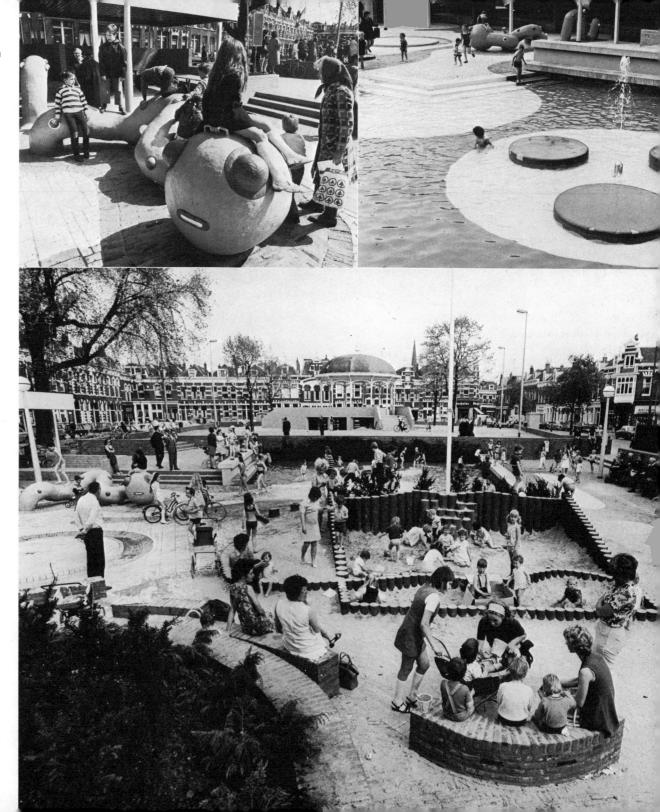

1	2
	3

Landsbury Market Playground, London, England

Design: Greater London Council
Completed: 1972

There is a parking lot in the basement, a market and the technical installation on the ground floor. The children's play area is on the terrace above. Apartments and balconies overlook this playground so that children can be conveniently supervised. The design (a man lying down) is made coherent through the placement of the playground equipment (painted paths, walls, and steel climbing apparatus for gymnastics) and is easy to read from above. The shadows of these somewhat cubistic-looking walls form different patterns depending on the direction of the sun. If lighting fixtures had been less conventional and the relationship with the planted areas on the ground floor more balanced, this design would have been perfect.

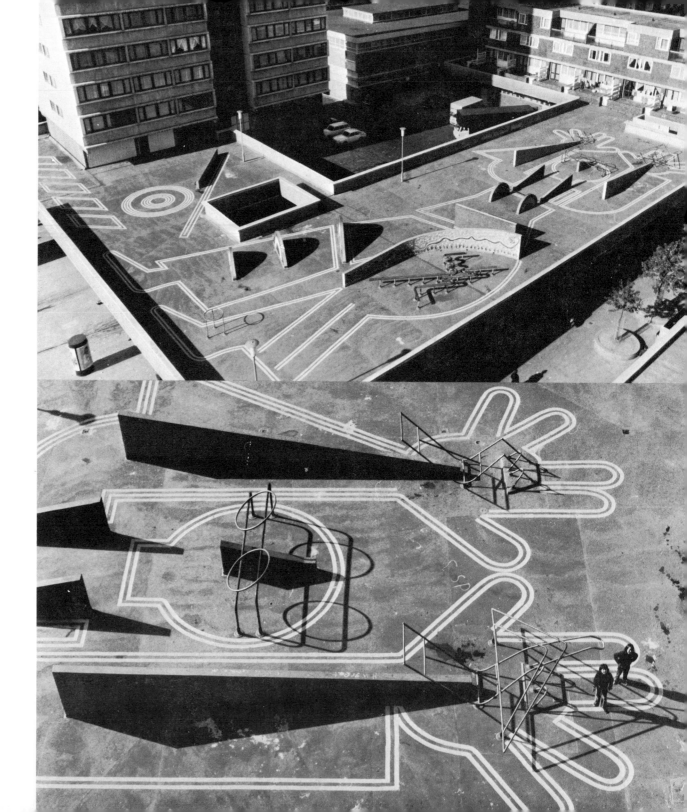

1
2

Playground on the roof of a firehouse, Munich, Germany

Design: Kurt Ackerman & Partner
Completed: 1972

Twenty-five years after the Unité d'Habitation in Marseilles by Le Corbusier, reclaiming the lost air space on roofs is still rarely considered. Roofs are safe from street danger and car exhaust fumes. Roofs make ideal outdoor play spaces. Although anything but green, there is fresh air and sunshine in abundance. Street level of this building houses firefighting equipment; a playground was installed on the roof for the children of the residents. A lively, attractive play space was created by choosing elements of wood and rugged concrete in strong shapes and primary colors.

 1 Chess-domino
 2 Sandbox
 3 Wooden elements
 4 Maze
 5 Ramp for running and riding
 6 Play castle
 7 Slide
 8 Swing
 9 Climbing poles
10 Climbing ropes
11 Flags
12 Bar (ballet)
12 Bowling alley
14 Mirrored surface
15 Trees (Robinia)

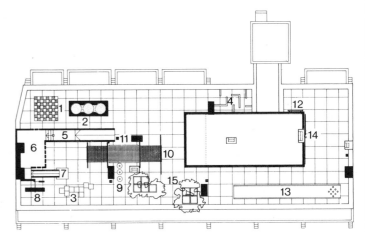

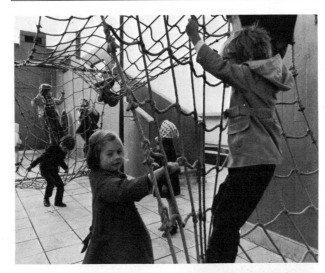

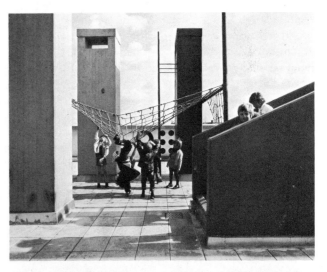

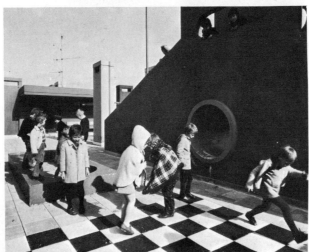

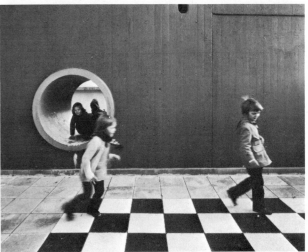

Schoolyard, The Montem Primary School, London, England

Design: David Cashman
Completed: 1972

At first, color was tried on the vertical surfaces only; it was then extended to the remaining areas. For the graphic layout of this schoolyard, the artist took his inspiration from the rules of the games children like best: running, jumping, the maze. The design had to evolve into a pattern useful for a variety of games. Decorative elements were played down so that the children might claim the ground as their own. In addition, the geometric figures are educational because they are enlarged reproductions of pictures from school books. This project clearly shows that schoolyards can be improved with little expense, be visually attractive, and take into full acount the needs of children.

Such attempts could go much further. It is a well-known fact that painted floors lend great dynamics to any room. Simple volumetric presentations or the use of different kinds of materials aid children in their quest for new dimensions.

	1
	2

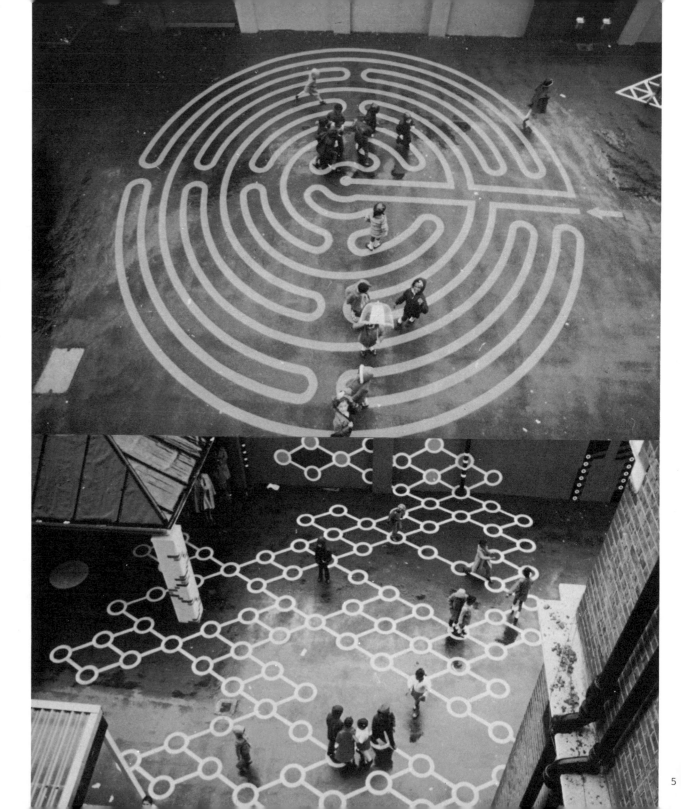

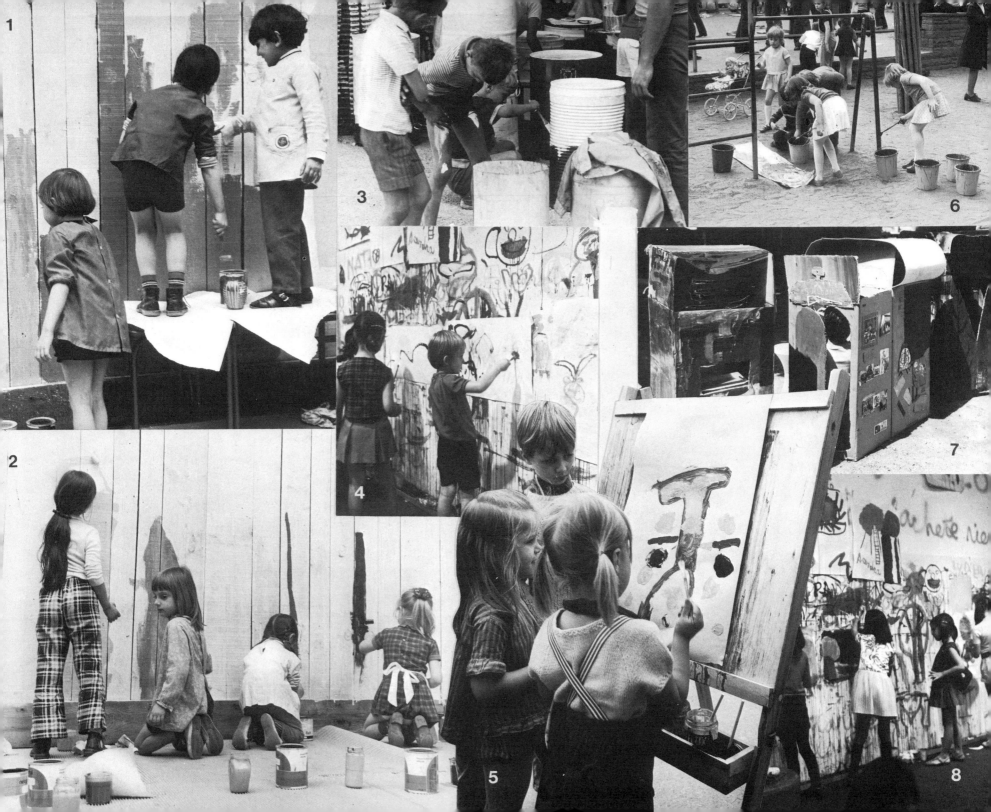

Schoolyard, The Buchanan School, Washington, D.C., USA

Design: M. Paul Friedberg & Associates
Completed: 1968

This entire area with all its equipment is open to the whole neighborhood. This complex includes a basketball court, a large dance hall connected to the street by a snackbar, and a large community room.

Being in a municipal area, this schoolyard is all inorganic. But the diverse forms and structures and the partitions separating the different functions provide for a great variety of activities.

Located next to an area filled with playground equipment, there is a large space for special events.

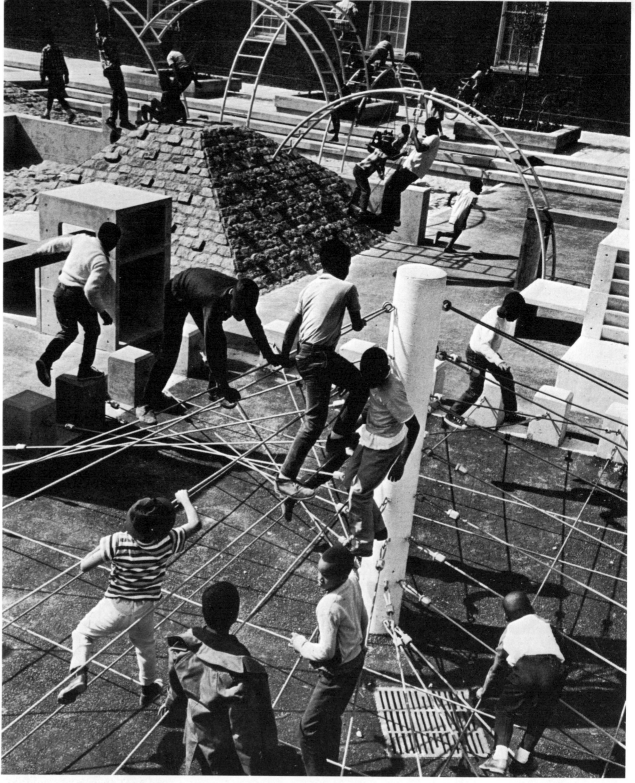

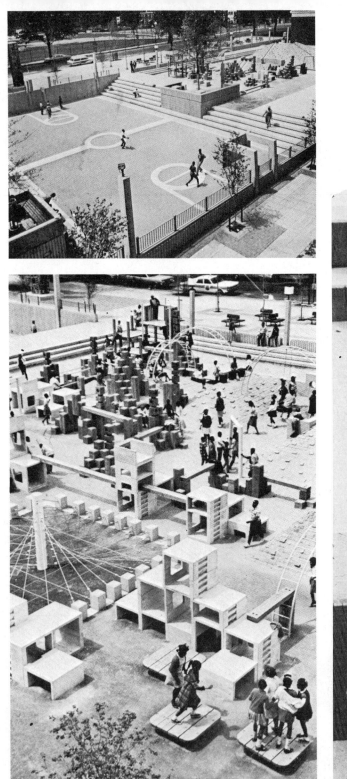

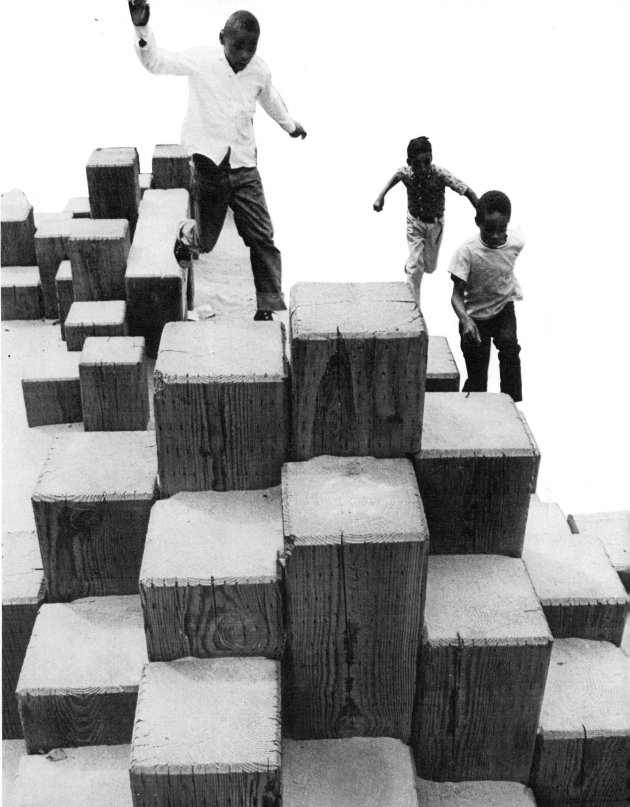

Schoolyard, The Maglegaard School,
Roskilde, Denmark

Design: Roland Declercq and M. Leroy
Completed: 1972

The hills consist of earth or firm sand covered over
by a layer of cement. The surface is fortified by
chicken wire set into the cement. To prevent the
surface from tearing, it was necessary to install ex-
tendible joints.

Architects Berg Bach and Kjeld Egmose didn't plan
this schoolyard as a closed-off area but as a multi-
purpose zone to insure interaction between the dif-
ferent age groups. This solution encourages healthy
social conduct. It is here that the child becomes
familiar with rules of community life and learns to
take into consideration the activities of others.

1	2

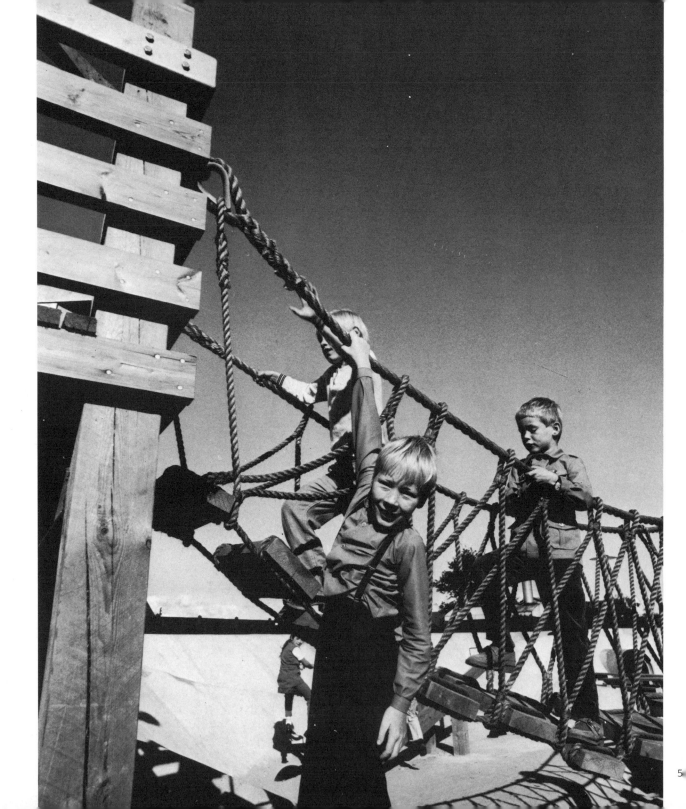

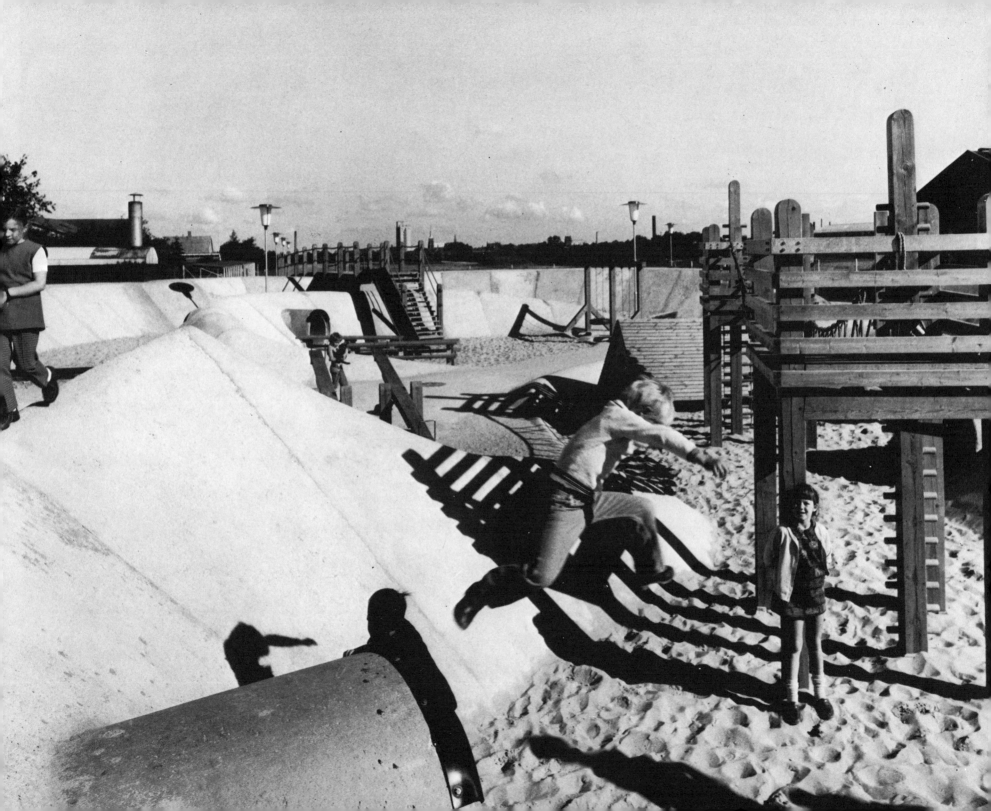

Sculpture garden of the Elementary School Aumatten, Reinach (Basel), Switzerland

Design: Michael Grossert
Painting: Theo Gerbert
Completed: 1973

This school is situated on a lightly inclined terrain overlooking wooded hills (1). With the housing project and road systems expanding, there was hardly any space left for the children to play. This "plastic" courtyard is a kind of "ersatz" garden, an artificial landscape on different levels. Narrow passageways lead to play spaces and niches—a universe 17 by 17m —where children can do as they please: climb, crawl, jump, do gymnastics and play hide-and-seek in a world of sculptured forms which do not reproduce nature. "The melody associated with forms and images plunges the child into the world of dreams," say the designers.

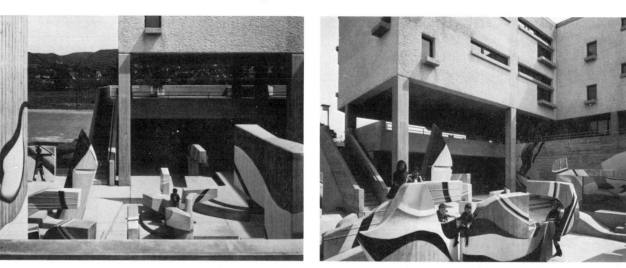

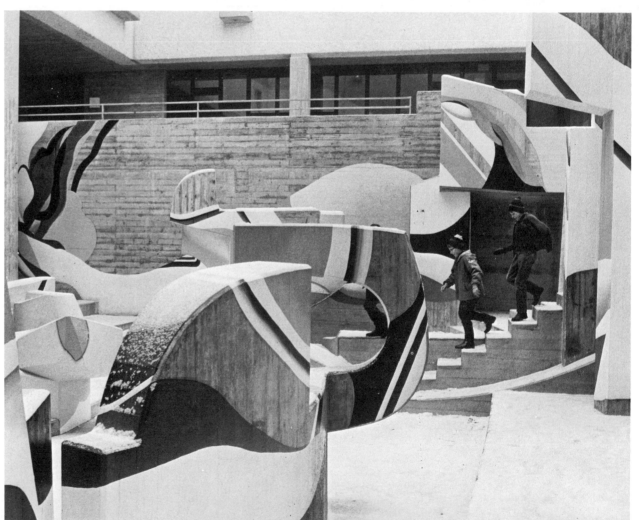

1	2
3	

Playground, the Moll housing project, Munich, Germany

Design: Kurt Ackermann & Partner
Completed: 1972

Considering the narrowness of the piece of real estate, the noise of the nearby highway system, the varying ground level, and problems of municipal planning, the designers chose an enclosed are for this playground. The grass-covered inner courtyard is located above a two-story garage. The playground and the walkway connecting the building with the street (4) are located on the sunny side to the south as far removed from the building as possible. By climbing across the "concrete" mountains and up 35 protruding rungs, the children can reach the walkway to the inner courtyard without using the staircase (2, 3). And they can crawl through a tunnel into a sandbasin and climb up the paved wide stairs to the walkway leading to a covered playroom.

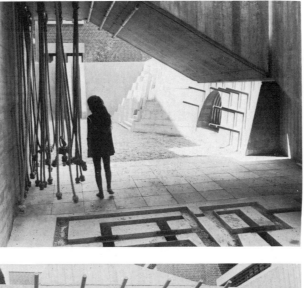

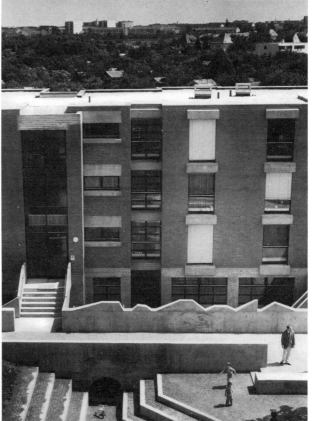

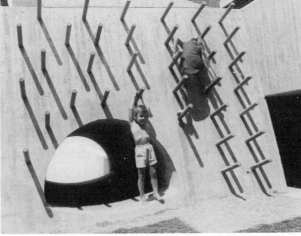

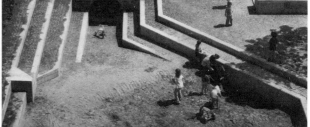

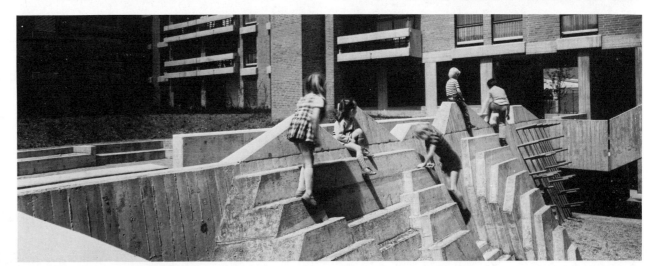

	1	
	2	3
	4	

Playground of a housing project in Garath, near Düsseldorf, Germany

Design: Department of Recreation and Parks, Düsseldorf
Completed: 1968

The entire surface of this playground is covered with asphalt and shaped in curves. Steel pipe constructions across the walkways straddle these waves of asphalt. The formation of this playground equipment allows for close visual contact between playing children and strolling or supervising parents.

This playground is a fine example of a satisfactory solution by administrative authorities when they take the trouble and care.

1	2

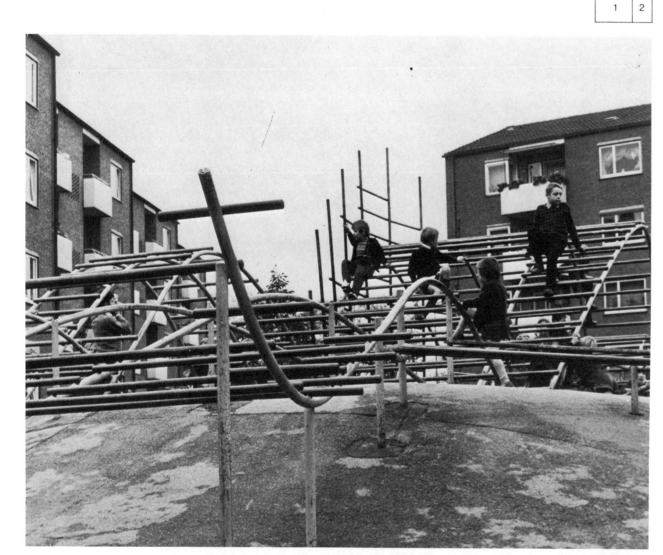

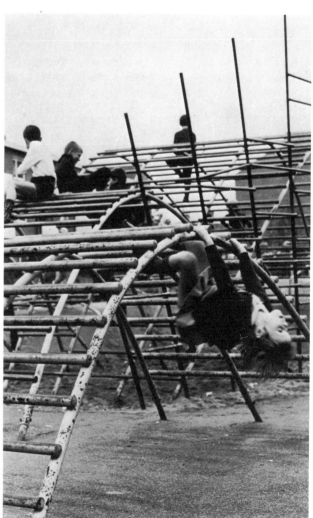

Playground in the Cité de la Croix Rouge, Reims, France

Design: Juan Broglia (concrete floor) and Ludovic Bednar (wood and steel equipment)
Completed: 1971

No particular technique is needed to build this wavy landscape. The forms are created by heaping up earth or sand into compact shapes and covering them with a layer of concrete.

The steel tree is constructed of one strong tube closed off on the top and curved thin tubing. The wood game consists of mass-produced elements; it has countless possibilities.

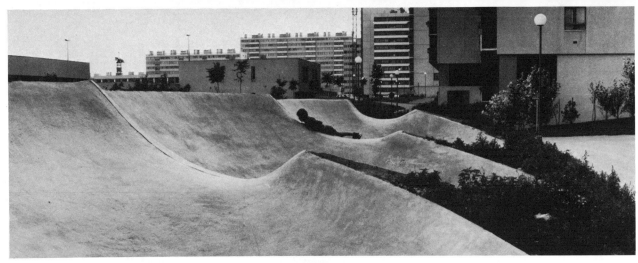

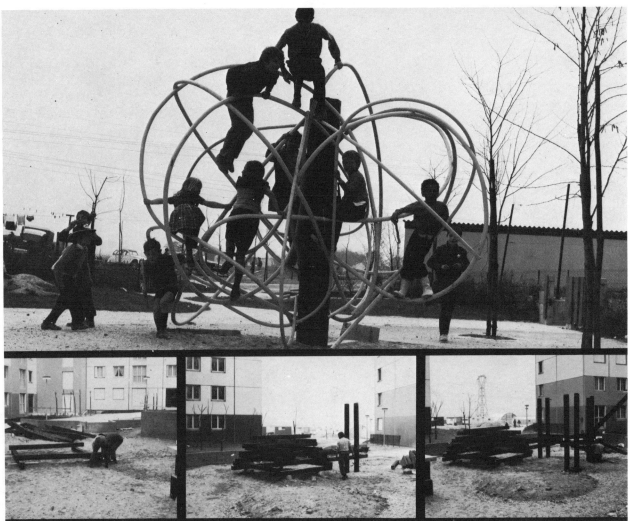

	1
	2

1

Playground in Nangis, France

Design: Jacques Simon
Completed: 1970

This playground is enclosed on three sides by buildings four stories high. The design had to provide passageways for pedestrian traffic. The thick undergrowth between the buildings and the walkways was trimmed to make room for an open center space. Asphalt areas, framed by concrete walkways, are shaped like small pyramids with lengths up to 6m and, in places where they don't block traffic, heights up to 80cm (3). The giant sandbox is surrounded by slopes with checkered surfaces of grass and stone. Children slide through plastic tubes in the slopes to the sand (2). The steel structures were welded on the spot (5) and the variable play areas of concrete (4, 6) permit a wide range of games to be played.

The asphalt paintings were created with the assistance of the children themselves as a special event.

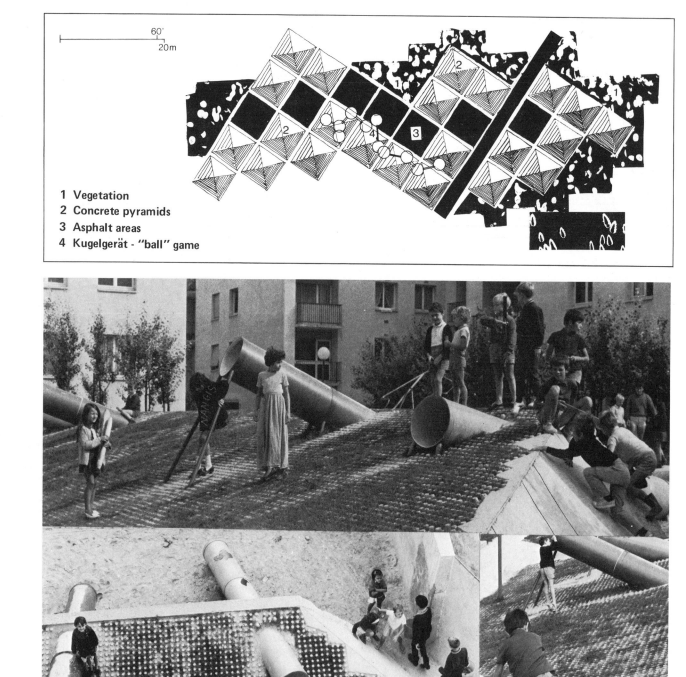

1 Vegetation
2 Concrete pyramids
3 Asphalt areas
4 Kugelgerät - "ball" game

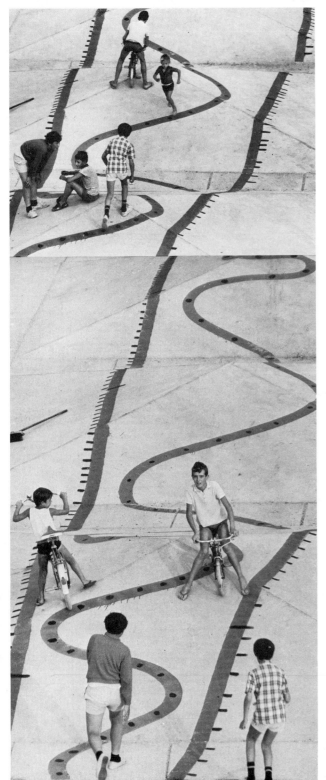
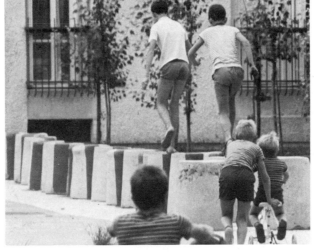
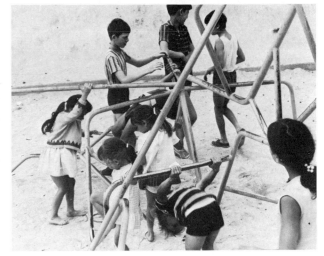
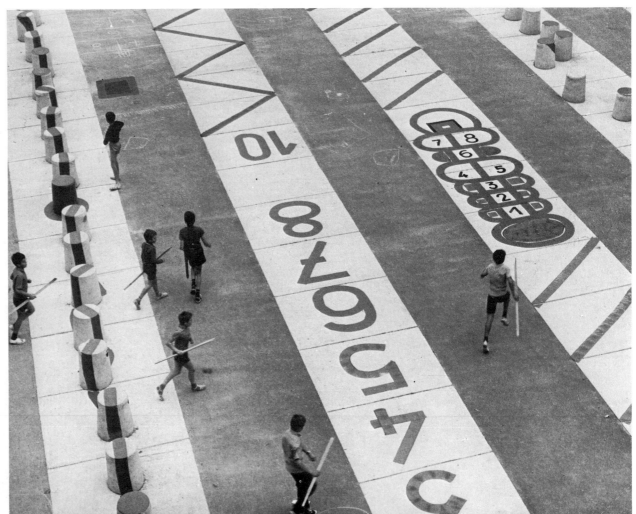

Playground in Utrecht, Holland

Design: Department of Municipal Planning, Utrecht
Completed: 1969

It will take several years until the trees at the edge
of the residential area will have grown high enough
to become a park with large clearings. The wading
pool and sandbox are located in one of these future
clearings. A shallow, safe wading pool is sufficient
for all children old enough to be left without super-
vision. The areas for the toddlers are imbedded in
earth depressions, while the older children have wide,
flat play areas at their disposal.

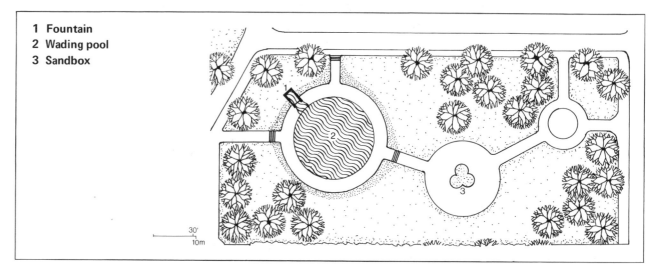

1 Fountain
2 Wading pool
3 Sandbox

30'
10m

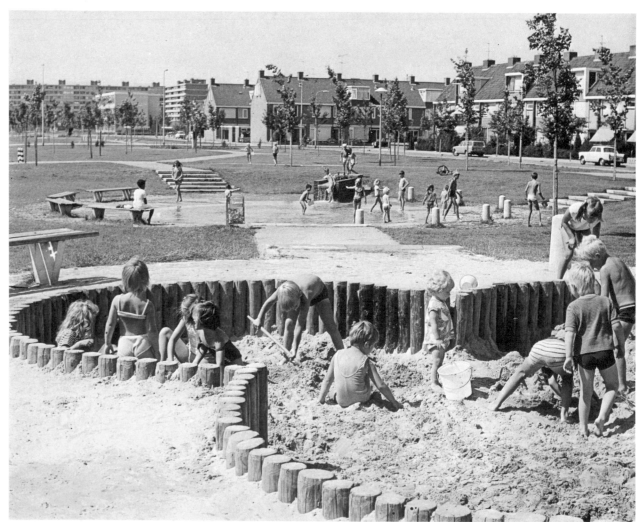

1
2

Playground in Massy, France

Design: Department of Municipal Planning, Massy
Objects: Ludovic Bednar
Completed: 1971

This playground is located in a public park on a land depression. The circular play areas are different in size and surrounded by big mounds of compacted earth. The mounds are covered with a layer of concrete 10cm thick. One circle is filled with fine river sand (4), another with water. A concrete road going around these "craters" is used by the youngsters for bicycling and roller skating. In the area covered with gravel and framed by bushes, playground equipment has been installed, one is a sphere made of 100 welded rings of steel tubing (3).

The Department of Parks and Recreation organizes happenings in this area. An example: Blowing up rubber sausages (2). The playground has some partly mobile and some fully mobile equipment—which makes for an essential variety of activities and games.

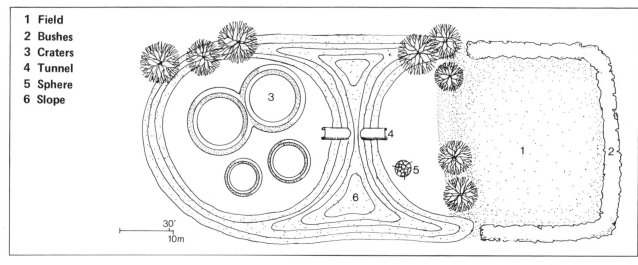

1 Field
2 Bushes
3 Craters
4 Tunnel
5 Sphere
6 Slope

30'
10m

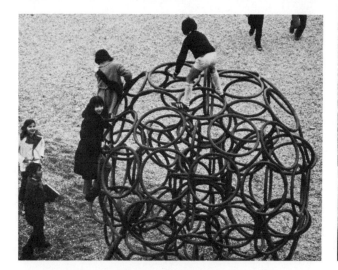

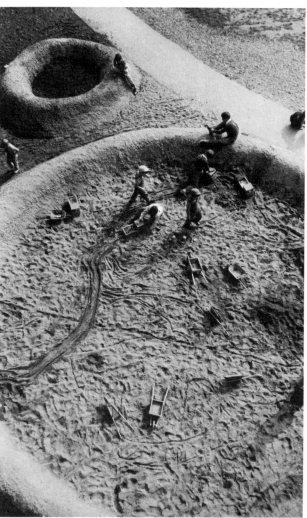

Playground above an underground garage in the Cité de la Croix Rouge, Reims, France

Design: Jacques Simon
Metal Constructions: Ludovic Bednar
Completed: 1971

This playground was arranged on the main square of the university district. The principal attractions are the water fountains (2, 3), made of a series of steel arches. These arches are up to 7m high and are crowned by five large flowery ornaments with a diameter of 2.5m. The water is caught in large pools and recirculated. The edges of the pools extend in waves over an area of 600sq. m coated with a light-blue plastic resin.

In another part of the playground there are curved shapes constructed of steel pipes 40m in diameter (4, 5). This large square is approximately 100sq. m and is covered with a 20cm thick layer of river sand so that the children will not get hurt by the concrete floor.

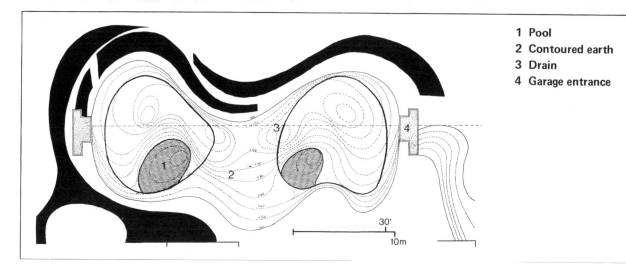

1 Pool
2 Contoured earth
3 Drain
4 Garage entrance

30'
10m

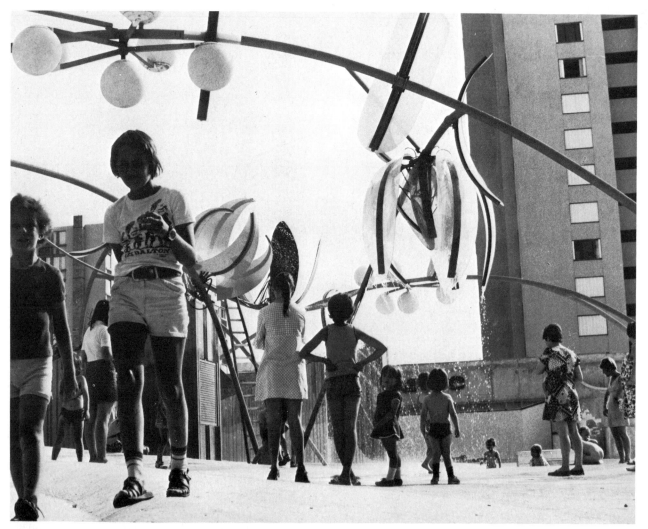

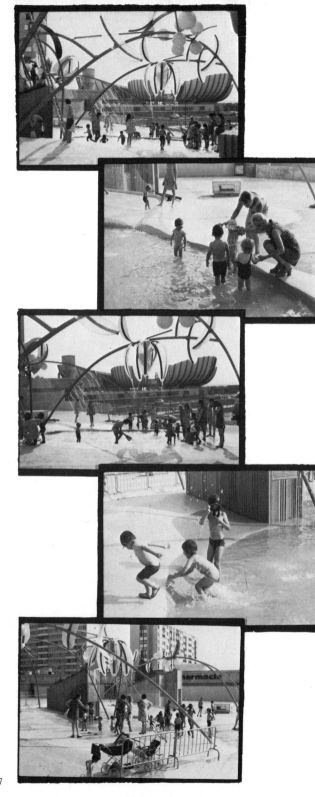

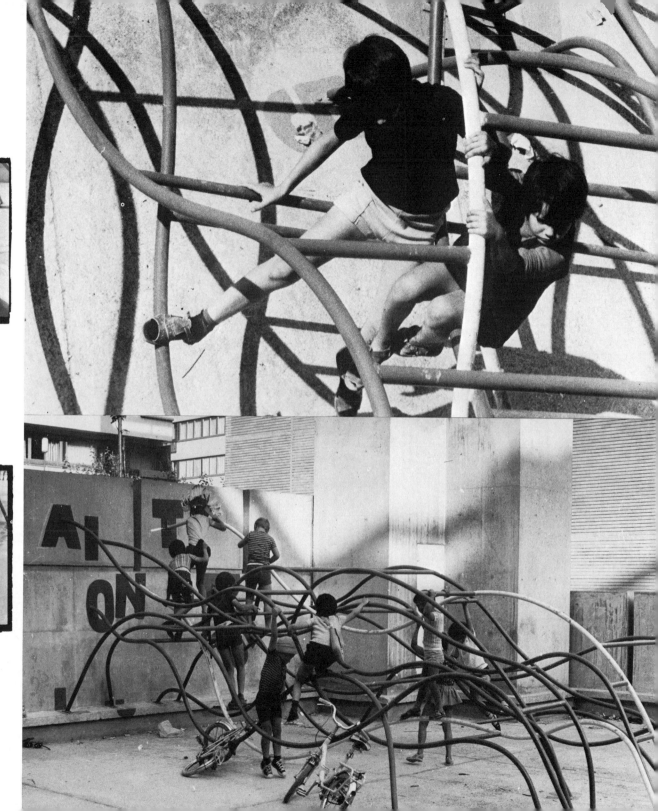

St. Aidan's Avenue, Blackburn, England

Design: Mary Mitchell
Completed: 1970

Conserving the trees and extensive excavation work near the housing were the given conditions of this playground (1). In the gulley between two hills paved with cobblestones are two steel slides. The lower hills are connected by ladders made of galvanized zinc. About a third of each cobblestone sticks out of the cement to make it easier for children to climb up and down.

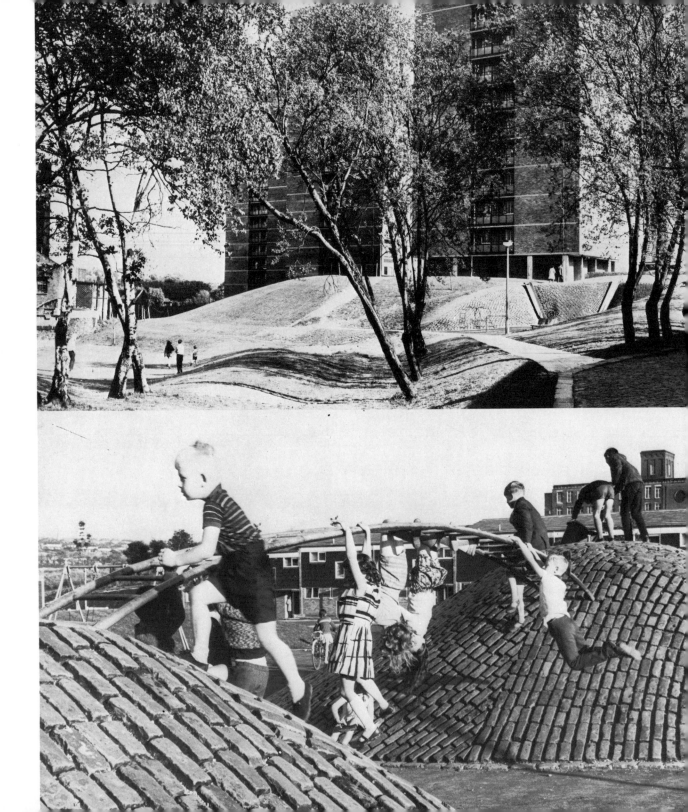

1
2

Queen's Park, Blackburn, England

Design: Mary Mitchell
Completed: 1970

With this project, Mary Mitchell sought to counterbalance the monotony of the buildings. Unfortunately her design was confined to determining the course of the creek which passes through this large housing project. She was commissioned to work in a defined area like a sculptor. On the sloped meadows the planting of robust domestic trees was apparently sufficient. The two stairs and the slide were especially made for this slope: all the other building material came from demolition sites. The rocks were found on the spot during the excavations. The benches were made of trees which could not be saved.

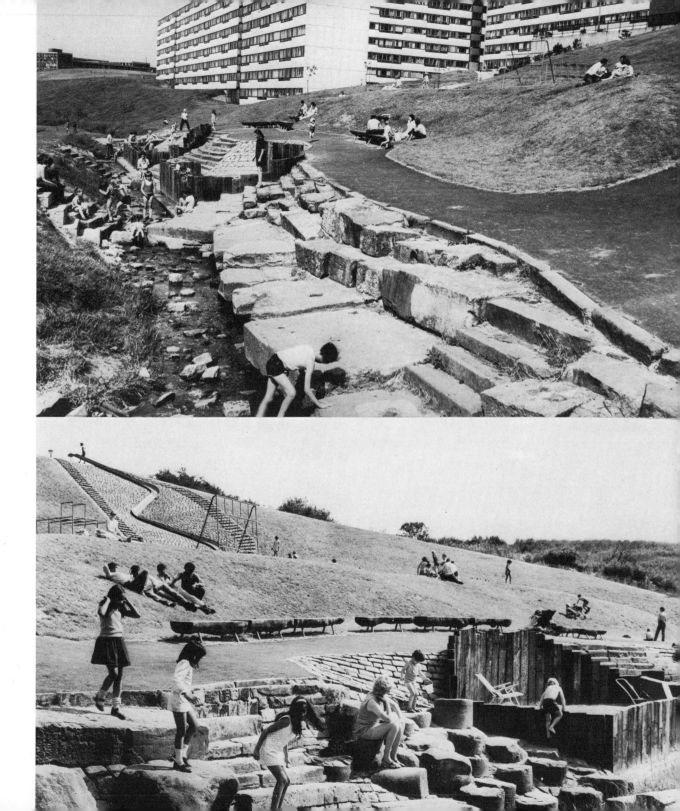

1
2

Markfield Playground, Haringey, London, England

Design: Mary Mitchell
Completed: 1966

The old filter plant built in 1850 served during World War II as a fire house and was later used as a hog farm. When the building was finally vacated, it deteriorated quickly and became a hazard; a guard had to be present at all times (2). The community decided to make better use of this area. Mary Mitchell left the main building as a covered play space and the engine house as a museum intact and converted the former basins of the filter plant into play pits (3, 6). To counterbalance the geometry of the basins, the surrounding terrain was slightly landscaped (4).

This low-cost playground is a very good example of what can be done for a community by converting a relic into a vital asset.

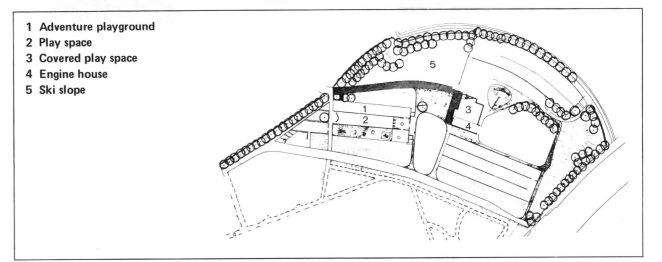

1 Adventure playground
2 Play space
3 Covered play space
4 Engine house
5 Ski slope

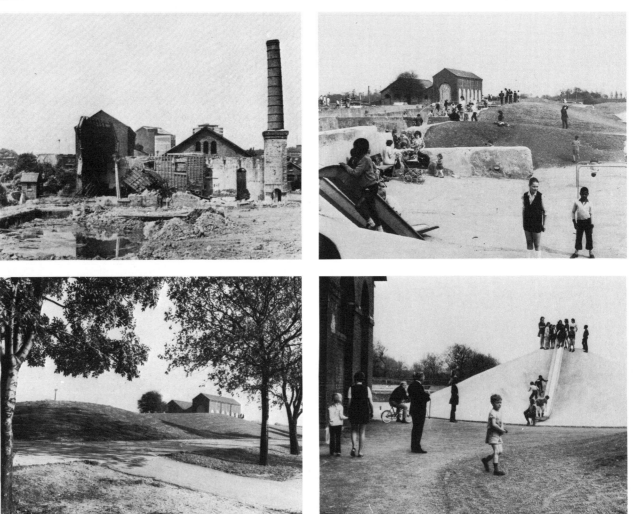

	1		
2	3		6
4	5		

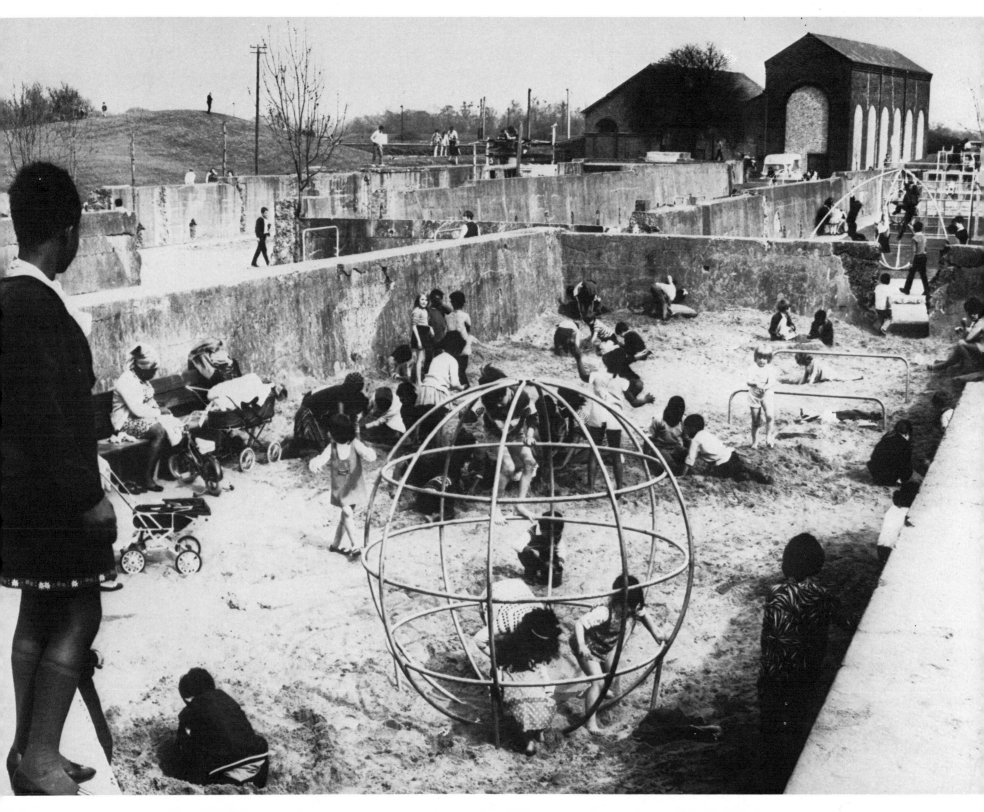

Municipal Park in Utrecht, Holland

Design: Department of Municipal Planning, Utrecht
Completed: 1970

This play area which belongs to a new housing project is protected from the highway traffic by dense foliage. Adjacent to the tree-lined meadows is a large wading pool where the children can play safely (1, 2, 3). Building materials are available in several enclosed grassy areas to be used by the children to build with as they see fit (7). In other paved areas wooden cylindrical forms are used as play equipment (4).

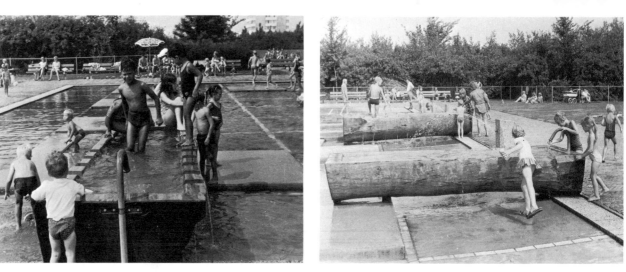

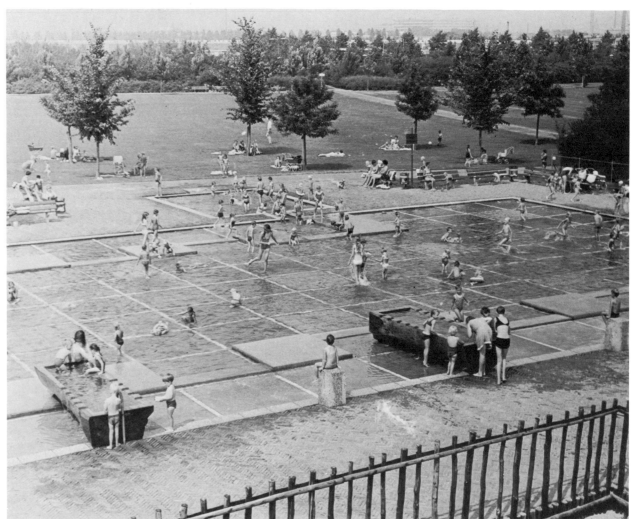

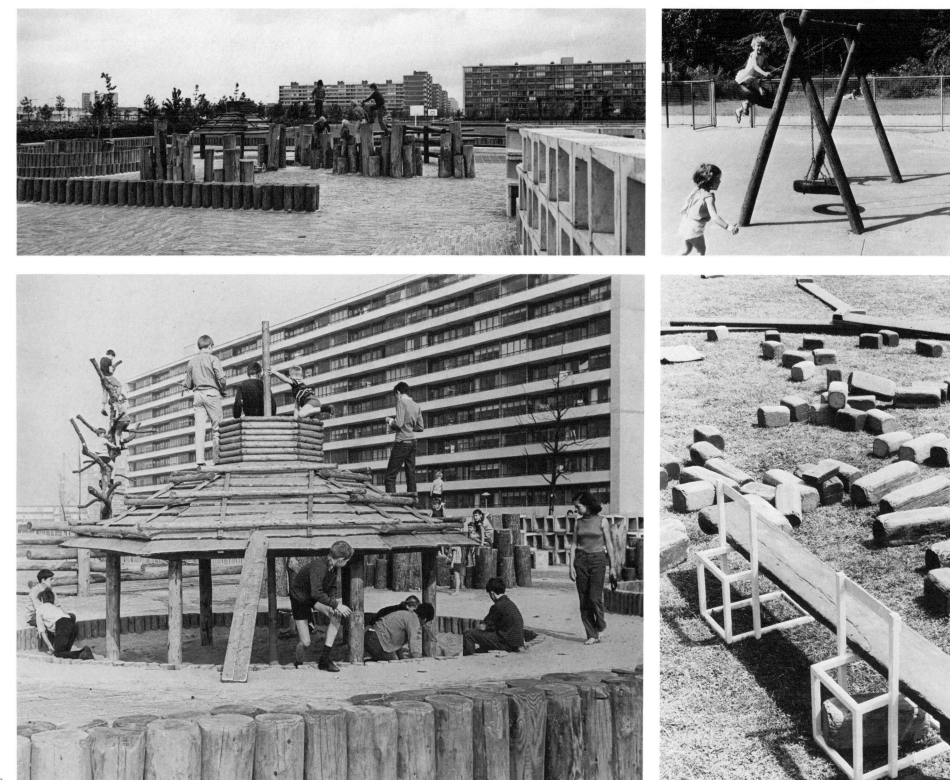

Playground of Patte d'Oie, Cité de la Croix Rouge, Reims, France

Design: Viollet and Brichet
Giant Mikado: Jacques Simon
Completed: 1971

Planning this playground on the edge of a large housing project had to consider the following requirements: maximum exposure to sunlight, protection against street noise and wind, topographical variation, a defined play area, and minimal costs.

Decisions defining the play area were made very late, too late to fill in some parts of the building site with earth. To the delight of the children, two of the depressions left filled immediately with water. A carpet-smooth field without paths, sandboxes, or flower-beds was in this case the most comprehensive, fastest, and most appropriate solution.

In the center of the landscaped area, a gigantic "Mikado" was installed. Its pine "sticks" are each 8m long and are fastened to each other with steel bolts; 200m of ship cable and nets are vertically attached to this construction. It took two months for the parents of the neighborhood to accept this playground and bring their children there.

	1		4
	2	3	5

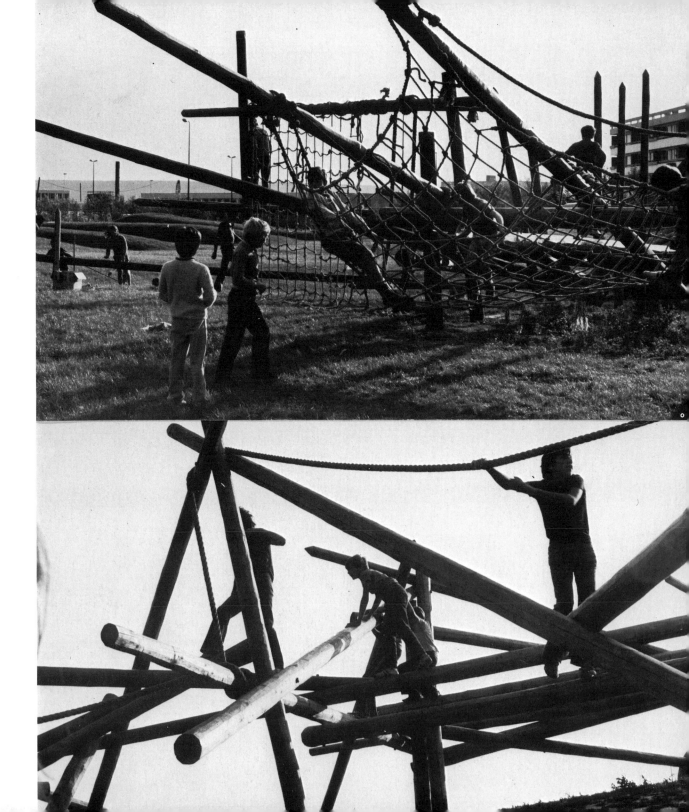

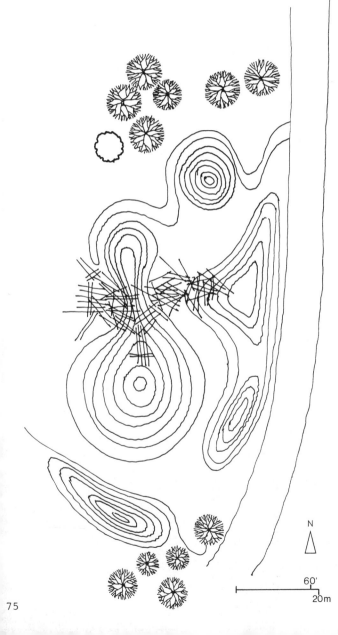

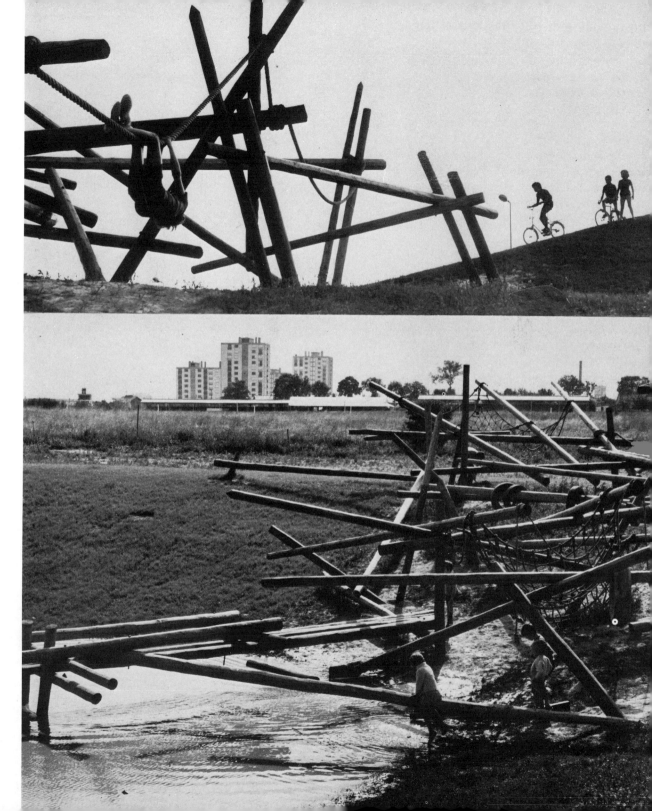

Playground in the Cité de Caucriauville, Le Havre, France

Design: Jacques Simon
Completed: 1971

This play area is bordered on two sides by housing projects and opens up on the other two sides toward a school and an athletic field. Planting soil had been stored there for a year. Then when a battery of bulldozers began to move the earth around, the operators kept in mind the shape of the terrain suggested in submitted blueprints.

The grounds are shaped as a sequence of larger and smaller mounds and depressions (2). In order to screen off the play space, the periphery was planted with trees. (Individually scattered trees wouldn't have been treated with kindness by the children anyway.) One of these hills is completely covered by a maze of multi-colored curved steel pipes anchored in the ground (4, 6). On another hill is the "ball-game," a construction of metal balls connected by welded pipes (3, 7). Climbing ropes and nets were installed to extend the possibilities for action games.

At specific times, special events take place here and mobile play elements, light polyester blocks, plastic tubes, inflatable materials, cables, ropes, etc., are brought in.

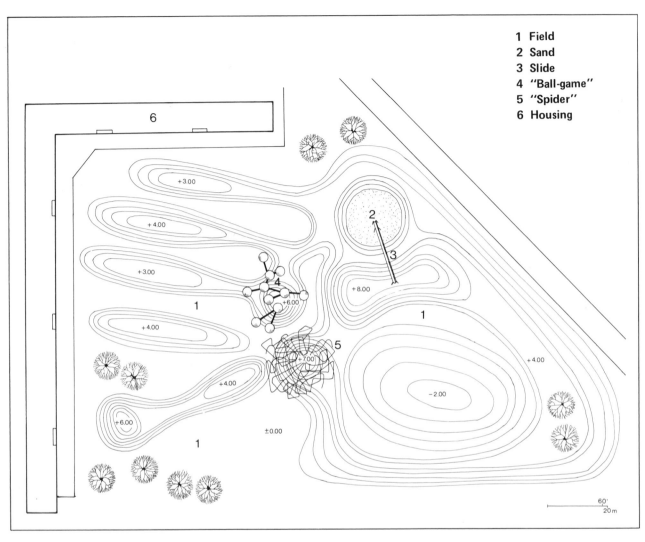

1 Field
2 Sand
3 Slide
4 "Ball-game"
5 "Spider"
6 Housing

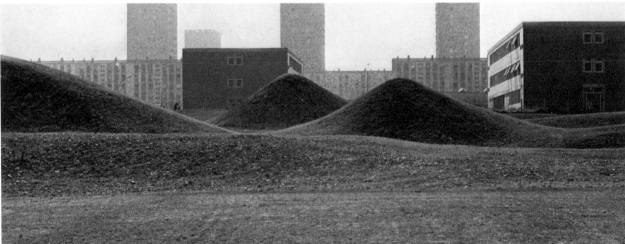

7

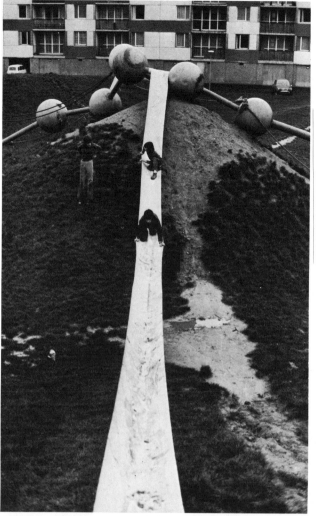
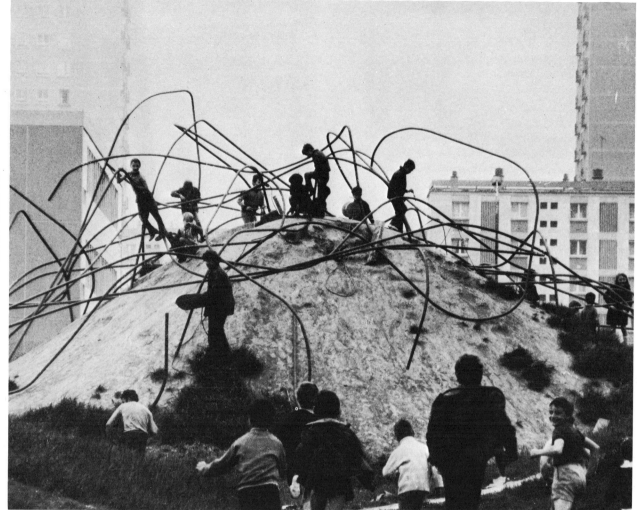
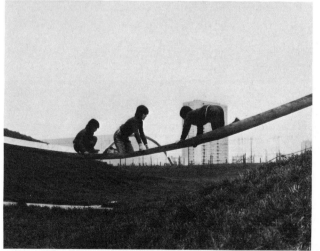
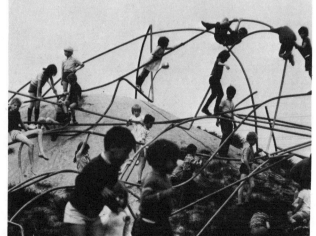
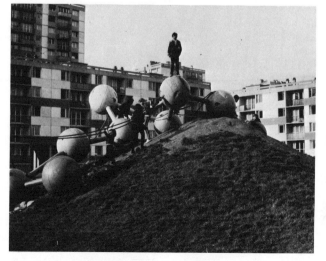

Playground in the Cité des Chatillons, Reims, France

Design: Jacques Simon
Objects: Ludovic Bednar
Completed: 1969

This playground enclosed by building projects features slides, mounds of earth, fields accessible to everyone, areas densely planted with bushes and trees, and many other attractions. For example:

a group of four plastic tubes mounted in flat rings on welded racks, cemented and anchored in the ground (1)

a stylized dinosaur of galvanized steel supported in the center by four pipes (2)

a spray fountain of steel pipes directed towards the center on a graded concrete platform (3)

a maze formed by upright flagstones (4)

a group of giant mushrooms made of old airplane tires, mounted on steel pipes (5)

a rubber sausage made from army surplus stocks (6)

a steel structure laced with nets and ropes (7).

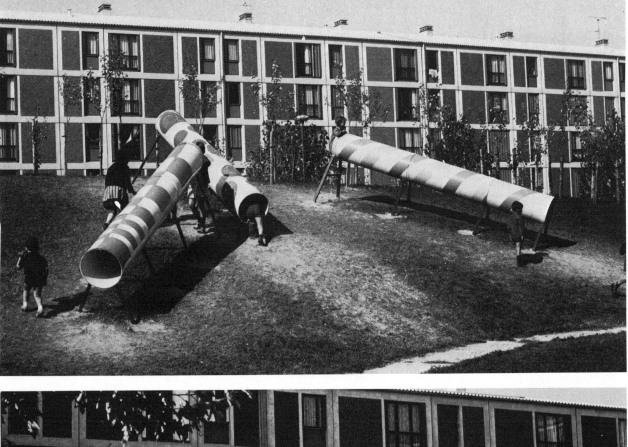

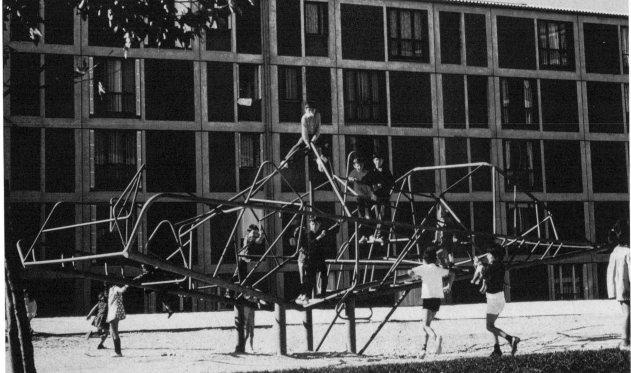

1		
2	3	

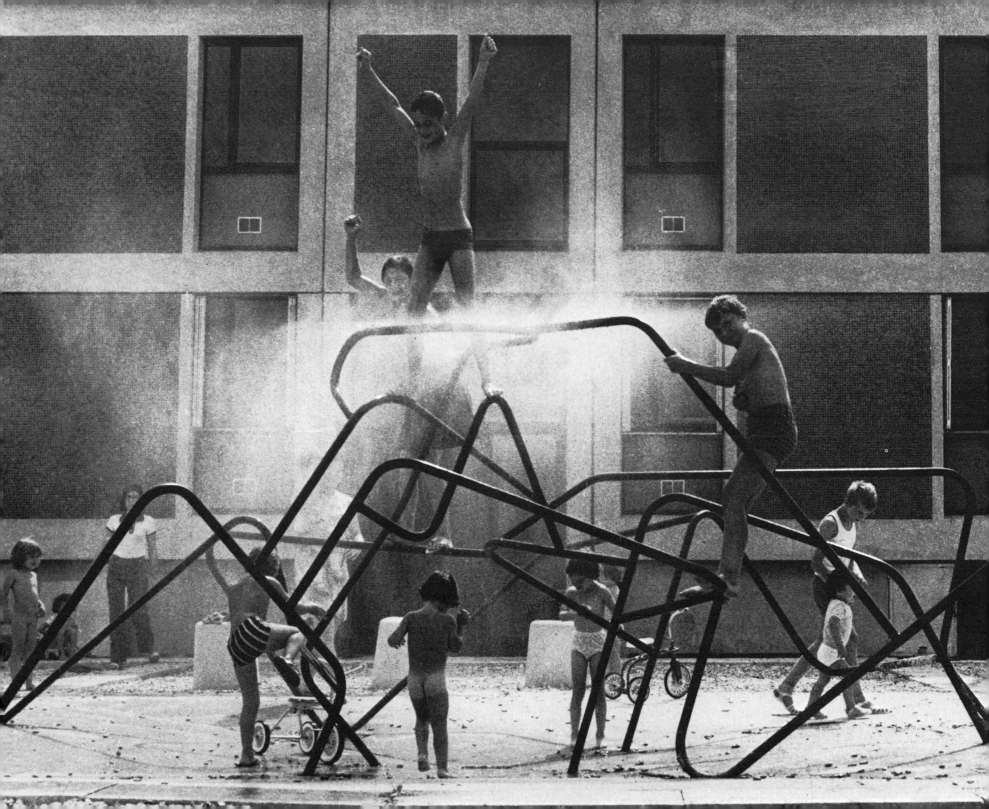

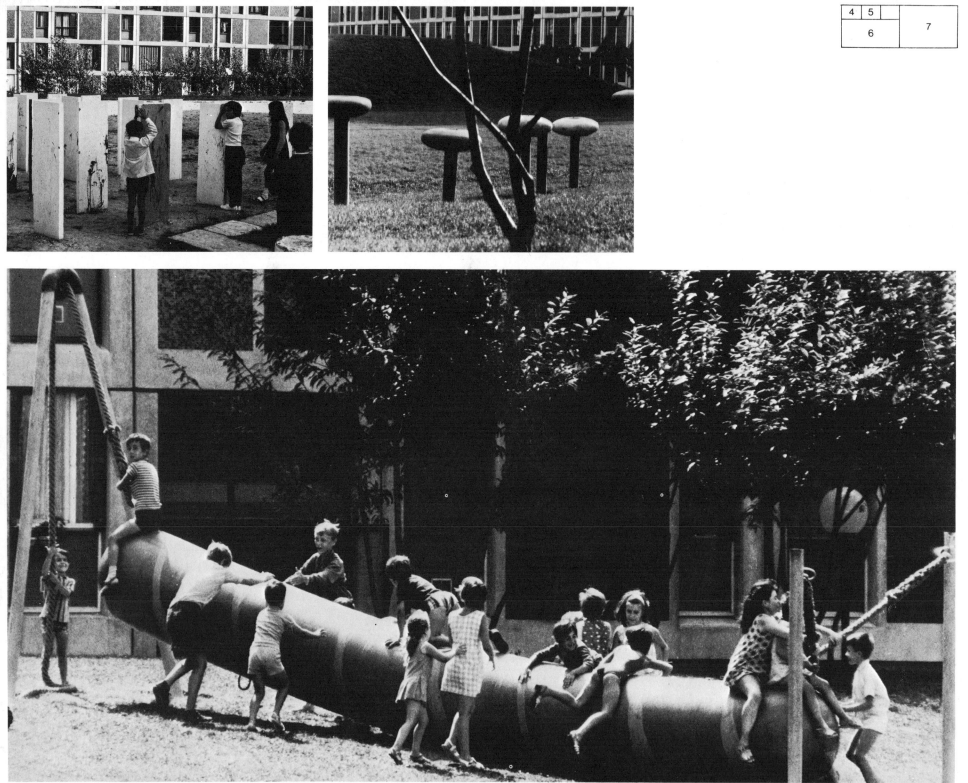

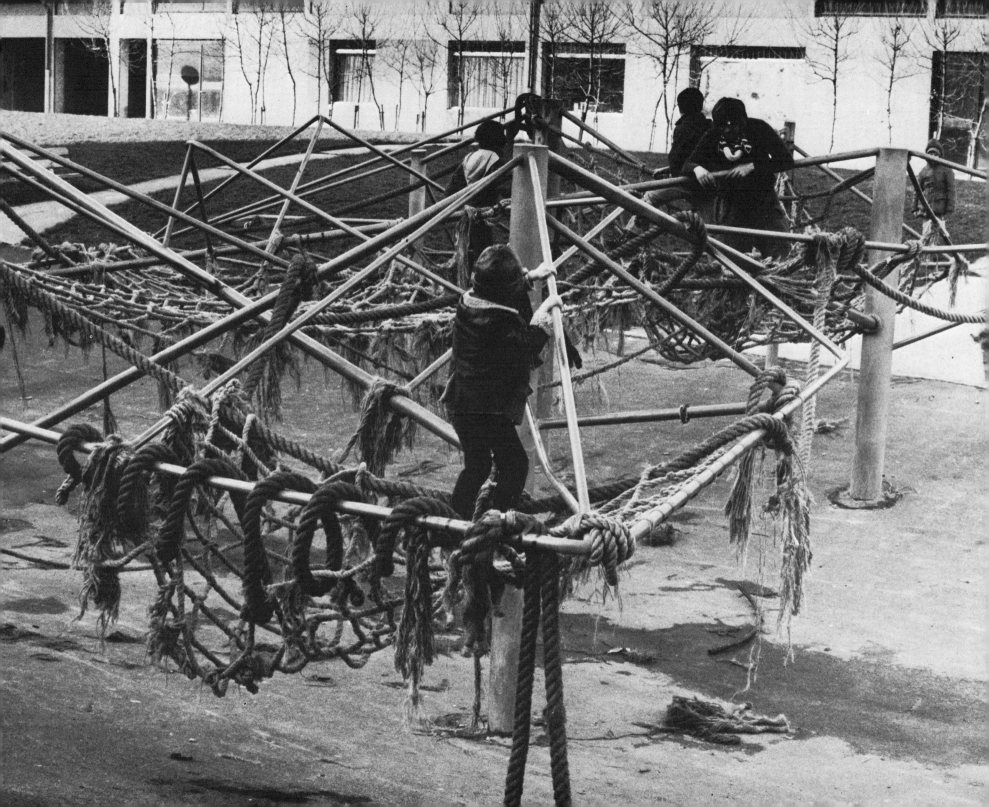

Recreation Center in Buchegg, Zurich, Switzerland

Concept: Alfred Trachsel
Design: Hans Litz and Fritz Schwarz
Completed: 1958

Buchegg is a municipal area, a compound of recreation spaces, assembly halls, and workshops, an open air theater as well as a "traffic-model" connected by a tunnel with the main area (6).

The playground for the toddlers (1) is a circular paved space with three shallow depressions, two of which are filled with sand. The third contains water, only 20cm deep for safety. A fountain surrounded by rocks feeds it.

The asphalt-paved court of the recreation area is enclosed on three sides, forming an arena (4, 5, 7) where children can climb, make noise, and romp.

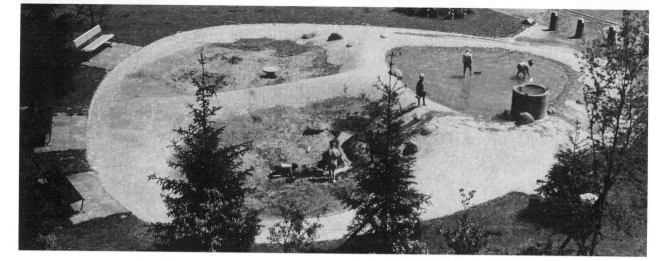

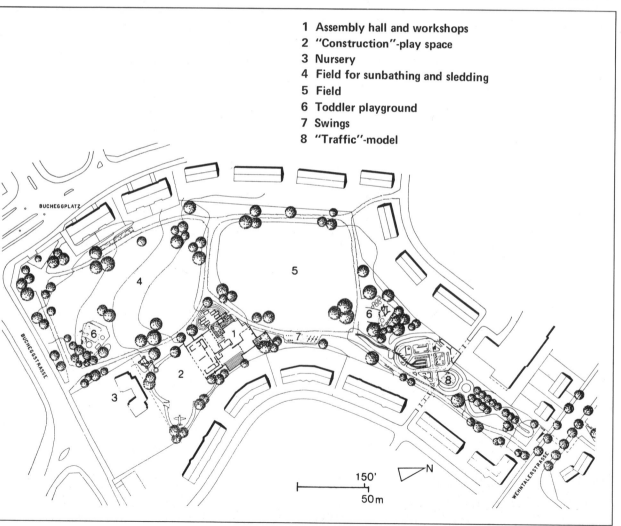

1 Assembly hall and workshops
2 "Construction"-play space
3 Nursery
4 Field for sunbathing and sledding
5 Field
6 Toddler playground
7 Swings
8 "Traffic"-model

150'
50m

1	3	6
2	4	7
	5	

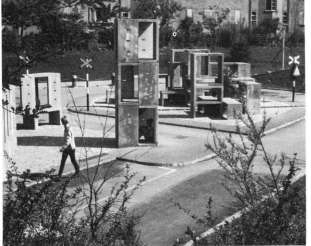
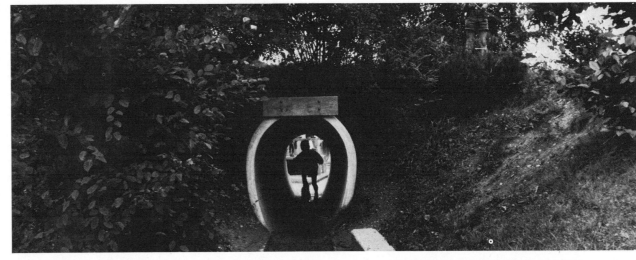

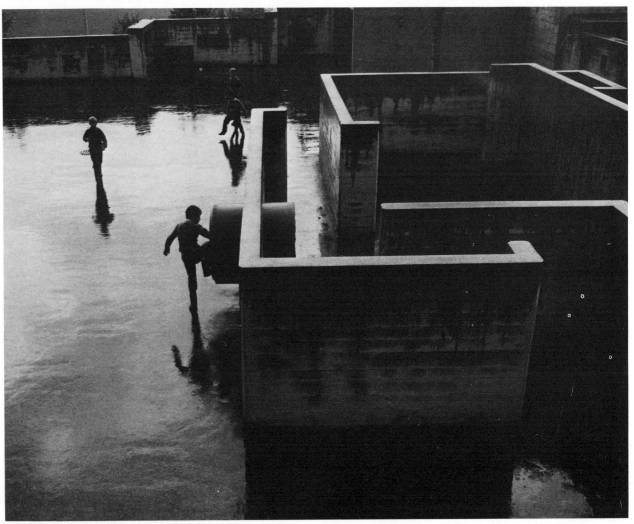
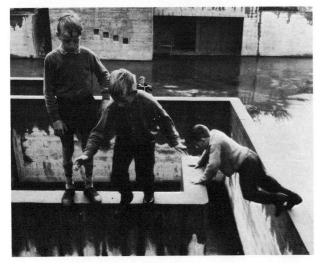

Central Playground Freiberg, Monchfeld, Stuttgart, Germany

Design: Department of Parks, Stuttgart
Completed: 1970

The playground is located on a heavily sloped area (1). It consists for the most part of a series of different-shaped terraces. The game tables (ping-pong) and the boccia alley are found on the smallest terraces; on the largest, the courts for basketball and tennis. In a lower area protected against the wind by thick bushes, the children have access to water in all forms: brook, waterfall, canal lock, spray, mist, and pond. The course and amount of flow can be regulated by the children themselves.

The different elevations are bridged by boulders, planted slopes, and climbing towers made of round logs.

The playground, which is deliberately open to the outside, was laid out in such a way that the children cannot go beyond a certain point. Here mothers can let their children play out-of-doors without worry.

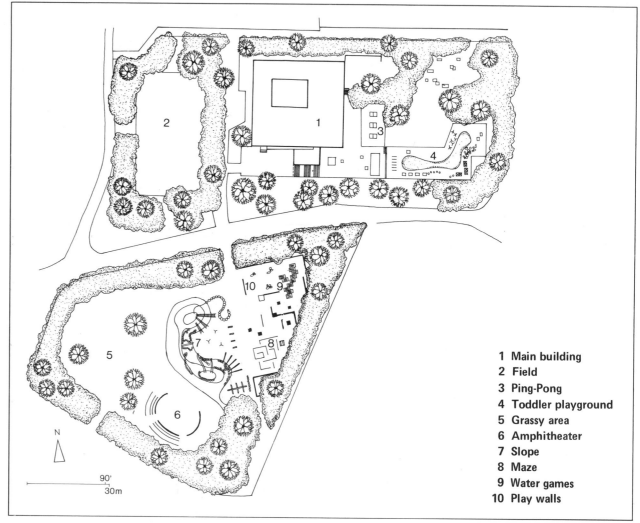

N

90'
30m

1 Main building
2 Field
3 Ping-Pong
4 Toddler playground
5 Grassy area
6 Amphitheater
7 Slope
8 Maze
9 Water games
10 Play walls

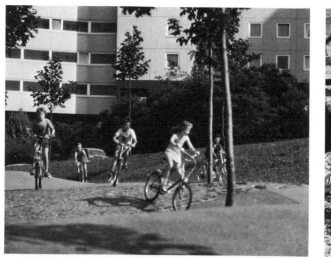

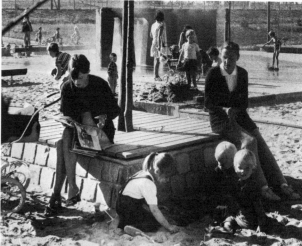

1		4	5		
2	3	6	7	8	

84

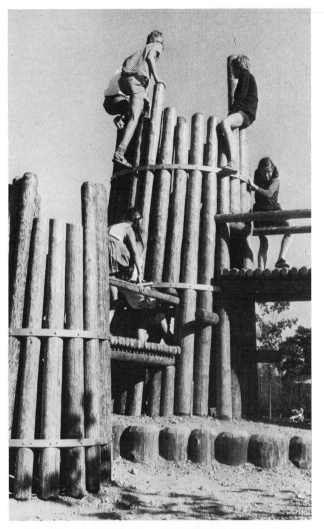

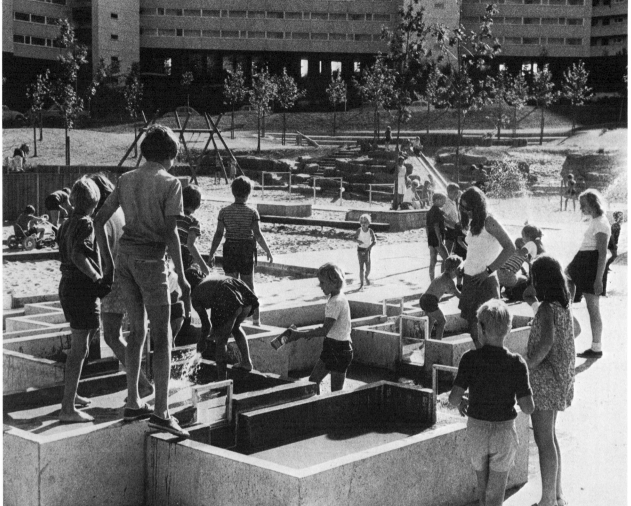

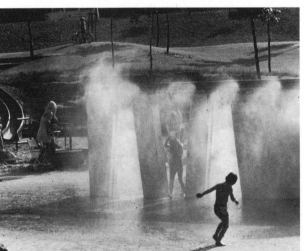

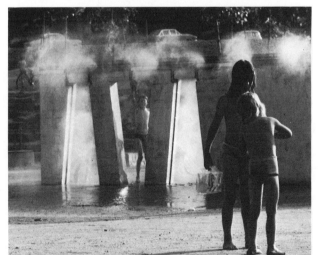

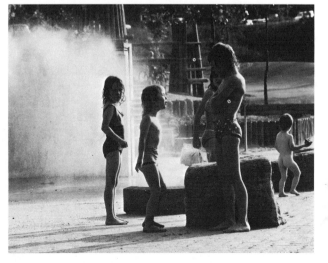

Rochdale Park and Playground, Queens, New York City, USA

Design: Richard G. Stein and Associates
Completed: 1970

Using methods of highway construction, the architect reshaped this flat area into geometric slopes and platforms. In the center is a vast field which is also used by the students of a nearby school. Toward the field and the tennis courts, the main hill has built-in grandstands. They are also used for festive events, concerts, and open-air theater productions. The central tennis court can be flooded in winter to create an ice skating rink.

The originality of this park lies in its versatility and its integration with the housing project.

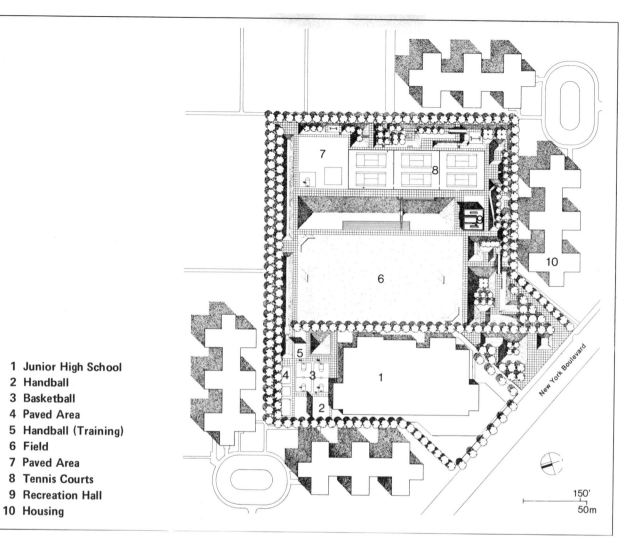

1 Junior High School
2 Handball
3 Basketball
4 Paved Area
5 Handball (Training)
6 Field
7 Paved Area
8 Tennis Courts
9 Recreation Hall
10 Housing

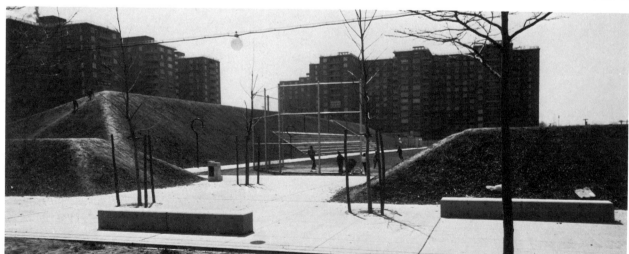

8

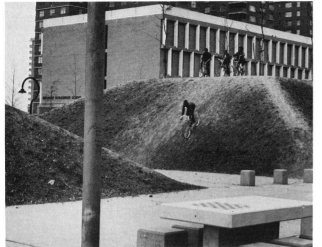
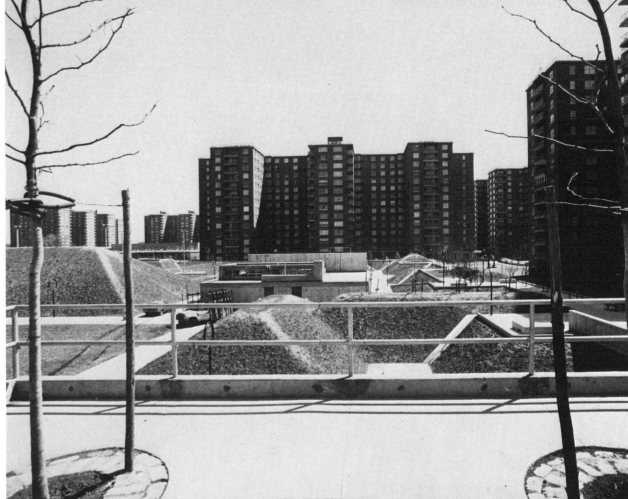
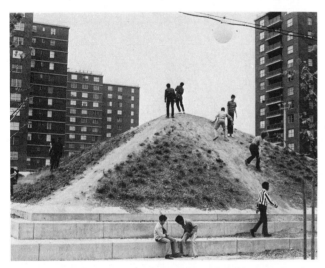
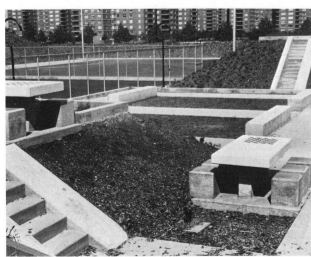
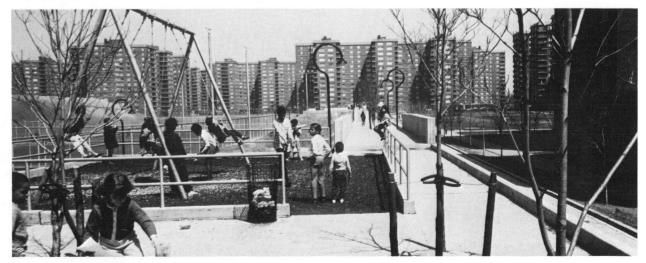

Playground in the Cité de la Grande Borne, Grigny, France

Design: Emile Aillaud
Colors: Fabio Rieti
Completed: 1971

The housing complex of Grande Borne had all the prerequisites necessary to become a livable city in the best sense of the word. Architecture, landscape, and playground arrangement were regarded as a unity. The problem of organizing different areas was solved perfectly: each area offers its own series of events. The arrangement of the walkways varies greatly and blends in smoothly with the terrain; surprises are everywhere; places to rest, promenades, and "solitary" corners alternate with large fields for community games. The design refers largely to symbols which are easily understood, or to forms which signify the relationship between man and the universe (The Hills, The Lake, The Egg, The Checkerboard, The Half-Moon, The Ellipse, The Bridge, The Meridian, The Scales.) The success of this design had a great deal to do with the decision of the municipal authorities to move all auto traffic to the park's periphery so that pedestrians could enjoy the scene undisturbed.

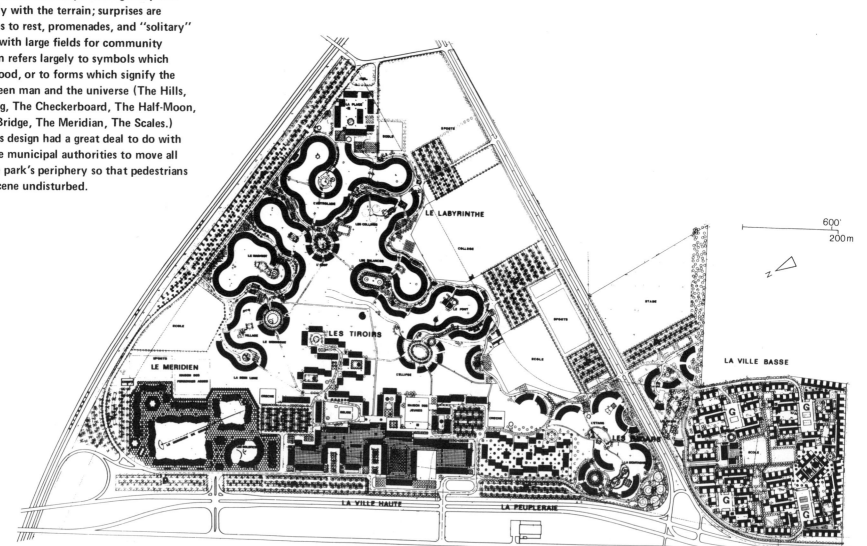

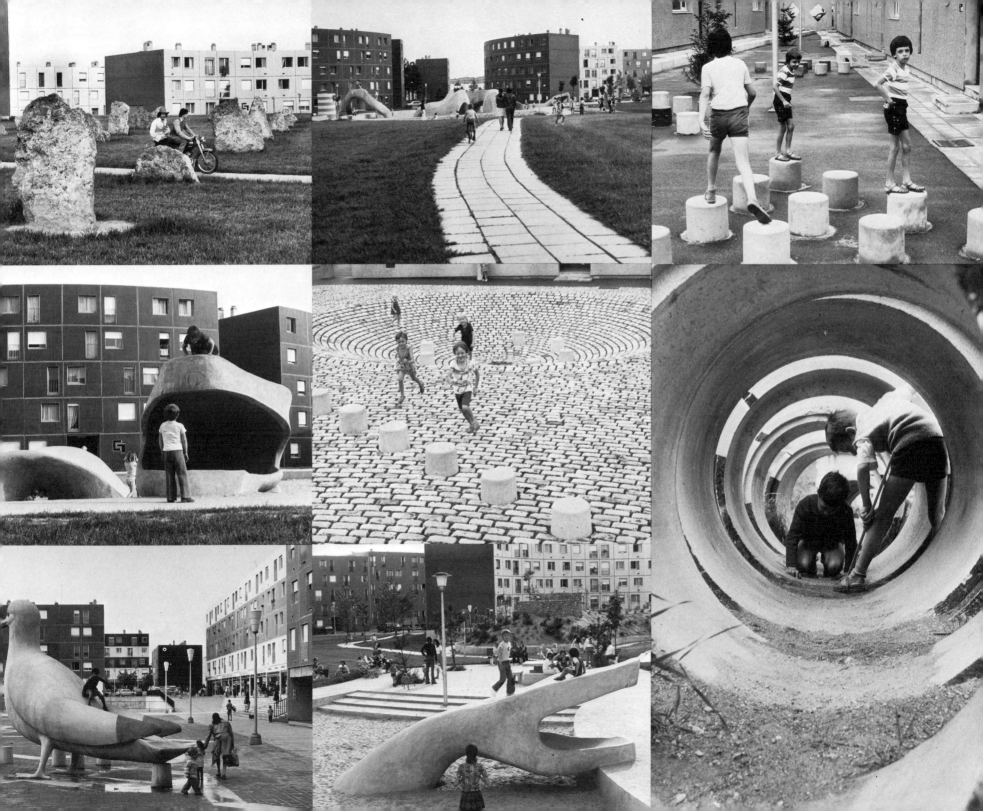

Play areas in Milton Keynes, England

Children's Play Officer: Margaret Groom
Designer: Brian Milne

Statistics indicated that within a number of years approximately one third of the population of the still-developing city of Milton Keynes would be under fifteen. It was therefore necessary to pay special attention to the planning of the playground. Since 1971, Margaret Groom and Brian Milne have been working out a basic systematic plan which will be satisfactory to everybody involved. To begin with, they follow exact calculations as to the amount of space to be allotted for each playground. Every 20 families will share a local playground of 100sq. m for children up to 5 years of age, and every group of 250 families a space of 0.2 hectares for children 5 to 12 years old, as well as an adventure center with a radius of about 1.2km; for smaller housing communities with less than 50 apartments, additional "junior playgrounds" will be built. Further calculations reassess the proper placement of the playgrounds. Finally, all kinds of playground constructions have been developed. A few samples are introduced here (1 - 8).

By the end of 1975, 23 playgrounds for preschool children were completed, among them Galley Hill (9, 10) and Windmill Hill (11, 12).

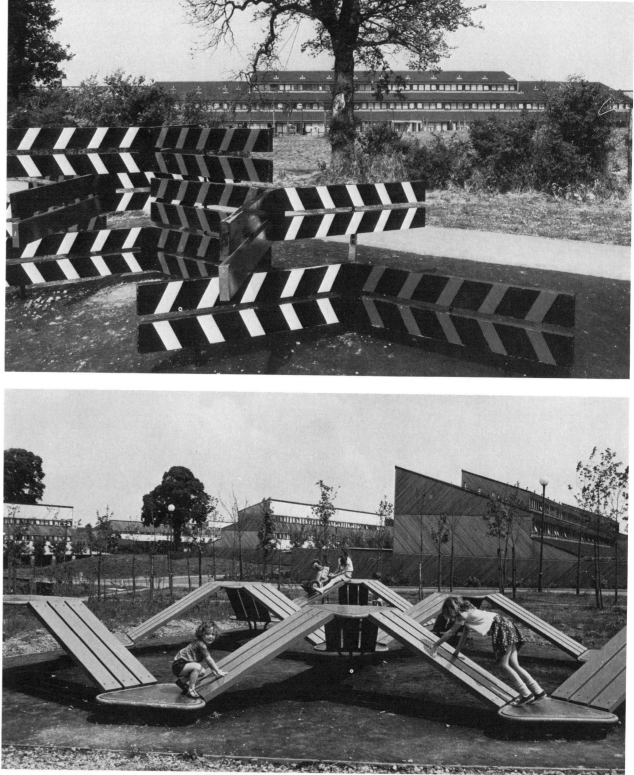

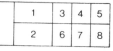

1		3	4	5
2		6	7	8

Tri-Stack

Age Range
Toddlers/Juniors
suitable for children 4 to 8 years

Construction
mild steel tube (legs)
brackets and bolts
ex works galvanized finish to BS 729
to be painted on site
timber vacuum pressure impregnated
with preservative to BS 4072
colour stained/painted

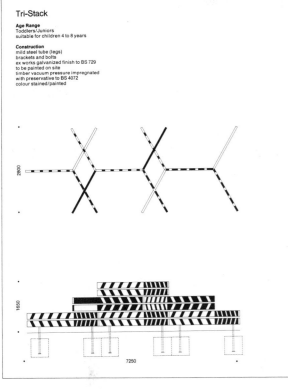

2800

1650

7250

Small Walkway

Age Range
Toddlers
suitable for children up to 5 years

Construction
mild steel tube
ex works galvanized finish to BS 729
to be painted on site
timber vacuum pressure impregnated
with preservative to BS 4072
colour stained

700

1000 • 1000 • 1000

Tent Frame

Age Range
Toddlers/Juniors
suitable for children 4 years

Construction
mild steel tube ex works
galvanized finish to BS 729
to be painted on site

1540

5040 1200

Tri-Mound

Age Range
Toddlers/Juniors
suitable for all ages

Construction
mild steel tube ex works
galvanized finish to BS 729
to be painted on site
plywood WBP colour stained
timber vacuum pressure impregnated
with preservative to BS 4072
colour stained

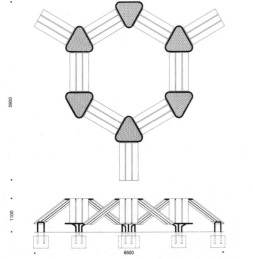

5900

1100

6500

Small Pyramid

Age Range
Toddlers
suitable for up to 5 years of age

Construction
mild steel tube ex works
galvanized finish to BS 729
to be painted on site

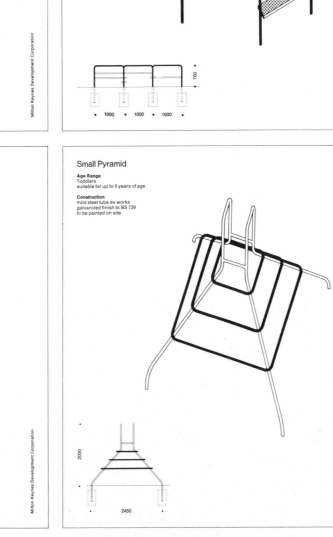

2000

2450

Squiggle Frame

Age Range
Toddlers/Juniors
suitable for children 4 years and over

Construction
mild steel tube
ex works galvanized finish to BS 729
to be painted on site

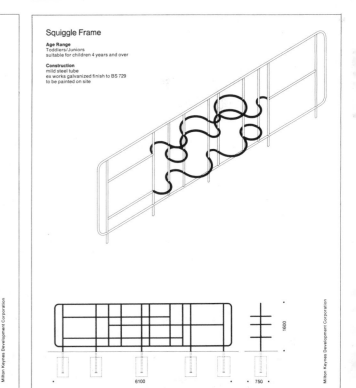

1600

6100 750

1

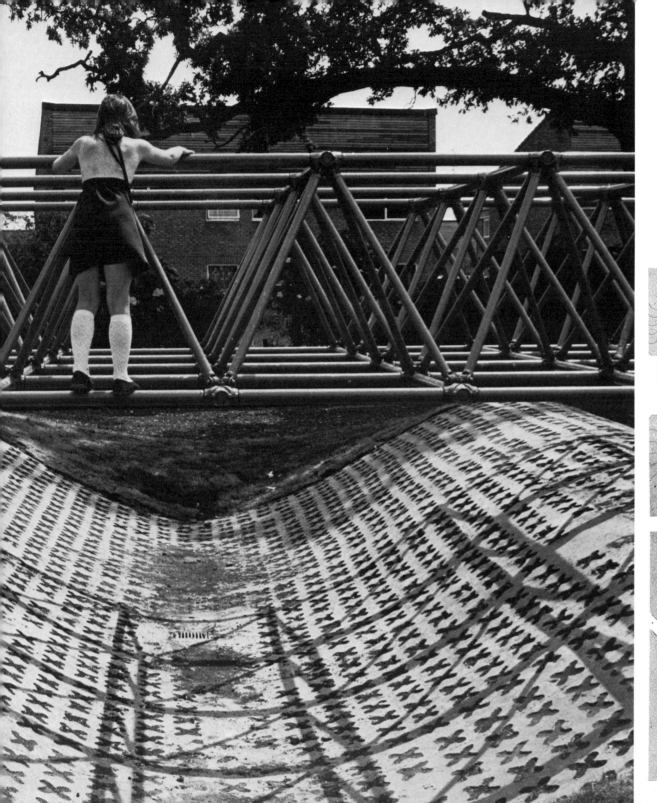

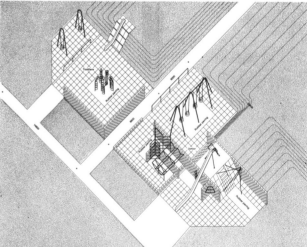

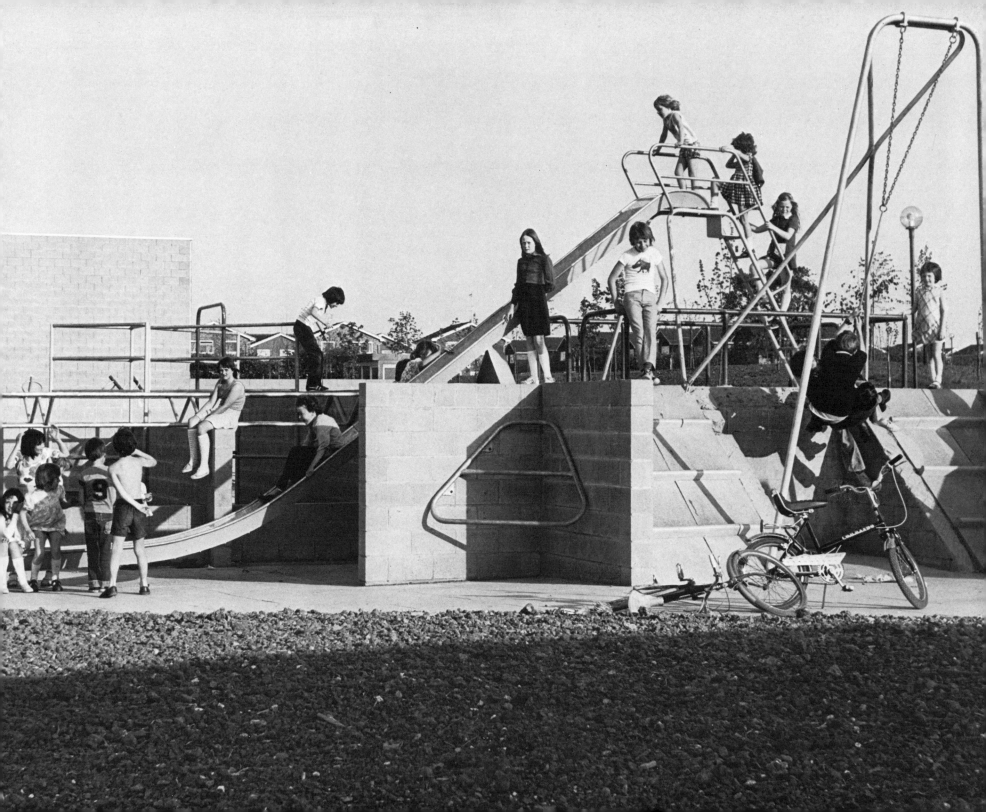

Water is a plaything in itself. Often a "no-no" in cities, it reminds children of the freedom of vacation time. Some parents cannot overcome the idea that water can be dangerous (drowning, illness, etc.). In areas with supervisory personnel and where the water is safe and shallow more are giving in to their children's preferences for a wet environment.

The possibilities for water as a plaything are endless—from ponds for model ships and wading, to mists and sprays, and from rivulets to canals, fountains, and cascades.

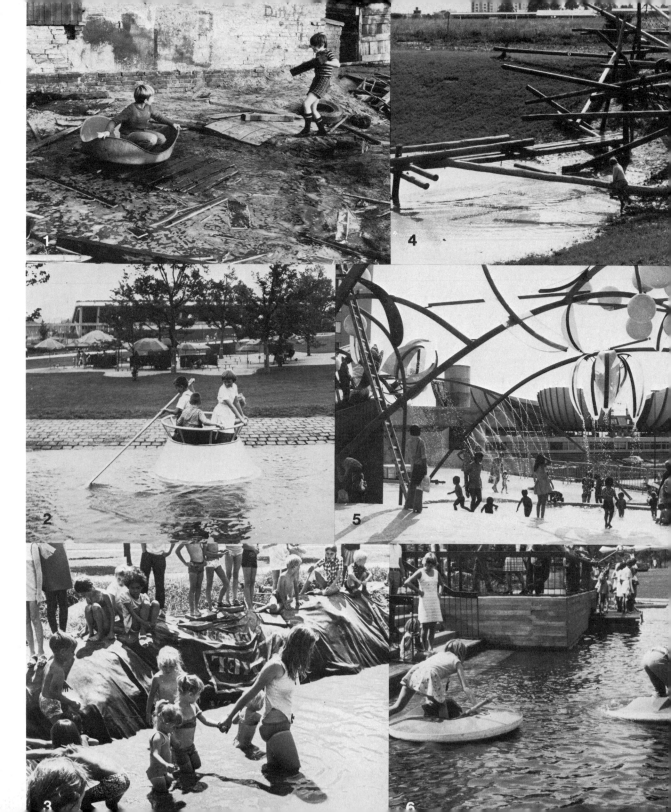

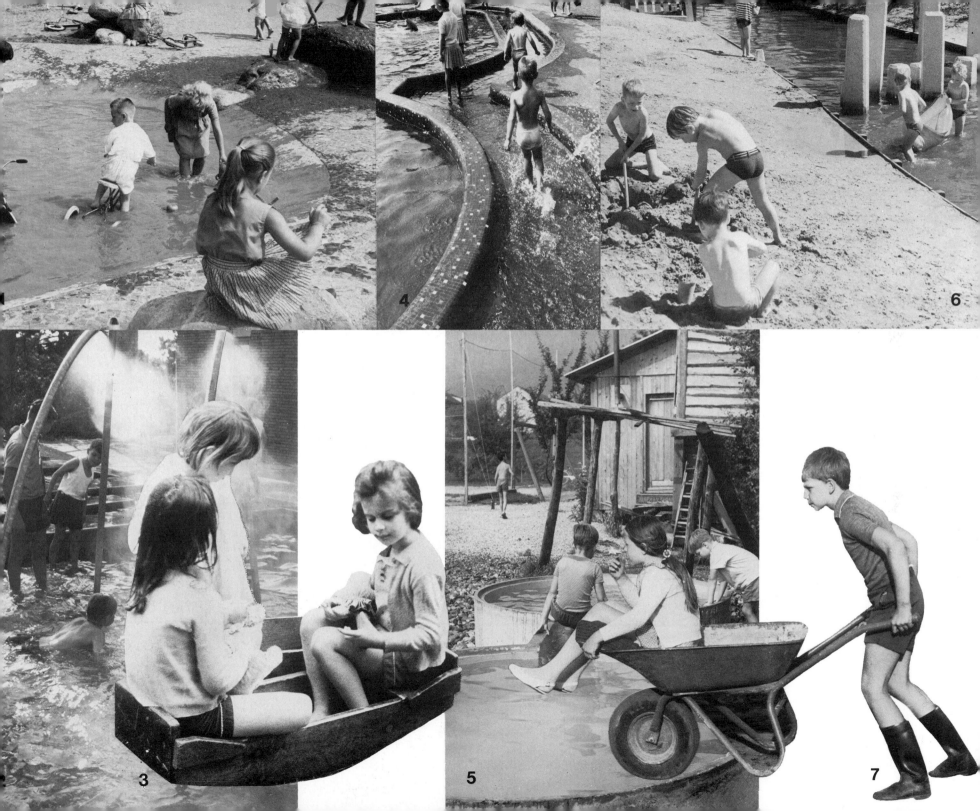

Rochdale Canal, Manchester, England

Design: Derek Lovejoy & Partners and Manchester
City Planning Committee
Completed: 1972

The Rochdale Canal is a typical product of the in-
dustrial revolution. It belongs to the history of the
city of Manchester and has contributed a great deal
to the development of Lancashire. However, it was
precisely growing industry that forced the canal to
be shut down in 1952. The city debated whether to
leave or reactivate it for industrial purposes. Then
came the decision to make the canal into a central
attraction of an urban renewal program; to open it
up as a waterway for the general public. The banks
were restored, the depth limited to 20cm for safety
reasons and the locks converted into waterfalls.

Before this, the inactive canal had been abused as
a garbage dump and then became a danger zone
which had to be fenced in to prevent children from
drowning (1). After reconstruction, the canal be-
came the area's main attraction. The locks (5) and
the different play spaces (2, 3, 4) were designed in
keeping with the character of the site. Through the
use of the same building material prevailing in the
area, the city's historical and aesthetic traditions
were preserved.

1	2	
3	4	5

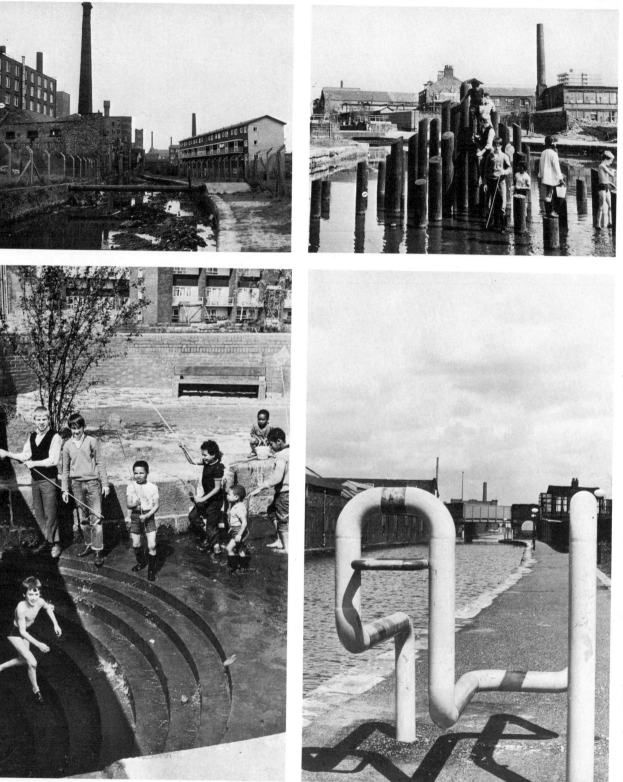

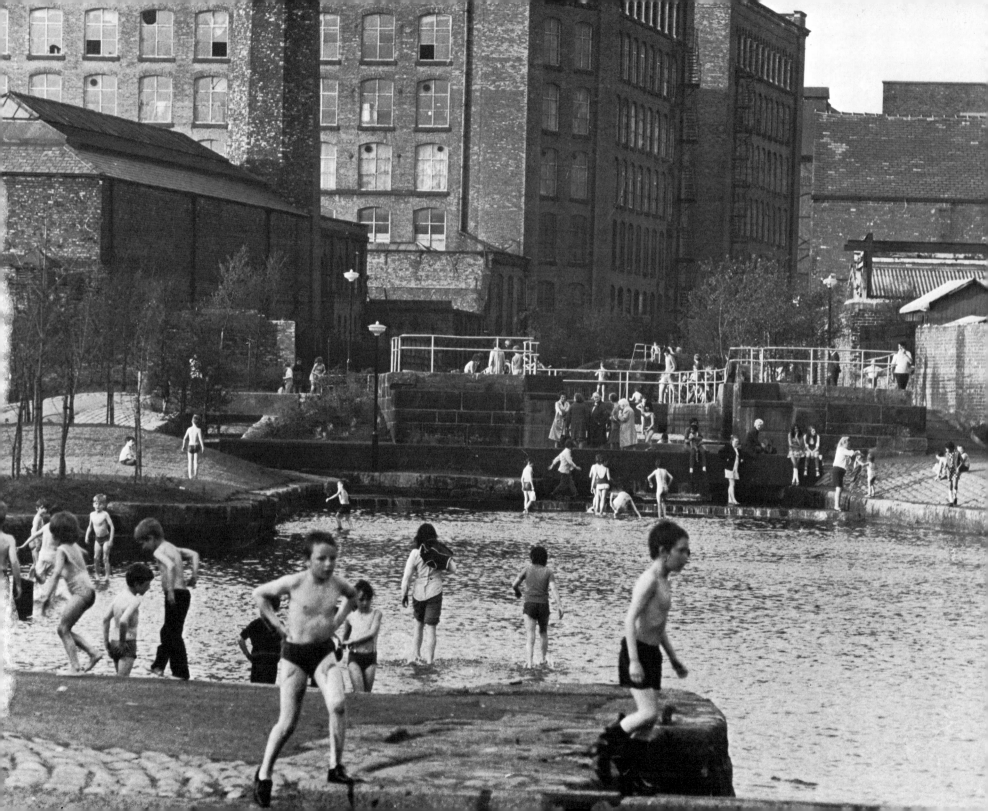

Water playground in Central Park, New York City, USA

Design: Richard Dattner & Associates
Completed: 1973

Of all the play areas in Central Park, this water playground is the children's favorite during the summer months. This space 150m long represents a variety of forms: a well, a waterfall, cascades, and a fountain. The concrete and wood structures combined with large boulders are reminiscent of man's efforts to overcome nature: bridges, canals, platforms, tunnels. This inorganic arrangement would be difficult to bear in a different surrounding, but here it is counterbalanced by water, rocks (representing nature) and large trees which frame the clearing where this complex is installed.

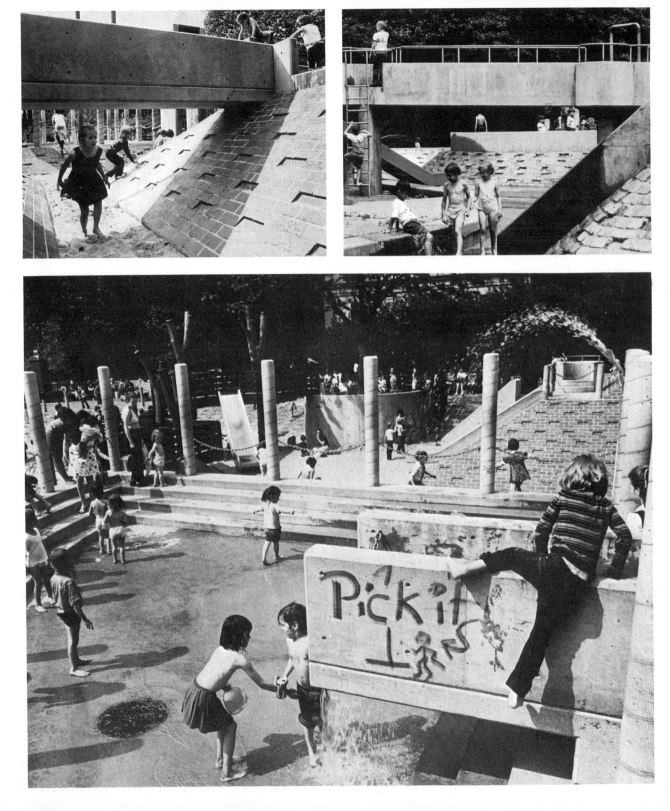

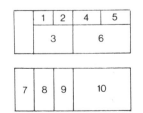

1	2	4	5
3		6	

7	8	9	10

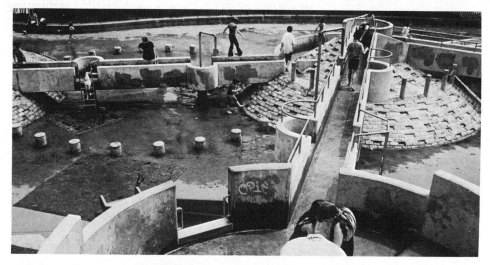
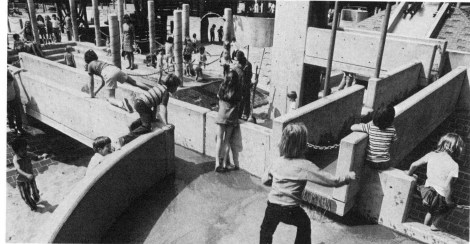
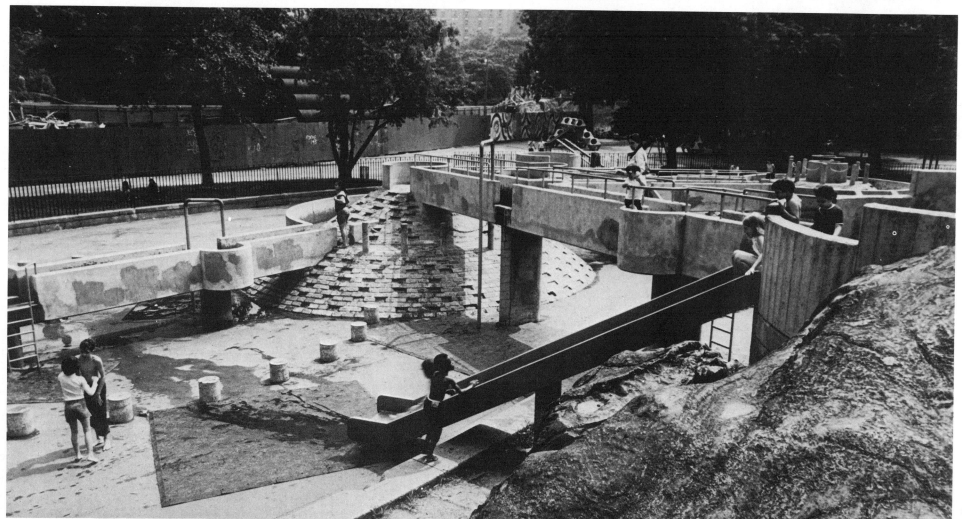

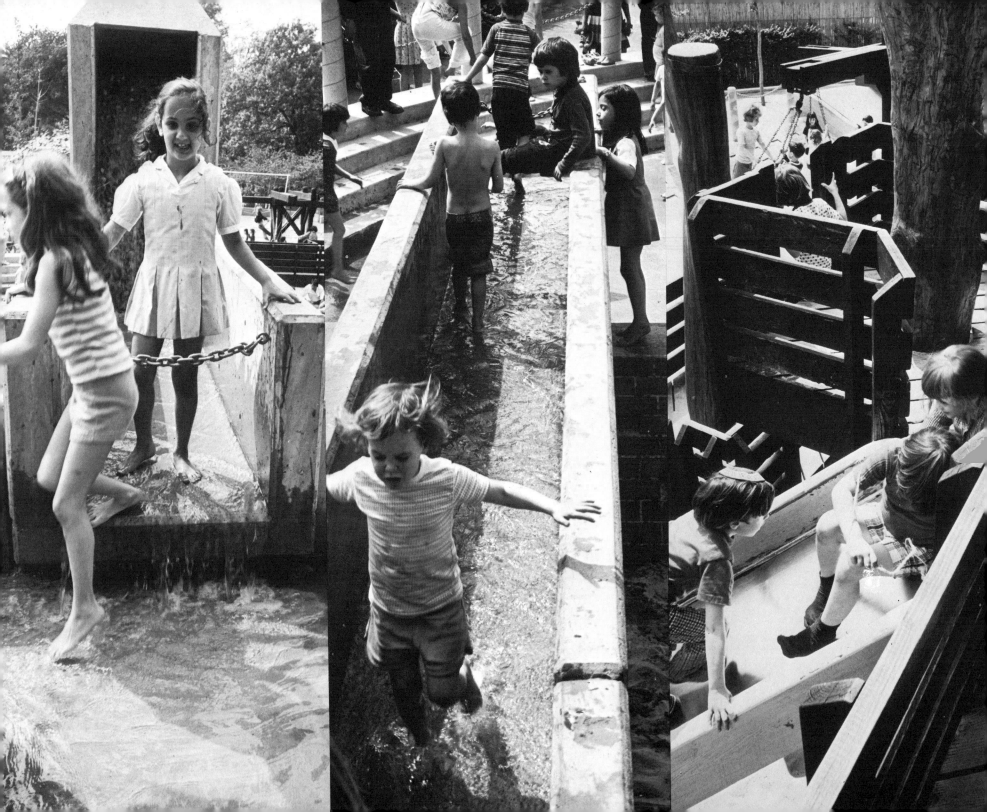

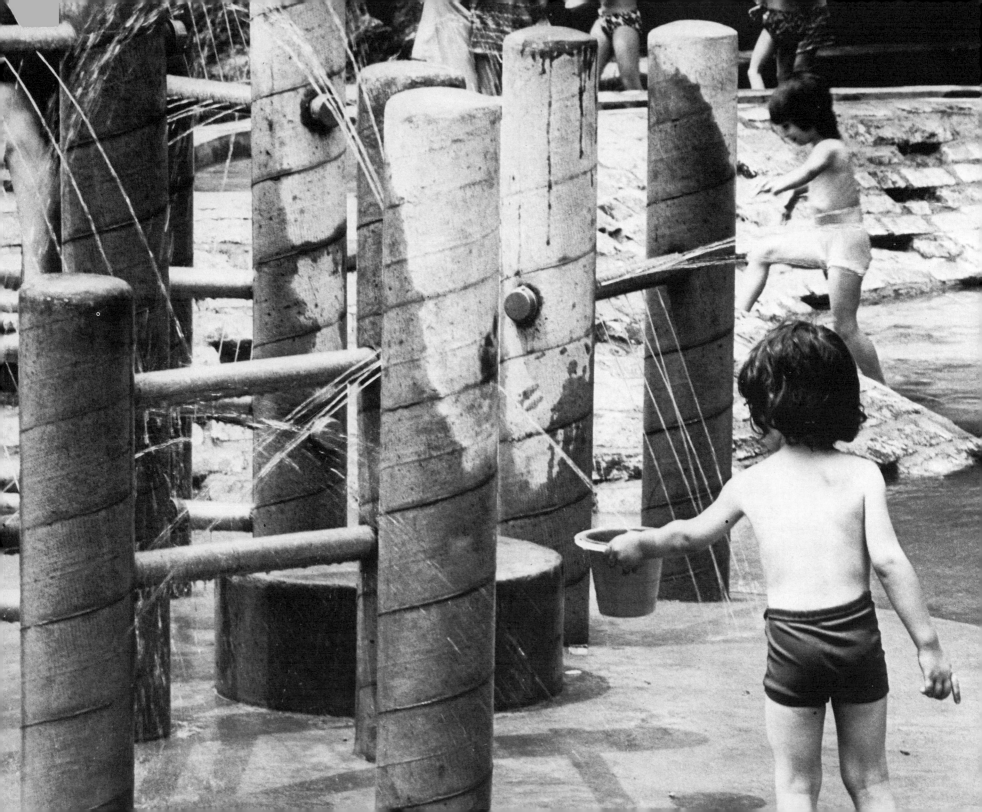

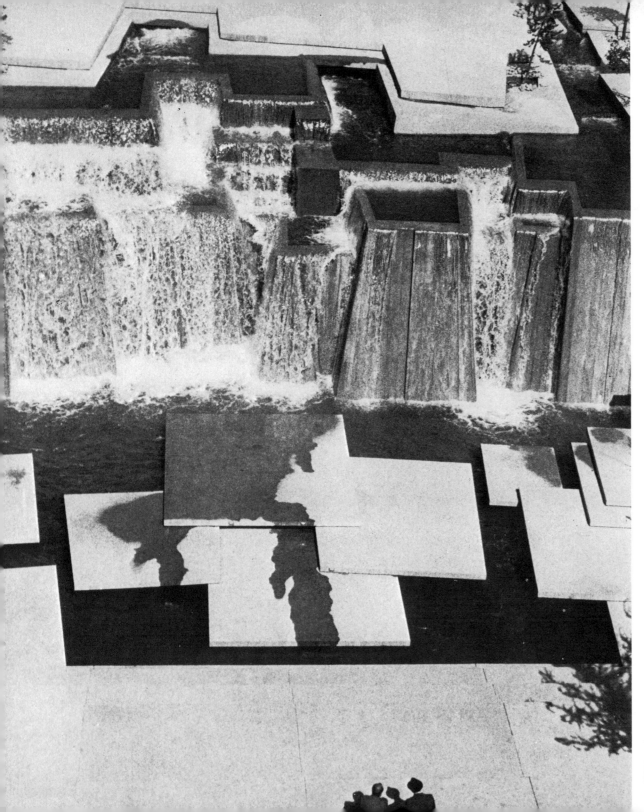

Portland Civic Auditorium Forecourt, Portland, Oregon, USA

Design: Lawrence Halprin & Associates
Completed: 1970

Only a few blocks away from the center of Portland, surrounded by busy streets, this area offers refuge from the noise of the city. Like the nearby Lovejoy Plaza, also designed by Halprin, it not only is visually appealing but invites participation.

Artificial fountains rise on the upper level and fall over a maze of concrete cascades after joining additional water sources gushing strongly over steep waterfalls 3 to 5m high. These waterfalls form the background of the lower level, an amphitheater which supplements the nearby auditorium and offers visitors to the auditorium the opportunity to take a walk in the open air during intermission. It is a good, serviceable space for happenings, fashion shows, art exhibitions, etc. If necessary, the water flow can be reduced to keep the noise level down. At night, the waterfalls are illuminated from below.

1	2

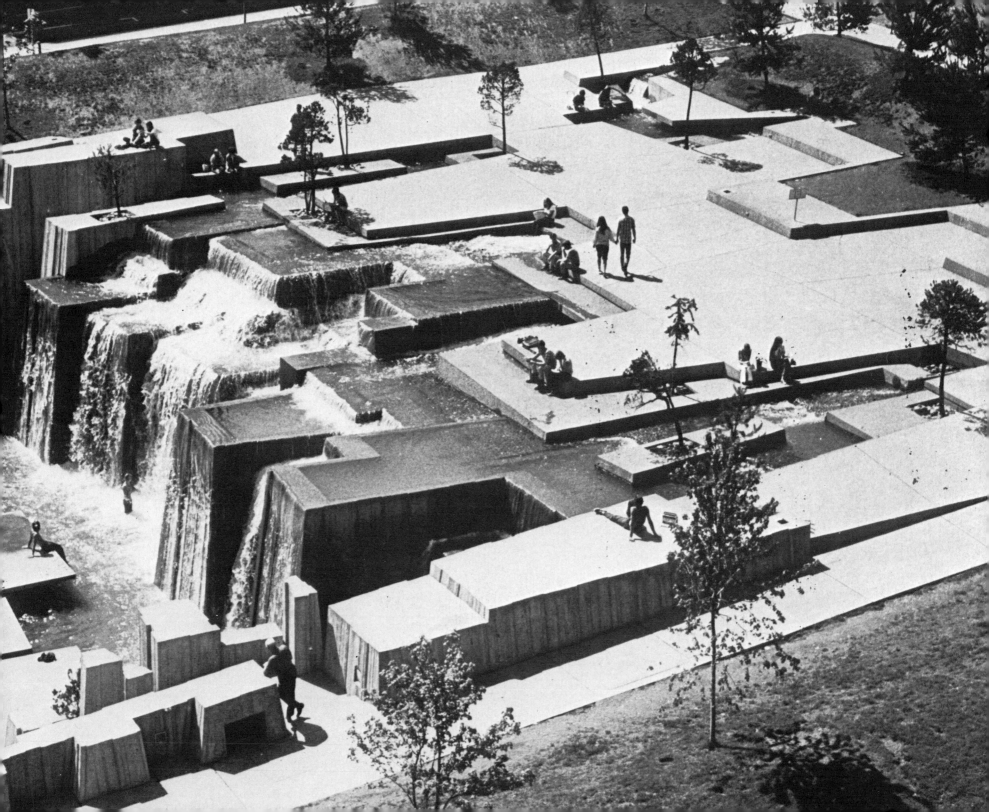

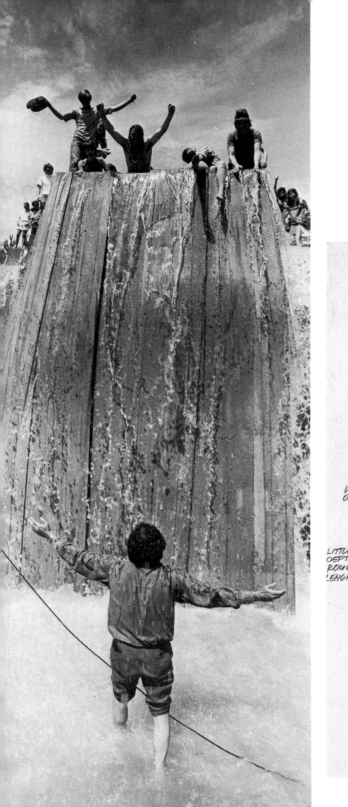

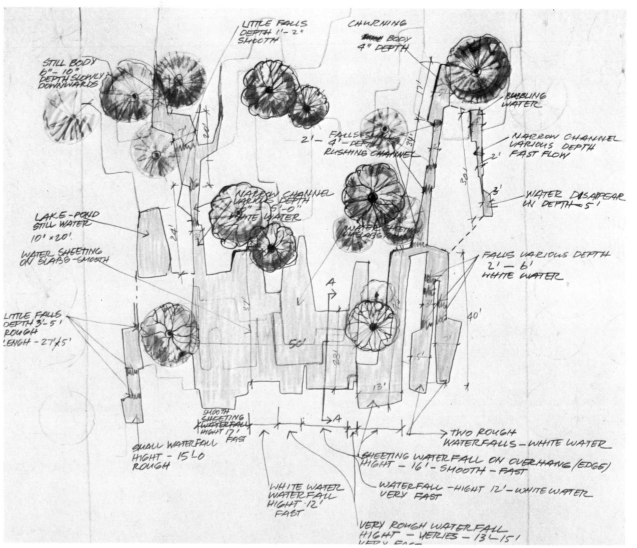

STILL BODY
6"–10'
DEPTH SLOWLY
DOWNWARDS

LITTLE FALLS
DEPTH 1'–2'
SMOOTH

CHURNING

BODY
4" DEPTH

BUBBLING
WATER

FALLS
1'–DEPTH
RUSHING CHANNEL

NARROW CHANNEL
VARIOUS DEPTH
FAST FLOW

LAKE–POND
STILL WATER
10' × 20'

NARROW CHANNEL
VARIOUS DEPTH
6"–5'–0'
WHITE WATER

WATER DISAPPEAR
IN DEPTH–5'

WATER SHEETING
ON SLABS–SMOOTH

FALLS VARIOUS DEPTH
2'–6'
WHITE WATER

LITTLE FALLS
DEPTH 3'–5'
ROUGH
LENGH–27'×5'

SMOOTH
SHEETING
WATERFALL
HIGHT 17'
FAST

TWO ROUGH
WATERFALLS–WHITE WATER

SMALL WATERFALL
HIGHT–15'0
ROUGH

SHEETING WATERFALL ON OVERHANG (EDGE)
HIGHT–16'–SMOOTH–FAST

WHITE WATER
WATERFALL
HIGHT 12'
FAST

WATERFALL–HIGHT 12'–WHITE WATER
VERY FAST

VERY ROUGH WATERFALL
HIGHT–VERIES–13'–15'
VERY FAS

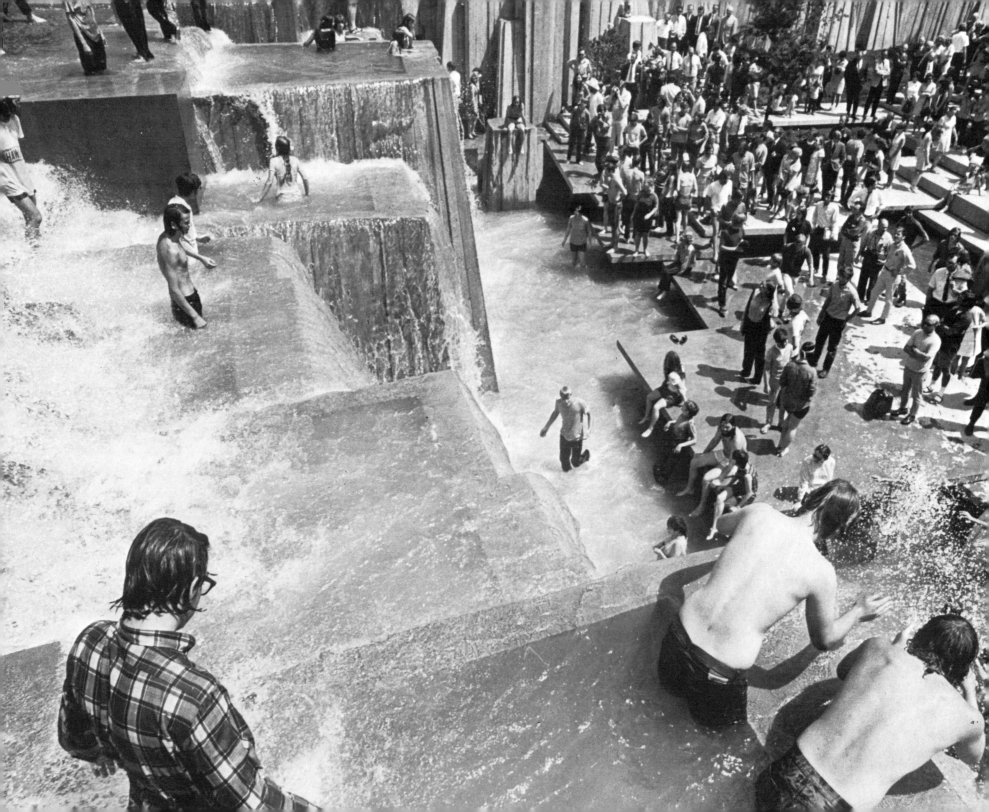

Ontario Place Children's Village, Toronto, Canada

Design: Craig, Zeidler, Strong
Completed: 1972

This playground offers children ample opportunity for creative activities and physical exercise. Taking into consideration the needs of children, the designers transformed the area into a large sculpture enhanced by acoustical and visual effects.

The playground, where children regard each object as a large toy, is an outstanding example of the designer's ability to make use of different materials (wood, concrete, steel, plastics, textiles) in the construction of playground equipment. It is breathtaking to children and encourages them to dream.

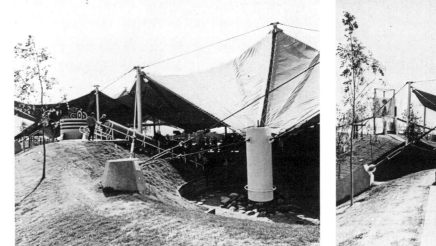
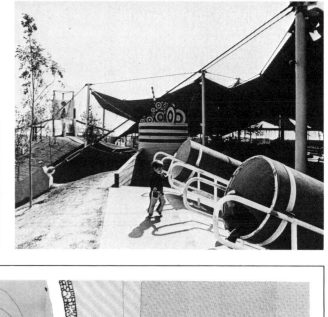

1 Hand pump
2 Sand basin
3 Toys
4 Public washroom
5 Toy shop and snack bar
6 "Butterfly races"
7 Rubber forest
8 Sack races
9 Climbing bridge over water
10 Earth space for crawlers
11 Pipe slide
12 Lion's head tunnel
　　to lemonade mountain
13 Rolling drum
14 Punching ball forest
15 Bird's leap
16 Puppet theater
17 King of my realm
18 Tubular climbing snakes
19 "Foam marsh"
20 Air pillows
21 Climbing nets
22 Suspended bridge
23 Climbing construction
24 Loudspeakers
25 Tire swings and oil drum swings
26 "Roll glider"
27 "Cable glider"

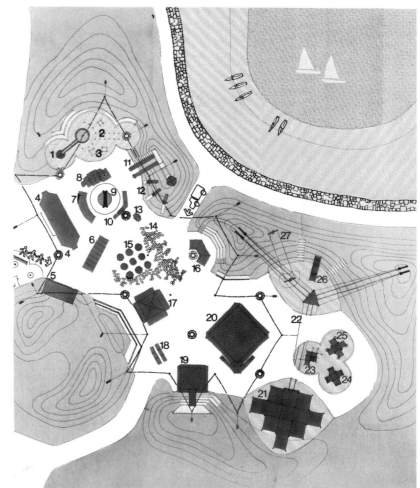

1	2	4	6	7
3		5		8

9	10	11	12

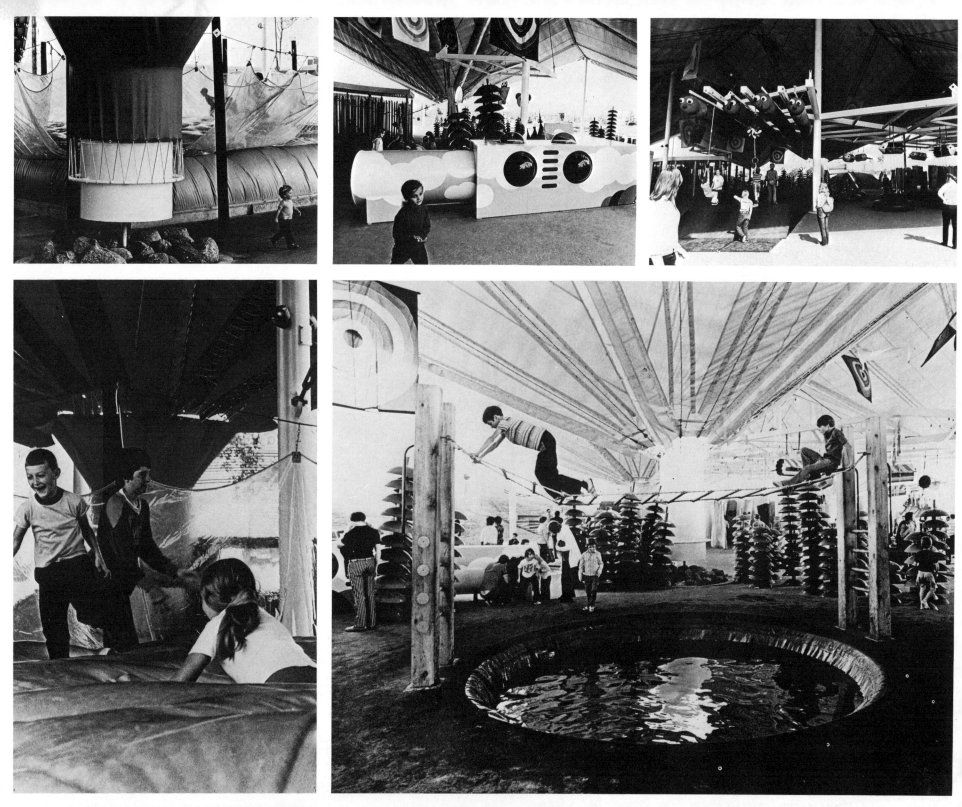

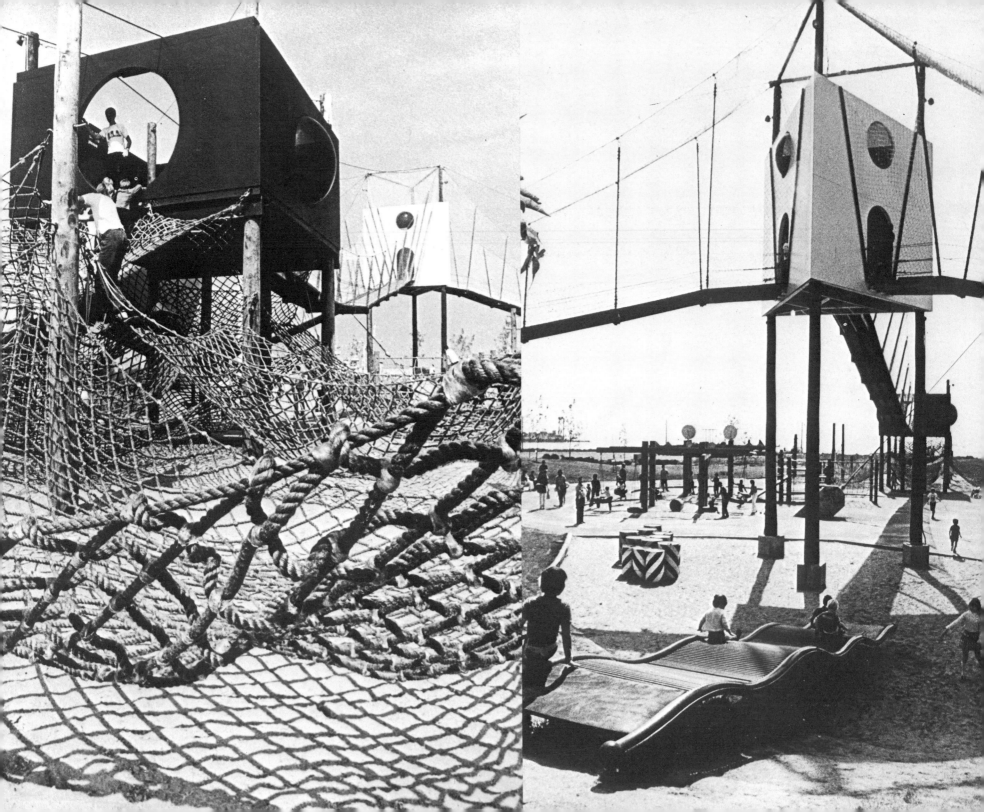

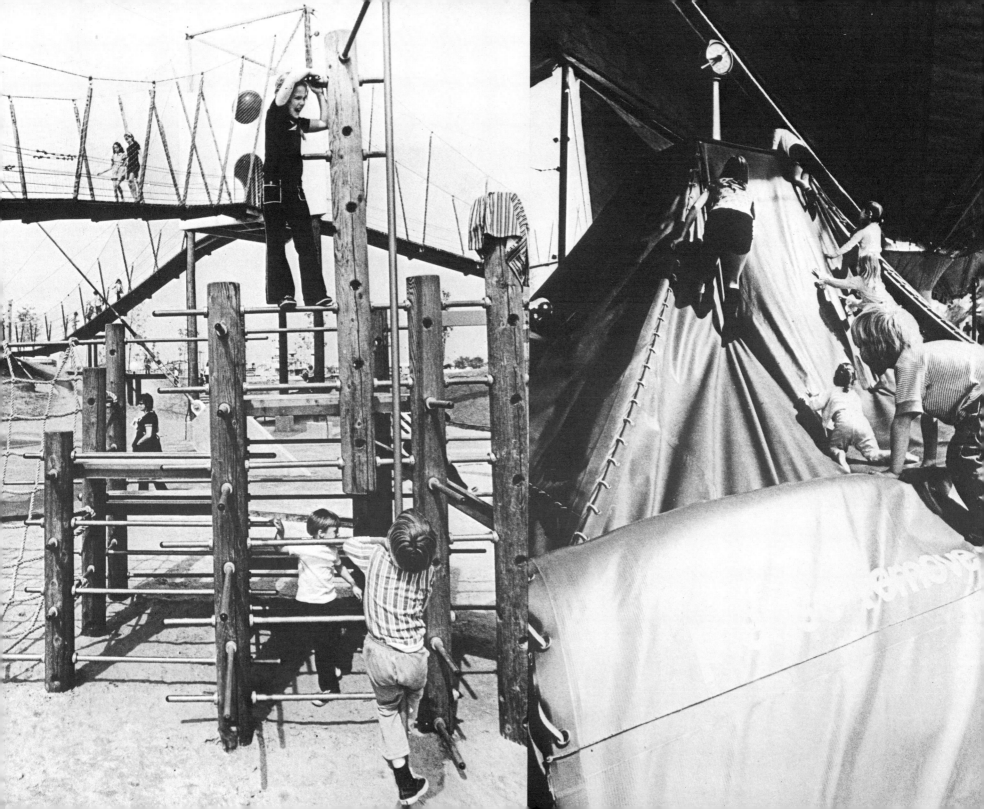

Playground in the woods on "Monte Scherbelino," Frankfurt, Germany

Design: Forest Department, City of Frankfurt
Playground Equipment: Hugo Uhl
Completed: 1971

The "Monte Scherbelino" is an artificial mountain 40m high, composed of rubble and debris. It is surrounded by woods and offers a beautiful view. The wood from this area was ideal as material to build the equipment for this playground.

This is a rare combination of monumentality and spontaneity. All construction was done on the spot using carefully detailed models as guidelines.

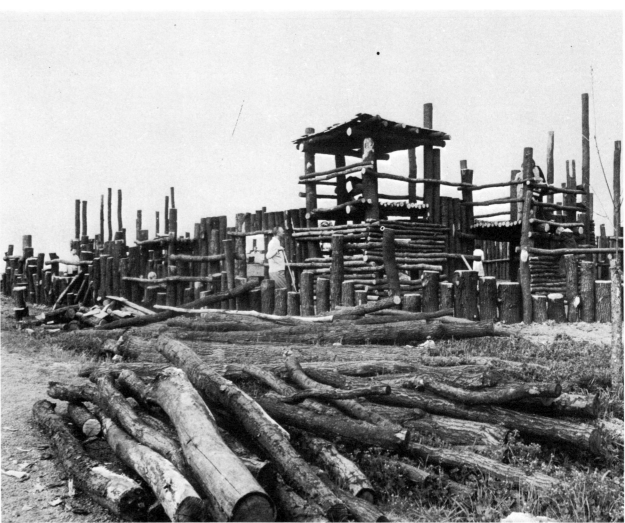

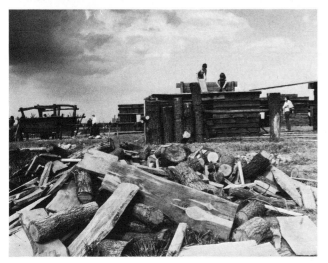
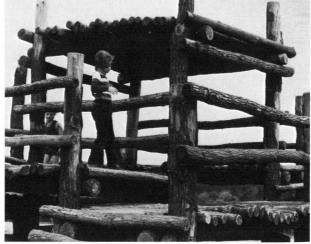
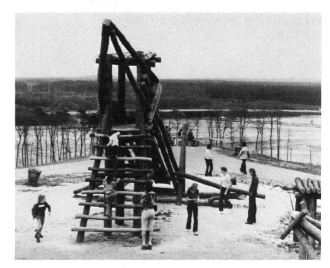
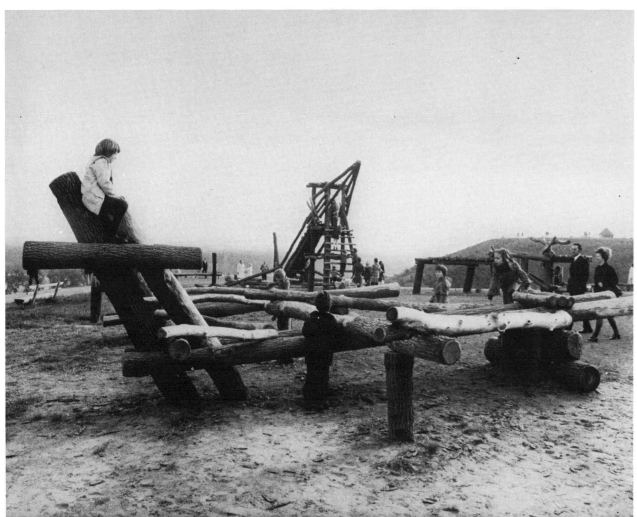
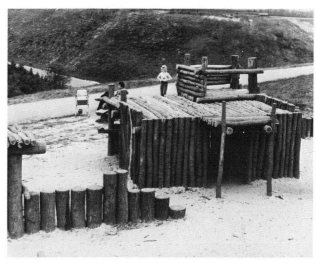
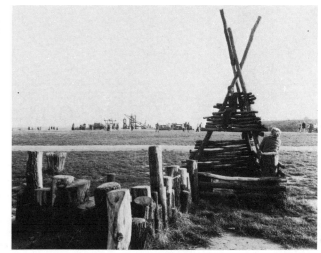

Nursery school in Keisho, Tokyo, Japan

Design: Hiroshi Hara
Objects: Nido Industrial Design Associates
Completed: 1968

The layout and general view is of a large sandy area framed by structures and playground equipment: a playhouse, an adjustable gymnastic apparatus, a mammoth turntable, several climbing poles, and a giant slide. The playhouse is of steel construction with slabs of plastic in relief to make climbing easier (3). The adjustable gymnastic apparatus is a construction of two concrete walls with arbitrarily arranged holes into which steel bars can be inserted in either parallel or zig-zag formations (4). The turntable is a circular steel construction over which a nylon net is stretched, 50cm above the ground; its dimensions are ideal for very young children (5). The tree-like poles are constructed of steel pipes and intended for climbing and balancing acts (6, 7). The giant slide of white concrete is coated with plastic which allows for a smooth and safe ride (8).

Not much initiative is left to the children in this playground, but it offers ample opportunity for physical exercise.

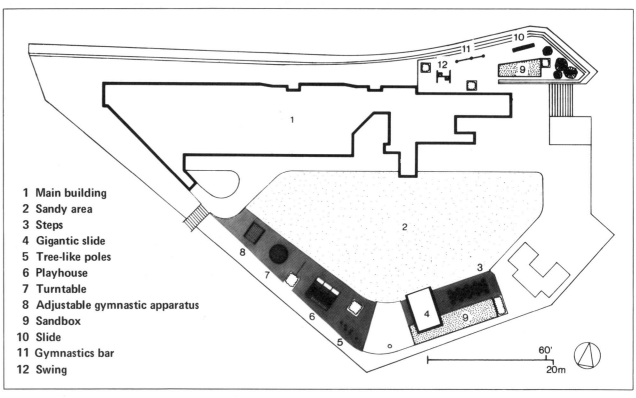

1 Main building
2 Sandy area
3 Steps
4 Gigantic slide
5 Tree-like poles
6 Playhouse
7 Turntable
8 Adjustable gymnastic apparatus
9 Sandbox
10 Slide
11 Gymnastics bar
12 Swing

1	3	4	5
2	6	7	8

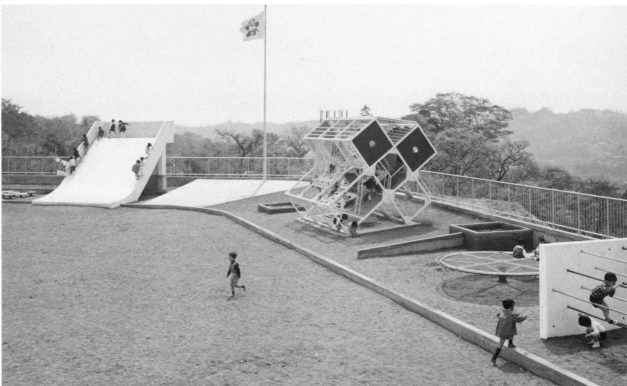

112

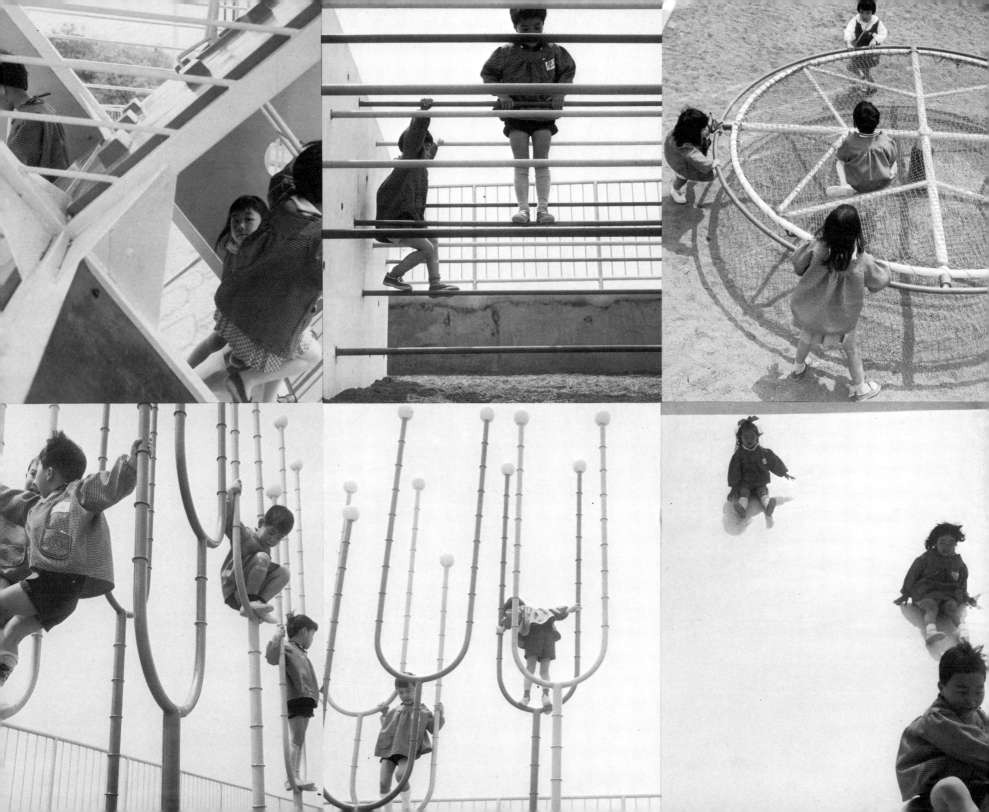

Youth Center Irikicho, Kagoshima, Japan

Design: Mitsuru Senda and Atelier Man & Space
Completed: 1971

This hilly and wooded play area is located to the northeast of the small town of Kagoshima. The main attraction is a giant steel construction which connects the two highest hills and is bordered at one end by two long steel cylinders, 20m long and 4m in diameter. Mitsuru Senda doesn't apply preconceived solutions which would lose their power of attraction in a very short time. He makes the most of the existing territory. Most designers would suggest extensive paving, or an excessive amount of folkloric or aesthetic objects. Senda's projects open up a surprisingly new aspect: his artifice is set into a natural surrounding.

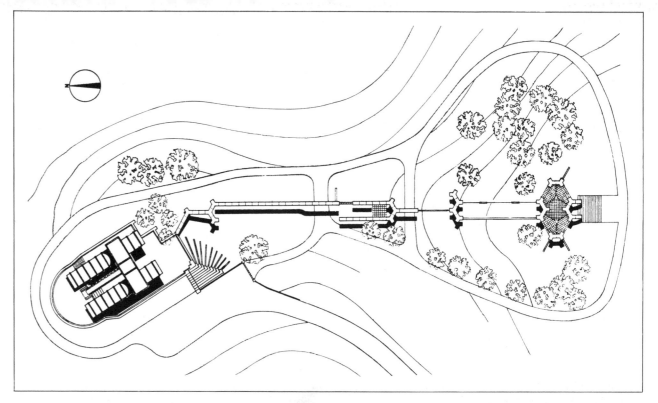

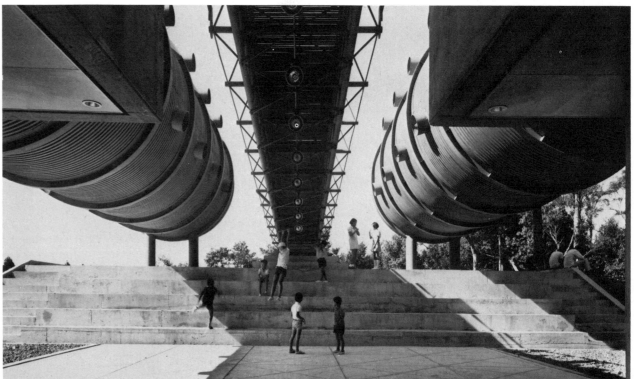

11

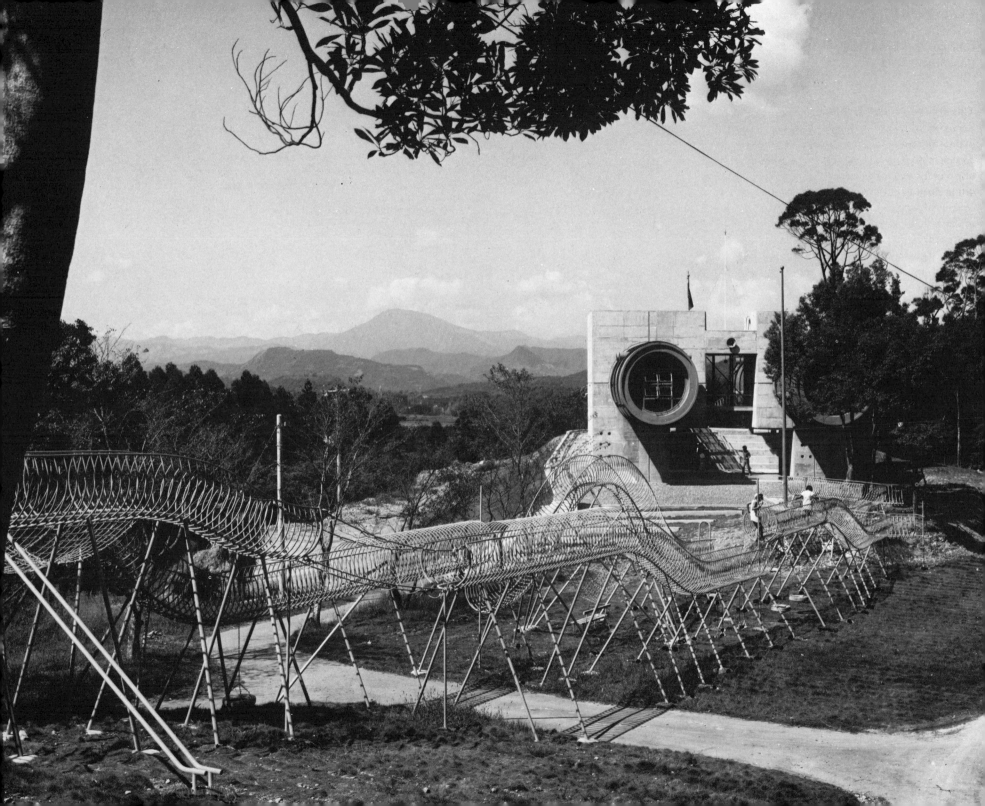

Play Park Atagoyama, Kofu, Japan

Design: Mitsuru Senda and Atelier Man & Space
Completed: 1972

The park is located on a mountain overlooking the city. The designers didn't change the topography of the area or its vegetation: trees and bushes were left growing wild. They provide a good contrast to the platforms and carefully designed structures. It was undoubtedly the panoramic view which led the designer to play off his ideas so intentionally against nature.

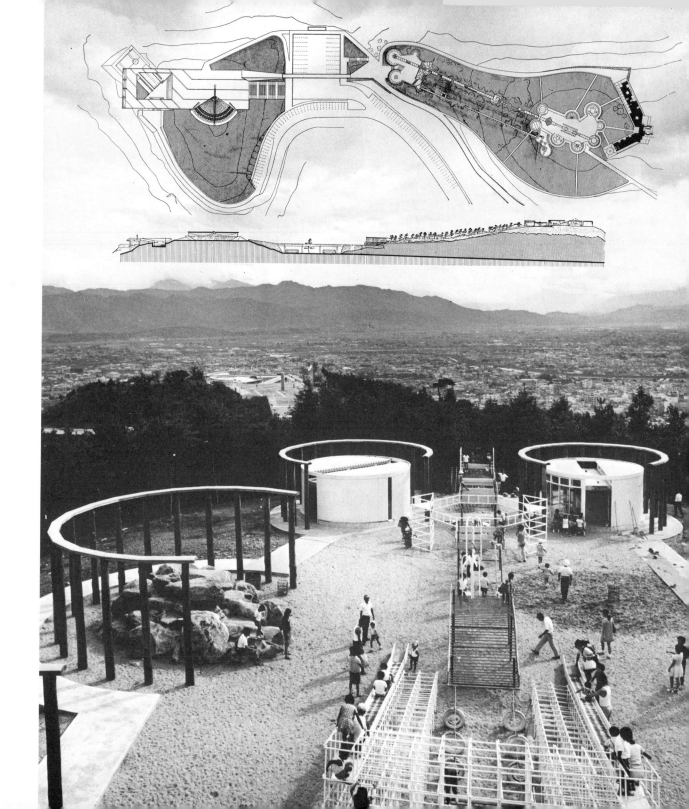

	1		
2		3	4

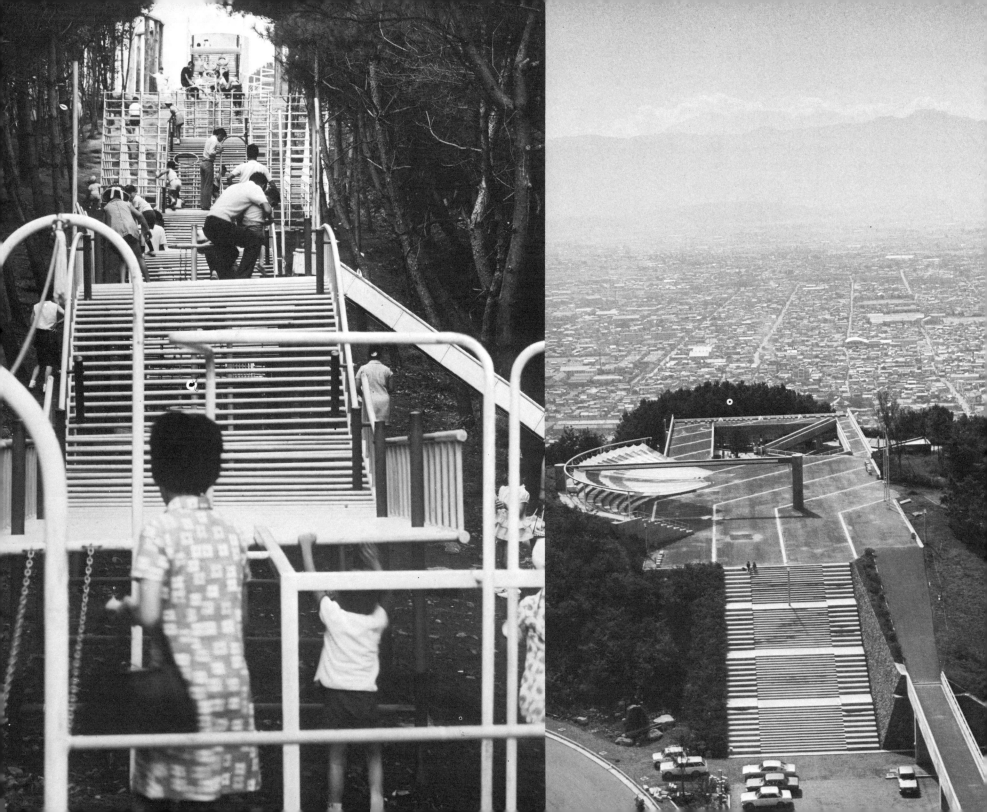

Slides have always had an attraction for children. They offer a combined experience of body weight and velocity. Sliding down exuberantly and swiftly is the reward for having taken the trouble to climb up. From grassy knolls to rolled sheet iron structures, the possibilities are endless.

If the material (steel, plastic) is absolutely smooth and the artificial or natural slope not too steep, but safe for children, the slide is an ideal device for any playground. If possible, a slide should be part of a natural elevation. Costly and purposely erected structures often prove to be ugly and dangerous.

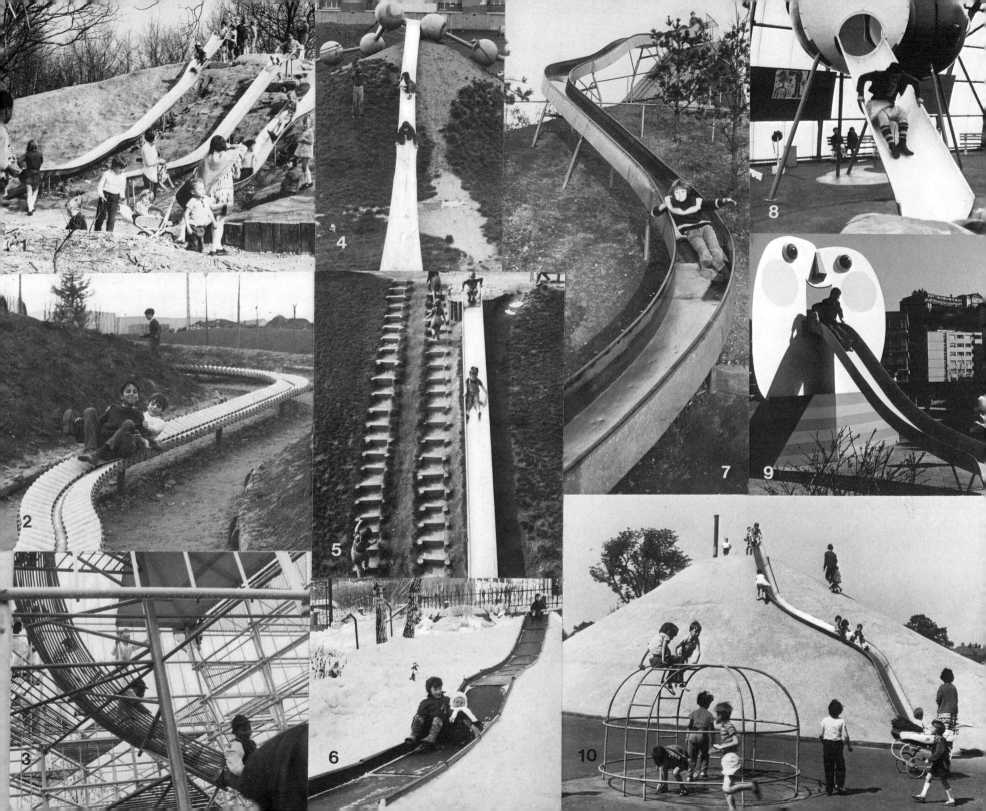

Play area in Miyagi, Japan

Design: Mitsuru Senda, Mikio Shiga and Atelier
Man & Space
Completed: 1969

The stylized design of this large terrain as a play-ground is in no way incompatible with the nearby pine woods. In most countries it would be impossible to realize this project, because the world has become too "civilized." Mitsuru Senda says: "Danger is a part of life. It can be overcome in playing." (Most designers would not agree with this statement.) Senda' projects are never designed for a stylized or artificial landscape. They always have a natural setting. Their dimensions are not limited to any traditional scope; they fascinate children, freeing their imagination and energies and testing their aptitude. The "flying snake" stretches 150m between a smooth pyramid of concrete and a roof of thin steel bars (2); steep slides (1) lead into a funnel (the ant-lion).

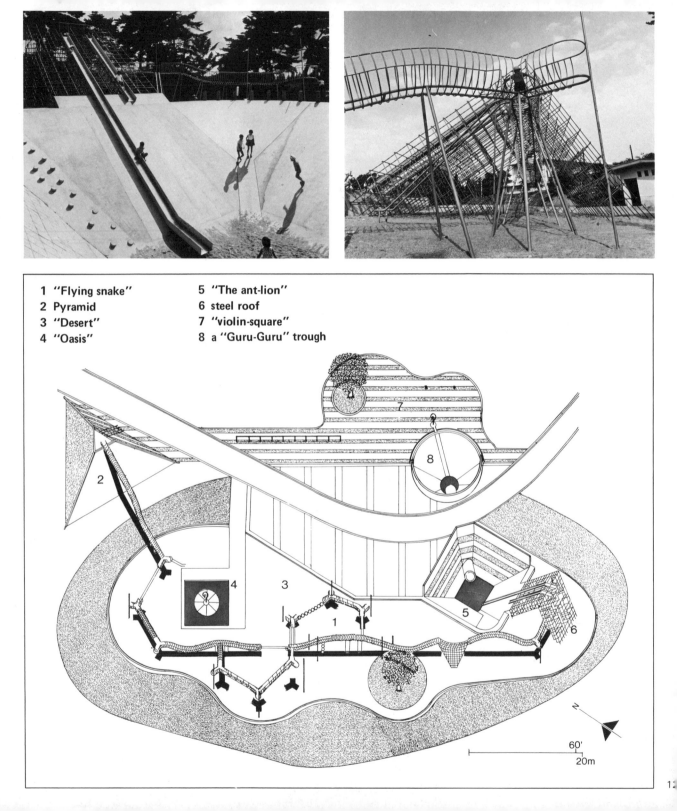

1 "Flying snake"
2 Pyramid
3 "Desert"
4 "Oasis"
5 "The ant-lion"
6 steel roof
7 "violin-square"
8 a "Guru-Guru" trough

60'
20m

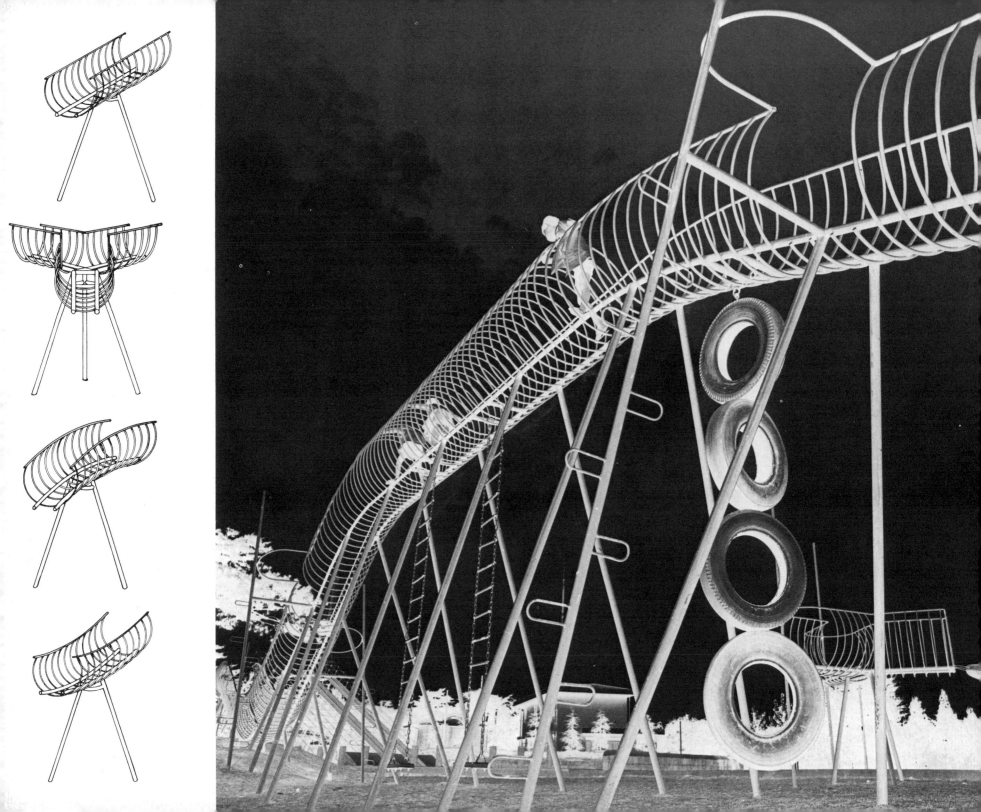

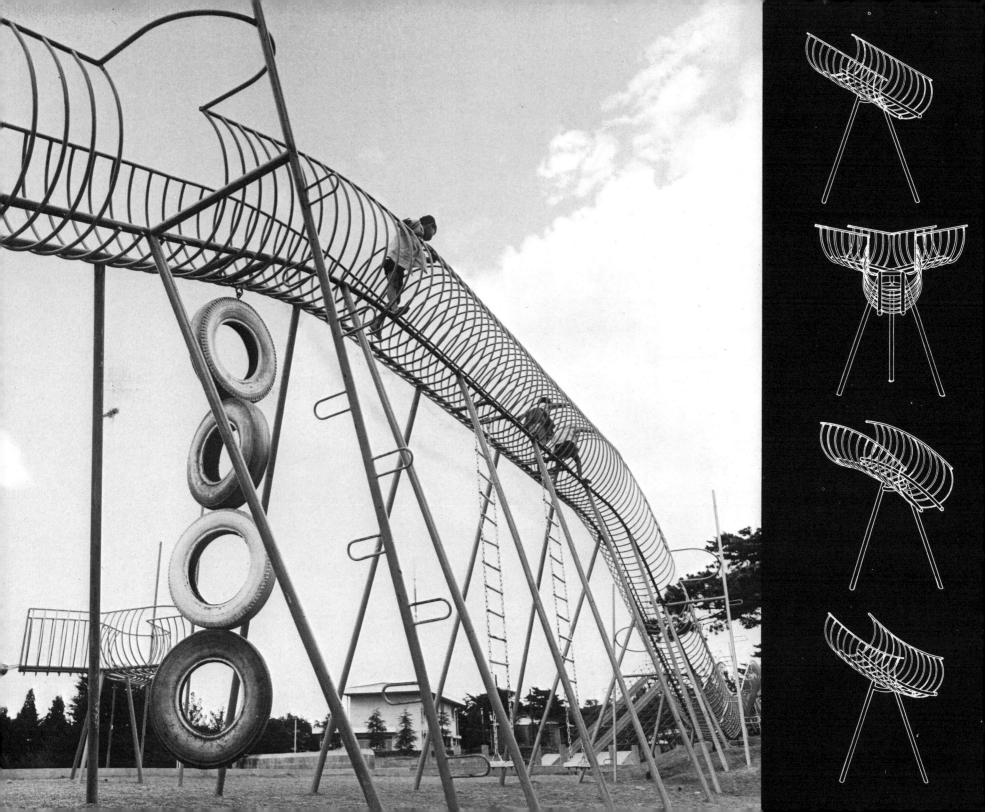

Play Park on Mount Ryozen, Fukushima, Japan

Design: Mitsuru Senda and Atelier Man & Space
Completed: 1971

As in his other projects, here, too, Senda has considered the natural surroundings and equipped the area with prefabricated objects.

At the foot of Mount Ryozen on a slope graded 15 degrees, a wooded area 150 by 500m was cleared. The general view shows that in order to install so much playground equipment—from brightly colored elements of concrete to the large prefabricated structures of varied forms and functions—extensive excavation work had to be done. Because of the contrast between topography and the many shapes and materials used (wood, steel, concrete, plastics, rubber), this area seems almost unreal.

There is a clearing for very small children bordered by high foliage with special equipment where they can play under supervision.

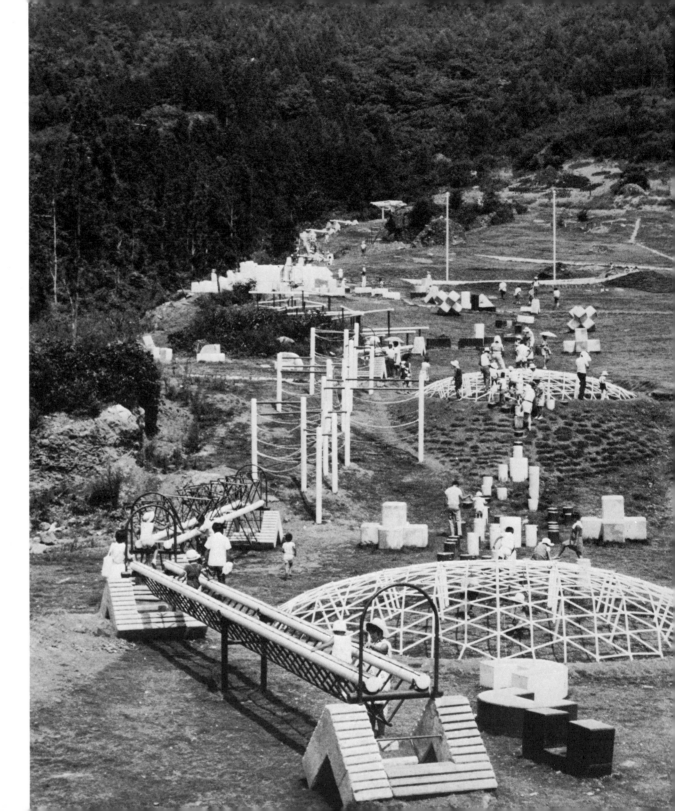

Play area in Shinkawa, Japan

Design: Mitsuru Senda and Atelier Man & Space
Completed: 1971

This original play area is located by the sea. Here Senda proves again what imaginative results can be achieved with modest means.

On a strip of land planted with pine trees, he built a bicycle track and six embankments 2m high crossed by three wooden bridges. The railings are peeled, bleached pine trunks with ropes and nets attached. To make climbing easier, the trunks were assembled close to each other. The nets are stretched between the bridges; the depressions between the embankments are filled with water. The last bridge ends in a slide which leads into a stylized boat filled with sand. The simple means are in accordance with the location of the area on the beach. The undisturbed ground is a logical continuation of the beach.

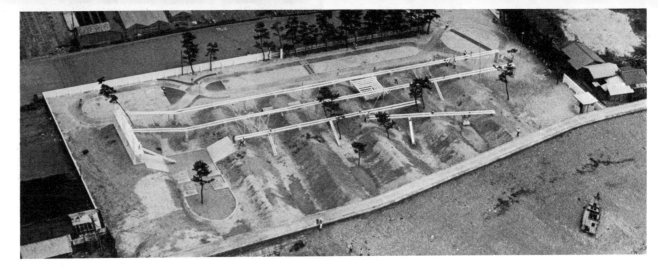

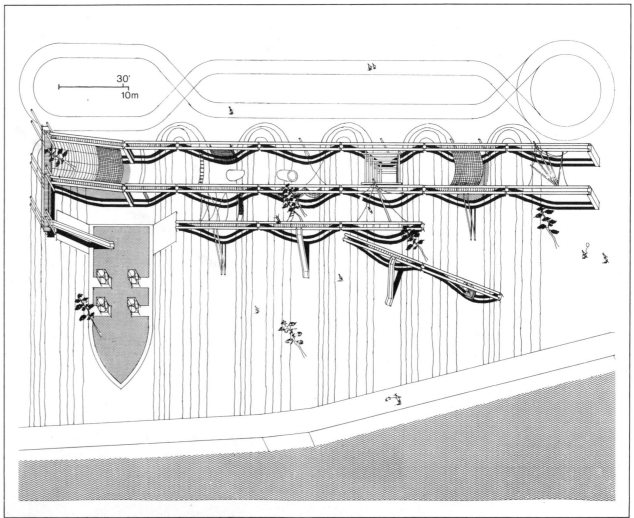

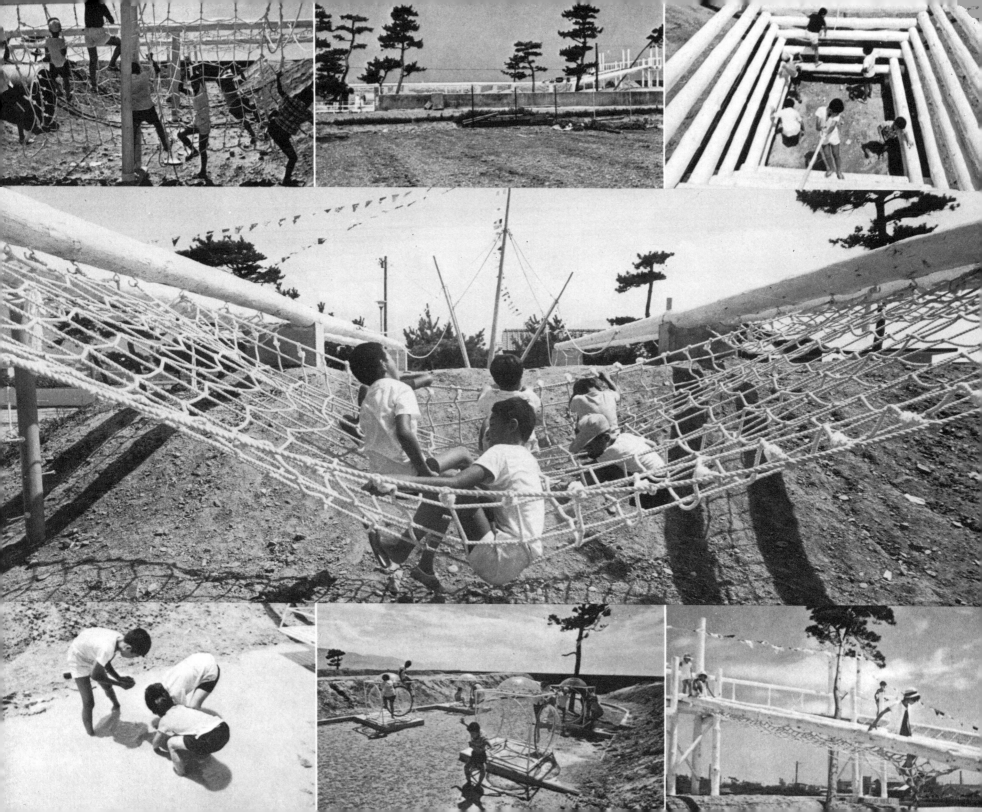

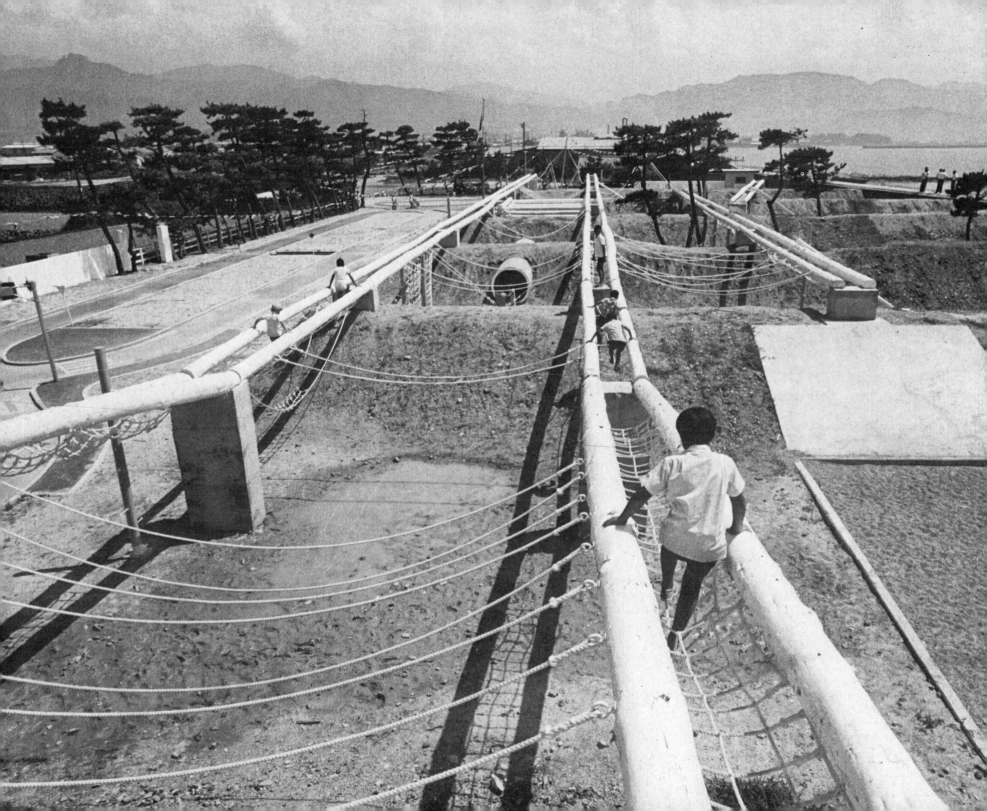

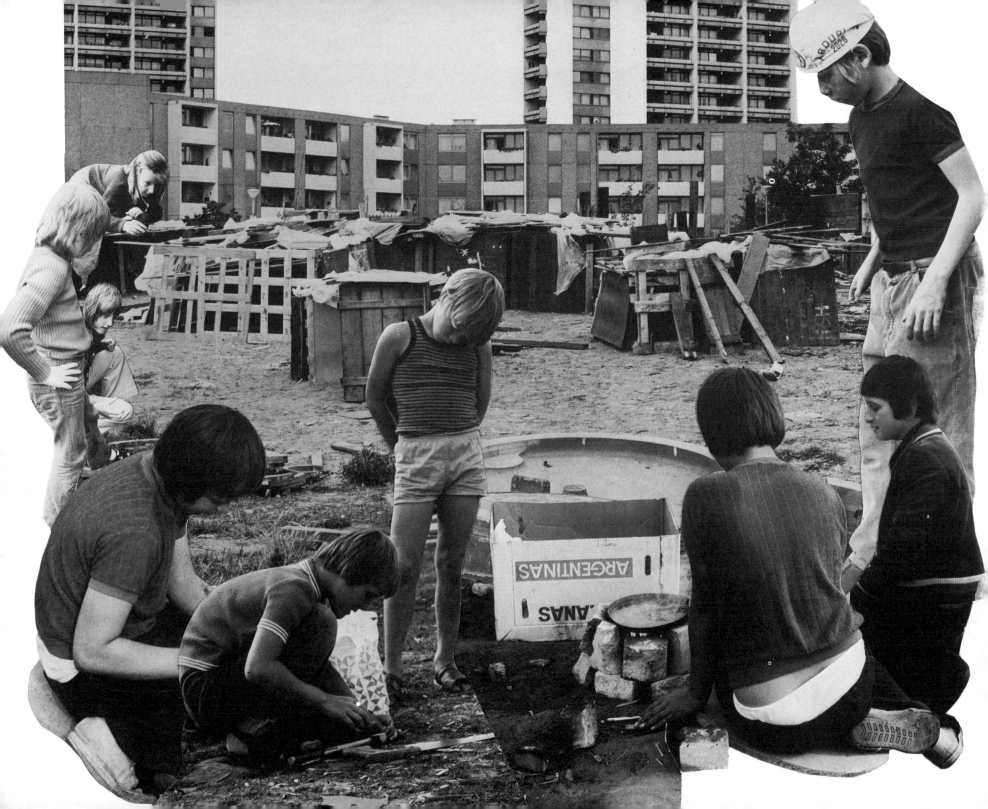

It is said that one of the earliest acts of man
was building a shelter. For children this is one
of the most rewarding experiences. It is
usually done through teamwork, where the
youngsters copy what they have understood
by observing the world of adults. The scope
of experiences and activities connected with
it is very large: a search for material, con-
struction (often with baffling imagination),
improvisation, decor, and experiencing life
in a community with all its joys and tensions,
simulating the social structure of adult life,
etc. Adventure playgrounds are often situated
on neglected, empty lots. Whenever a city
places such an area at the disposal of the
children, where they are able to build shacks
with materials from building sites and
borrow tools, it turns out to be a striking and
lasting success.

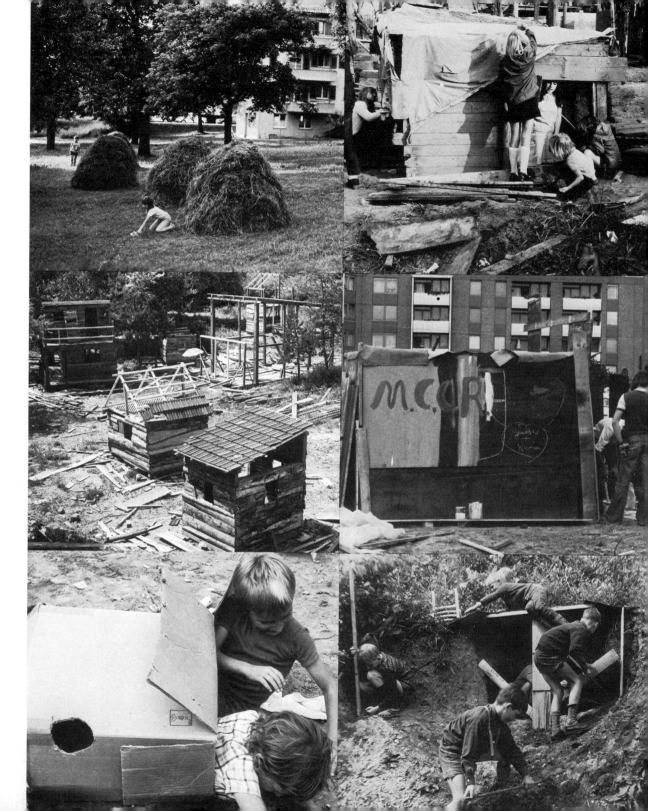

		2	3
	1	4	5
		6	7

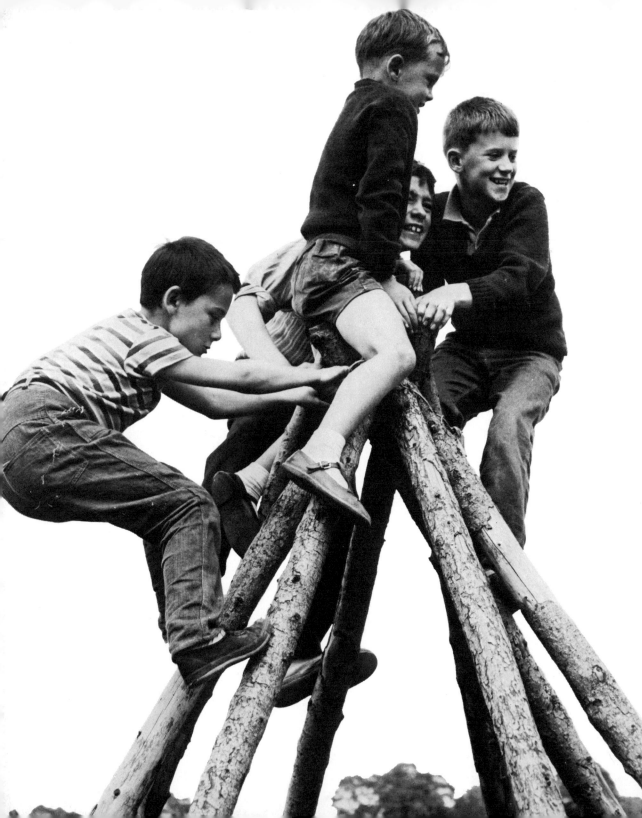

Construction playground in Basel, Switzerland

Design: Department of Parks, Basel
Completed: 1972

After the Swiss social welfare agency "Pro Juventute" built the "Robinson" playground in Zurich, playgrounds with facilities for building have become more and more popular in Switzerland, Germany, and the Scandinavian countries.

The resident community decided to install such an adventure playground on the grounds of a former orchard near the banks of the river. The area is opened at certain hours by a supervisor whose barracks serve as an office, Red Cross station, and playroom for rainy days. The building material consists of boxes from industrial plants. The shacks and other structures are in most cases clearly visible and the residents of the neighborhood have gotten used to a certain amount of disorder and construction confusion.

Grass and sandboxes near the buildings are accessible at all times.

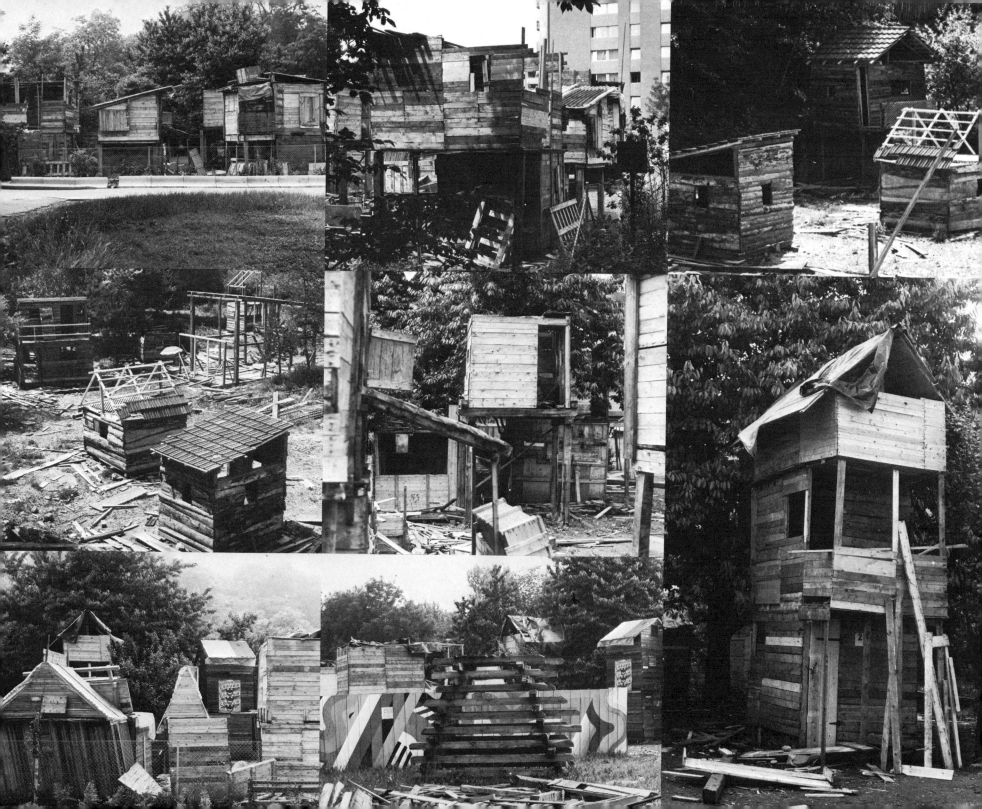

The Department of Parks of the Greater London Council has created three different types of playgrounds in accordance with a standardized program for outdoor play: "One O'clock Clubs" for children under 5 years of age, play parks for the 5-10 year olds, and adventure playgrounds for older children and juveniles. These play areas usually conform to local conditions, but they have common standards: to offer children diverse activities under the supervision of an educational assistant at playgrounds that are unconventionally arranged, to minimize discipline and promote positive human contact.

The "One O'clock Clubs" are supervised by the mothers on a volunteer basis. They are open year-round from 1 - 5:30 p.m. and provide children with costumes, water, sand, and building games.

In 1959 the Department of Parks of the G. L. C. built the first play parks. To begin with, there were three in the suburbs of London. After a sufficient amount of experience had been gathered, more parks were built supervised by a hired staff. These parks became popular very quickly and by 1968, twenty-eight were in existence. The children have a great variety of games to play. They can climb, dig, build shacks, slide, hang by their hands on ropes, and improvise with scrap material or old clothes. Workrooms are provided for rainy days for games such as ping-pong or handicrafts.

The adventure playgrounds, unlike the other play areas, are located in the middle of residential areas on rehabilitated real estate, and their hours are flexible. The children have scrap materials (wood, plastic, etc.) at their disposal in order to build structures or fires for grilling—activities usually forbidden in playgrounds. The areas are open year-round and supervised by professional staff. Success depends on the relationship between the children and the residents of the neighborhood. These parks are an integral part of the life of the urban community. Collective activities connected with schools or parents' organizations originate here: craft courses, theatrical productions, outings, or camping.

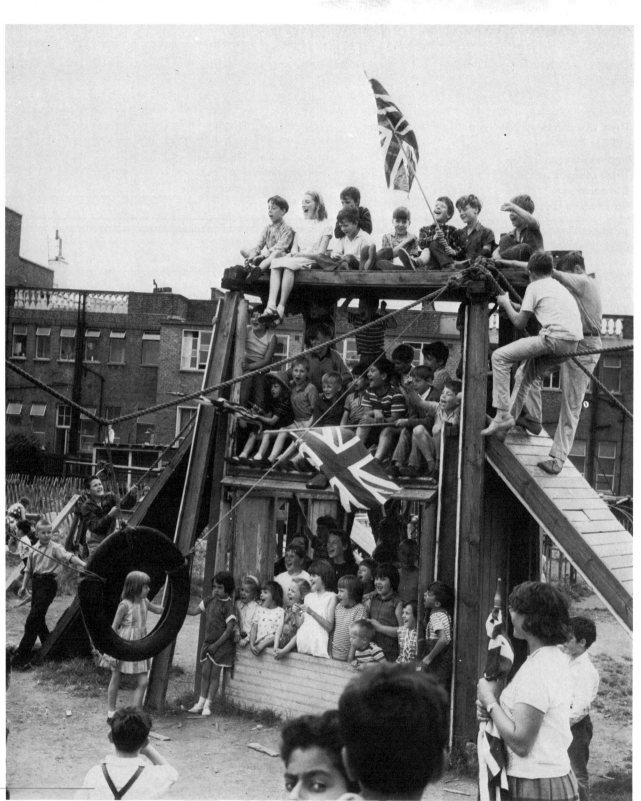

Playground in Kensington Park and Gulliver Playground, London, England

Design: The Greater London Council
Completed: 1970

These two adventure playgrounds (Kensington Park 1, Gulliver Playground 2-5) are located close to nearby housing complexes. The G. L. C. took over these pieces of real estate in order to create lively play areas. These temporary solutions are better than none and better in any case than the old-fashioned type of playground styled after rigid logical principals. These adventure playgrounds promote the development of a child's imagination: under the supervision of an educational assistant, shacks and swings can be built from boards and ropes.

				4
	1	2	3	5

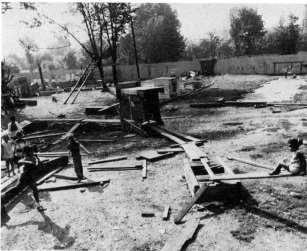

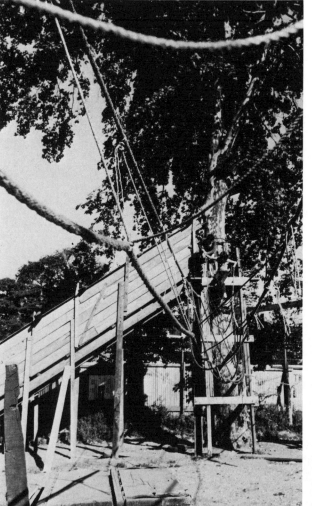

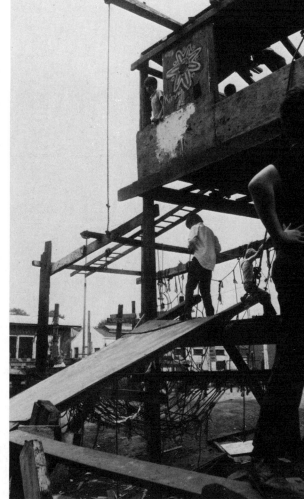

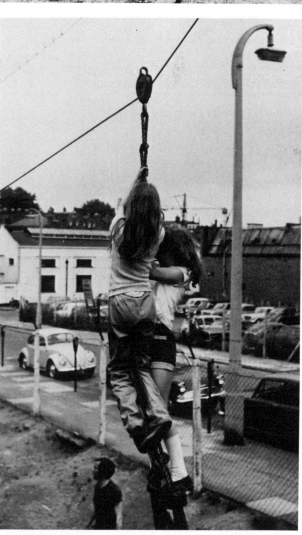

Playgrounds on the Queen's Road and on Swedenborg Square, London, England

Design: The Greater London Council
Completed: Queen's Road 1970, Swedenborg Square 1972

Urban renewal provides temporary play spaces. The Greater London Council moves in and makes them available to children. Two areas (Queen's Road 1-6, Swedenborg Square 7-10) are good examples of the use of empty lots that became available when old housing was torn down. Scrap materials are used as equipment. Until renewal begins, children can play and build here under the guidance of a counselor—unlike parks and fields where stepping on the grass is prohibited. These temporary playgrounds sometimes develop into permanent situations with regular buildings housing day care centers, workshops, or kitchens.

1	2	7	8
3	4		
5	6	9	10

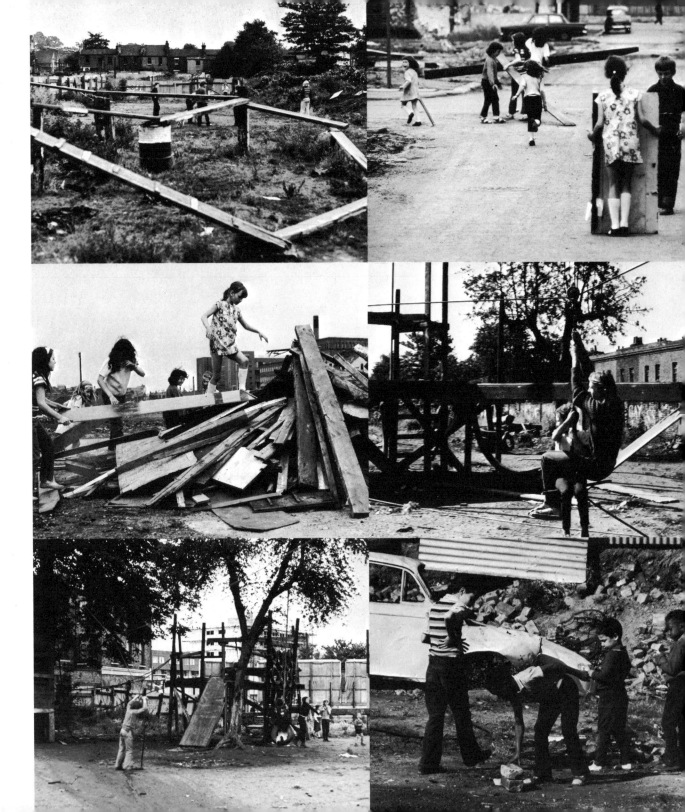

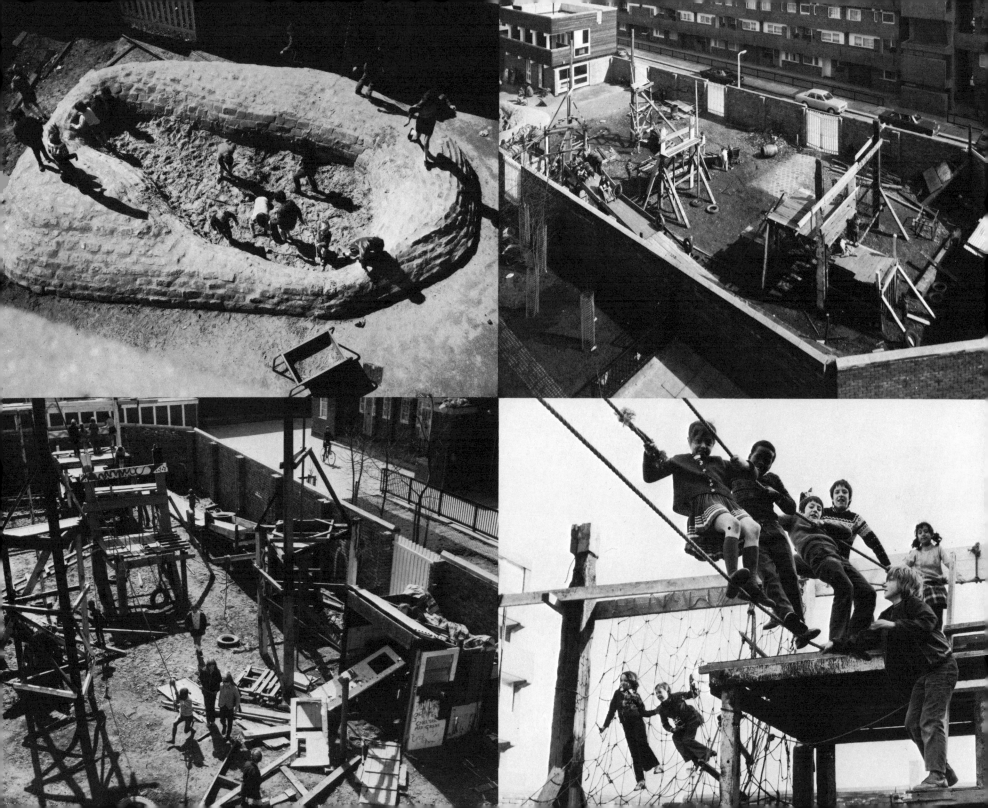

'Robinson" Playground in Garath, near Düsseldorf, Germany

Design: Department of Parks and Recreation Düsseldorf
Completed: 1972

In this former industrial area between a housing project and the turnpike, prohibited to parents, children can play freely with three elements: water, earth, and fire. A great variety of building material is at their disposal. The young architects can borrow the necessary tools from the supervisory staff. A large circle is reserved for fire alone, all the more fascinating to children since playing with fire is usually prohibited. Here are opportunities for the most imaginative games, and this area has become an irresistible attraction for children.

The pleasure of building and tearing down fills a small, forever-changing world with life. This area proves that "freedom" works with kids, as long as the play space is appropriately equipped.

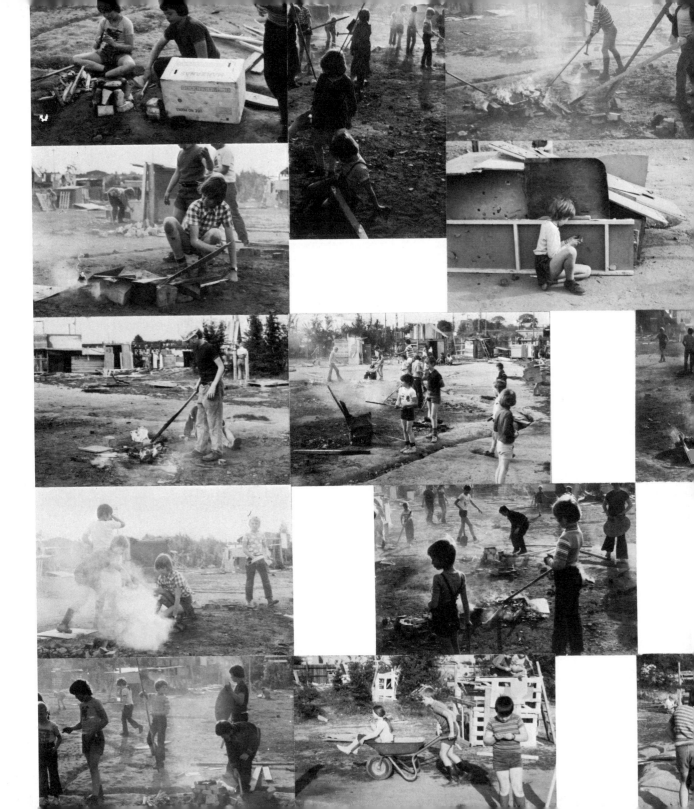

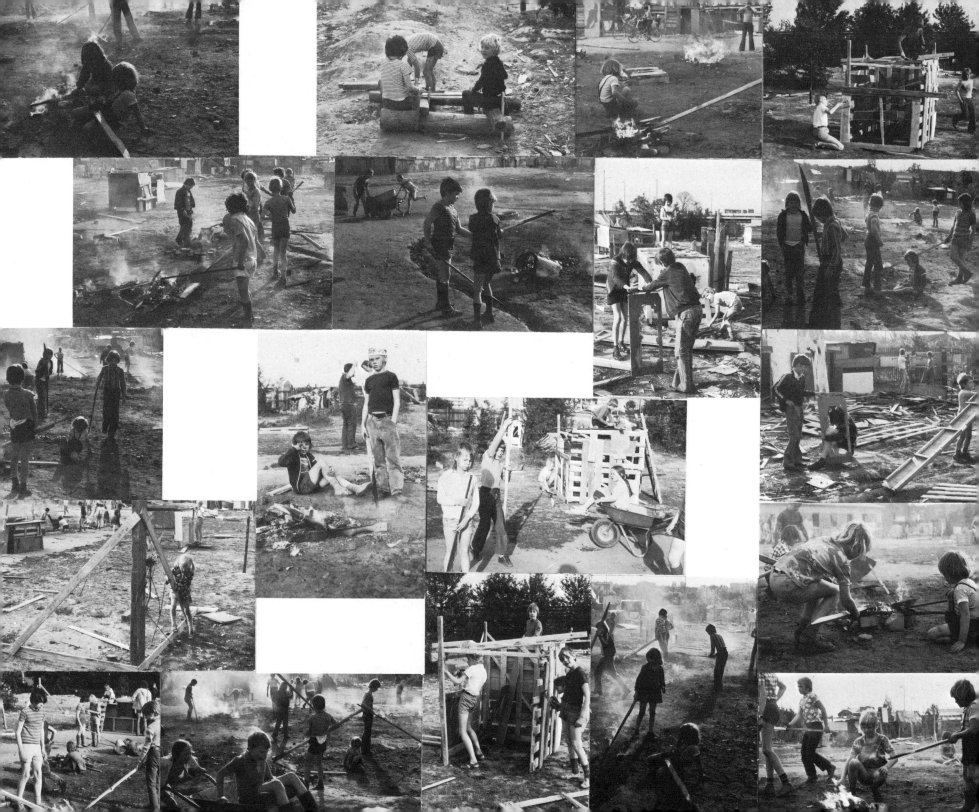

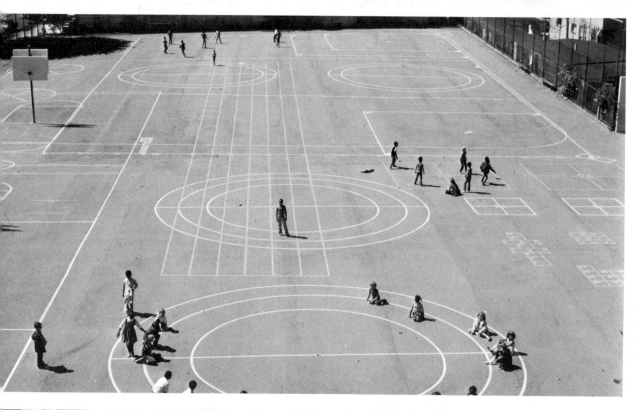

Washington Environmental Yard, Berkeley, California, USA

Design: Robin Moore and Herb Wong
Completed: 1971

This environmental yard, built in an ordinary munici-pal schoolyard (1), is "a place where picking flowers is permitted." The authors call it a "living-learning-laboratory." It is doubtless an interesting attempt to bring about a decisive qualitative improvement in the area of recreation.

Numerous natural and artificial elements—earth, water (7), vegetation (8), animals (5, 6) and play-ground equipment (3, 4)—stimulate creative inter-action and give children the opportunity to "do it themselves" and to practice self-determiniation. While this is a model of the world as "curricular space," it is at the same time an effective model for the endeavor to "de-school" the schools in order to bring school and life closer together.

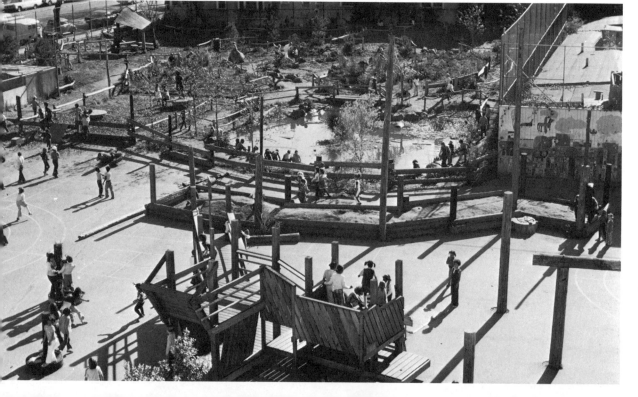

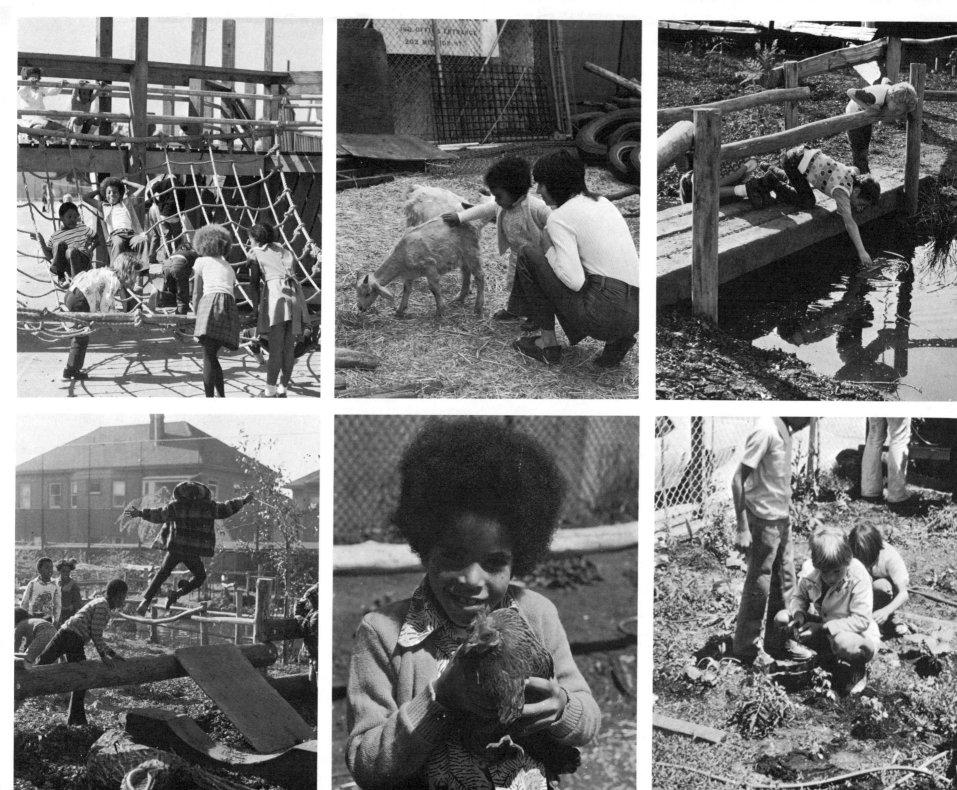

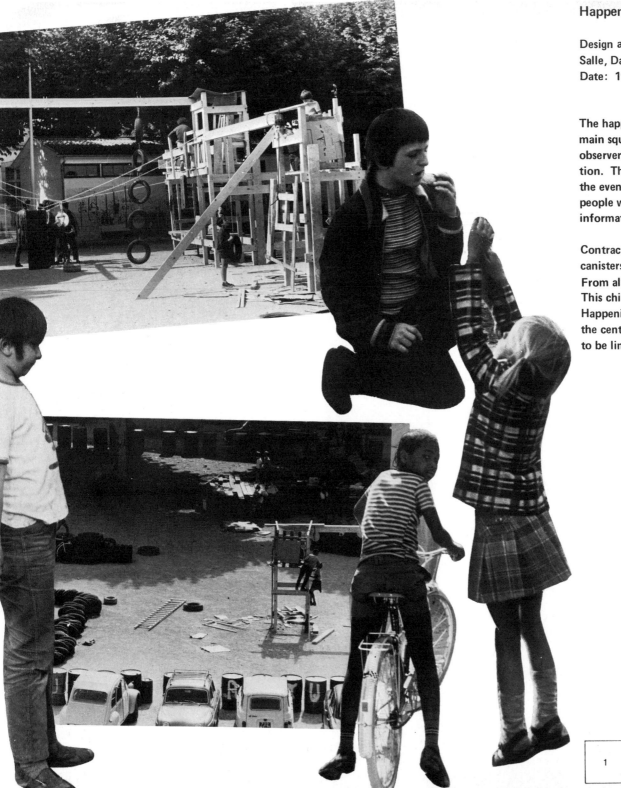

Happening in Châlons sur Saône, France

Design and execution: Groupe Ludic (Xavier de la Salle, David Roditi, Simon Koszel)
Date: 1972

The happening lasted a month in one of the town's main squares. The event supplied local agencies and observers from nearby cities with valuable information. The convenient location—a parking lot—made the event an integral part of the life of the city: people were able to follow the action and gather information about the methods applied.

Contractors supplied the boards and pipes. The oil canisters came from the warehouse of a refinery. From all over, parents brought their children. This children's fair proved to be a huge success. Happenings like this can easily be carried out in the center of any city. A happening doesn't have to be limited to an abandoned location.

| 1 | 2 | 3 |
| | 4 | 5 |

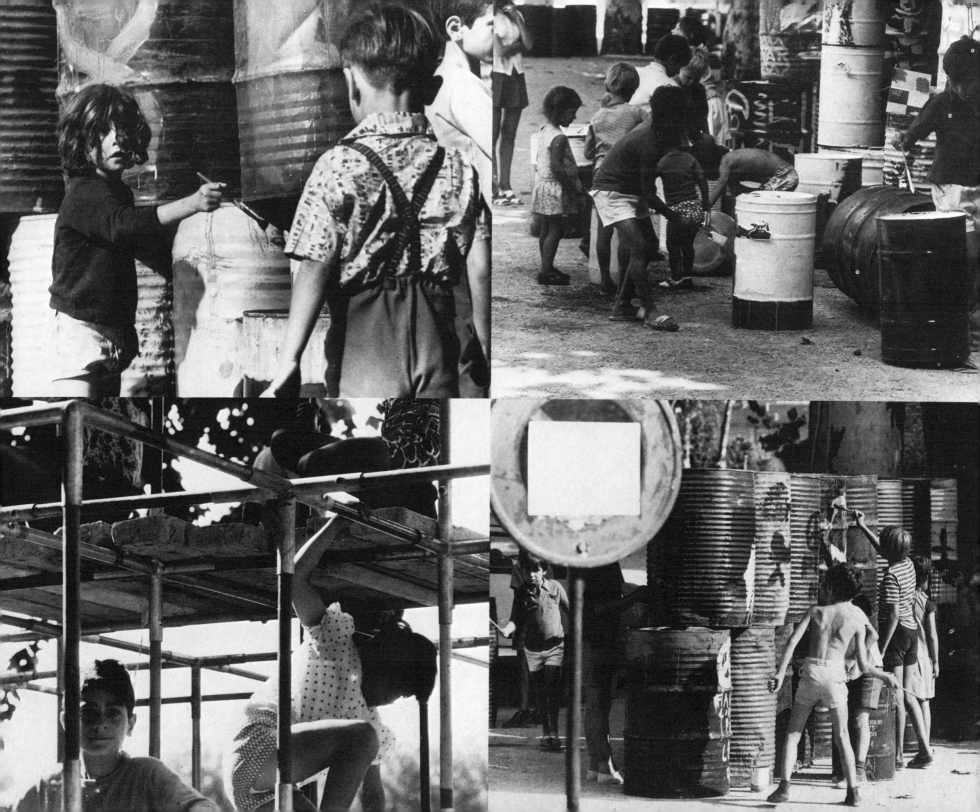

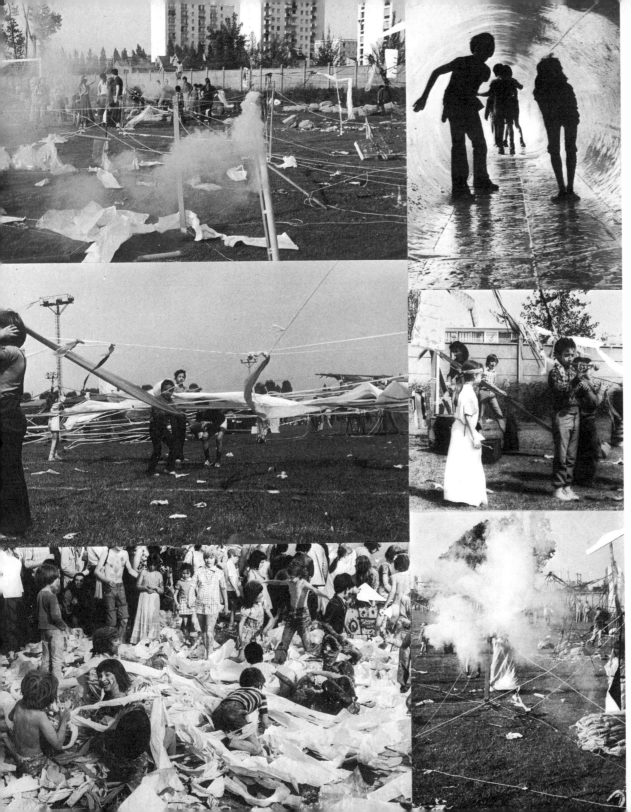

Happening in Colombes, France

Concept: Ritacalfoul
Date: 1974

The happening, which lasted three days, didn't have
a precise educational concept. The responsible
agencies together with the children made up a special
program for each day. On the first day they worked
with paper and cardboard, on the second with costumes,
on the third with inflatable objects and colored
smoke. The materials were provided at low cost by
several retailers from their remnant stocks.

1	4		7	9	10	12
2	5					13
3	6		8	11		14

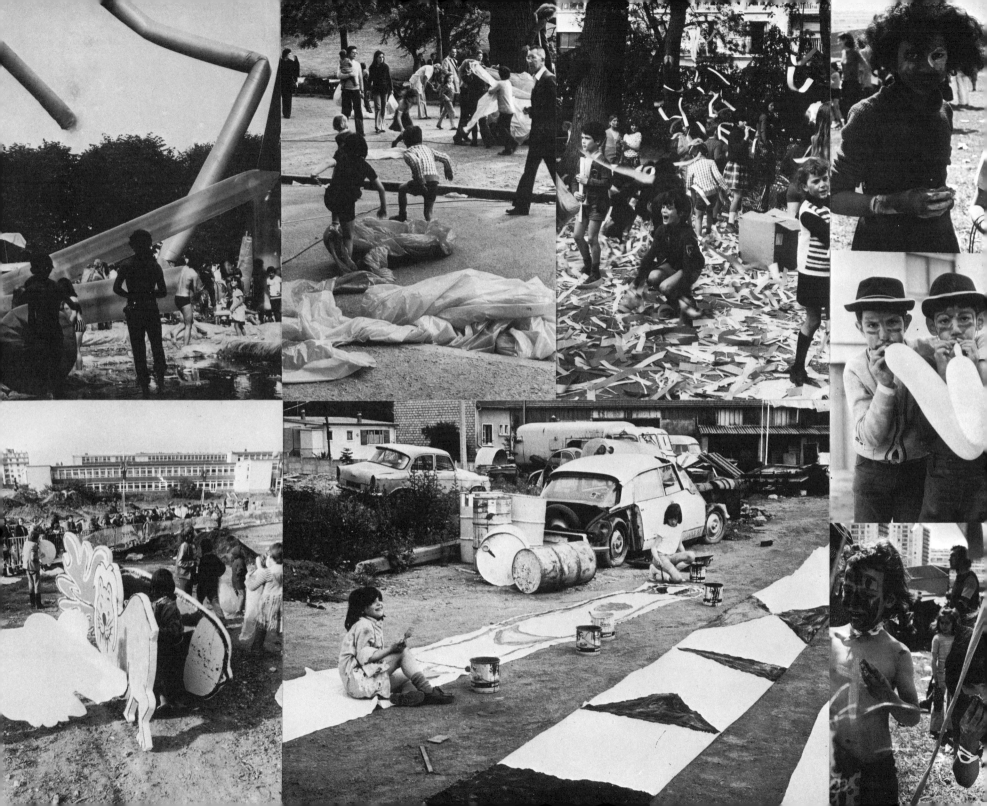

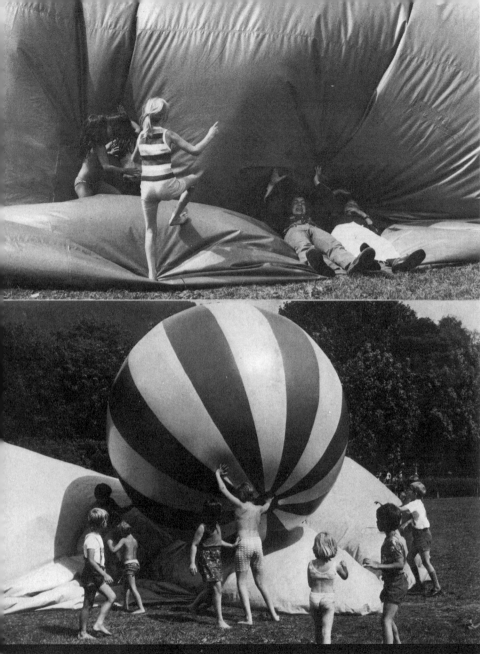

Happening in Bregenz, Germany

Concept: Klaus Göhling
Date: 1974

Inflatable objects are a great attraction at happenings. An ideal area for them is a field so children can run and climb safely on the giant air cushions. If the balloon tears, patches can easily be glued over the torn area. The objects are inflated to half their capacity by a normal vacuum cleaner hooked up in reverse. Other sturdier balloons are filled with water. Children and adults get the surprising sensation of learning to walk all over again.

1		3	5
2		4	6
7			

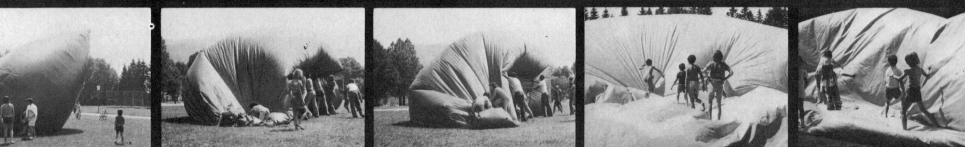

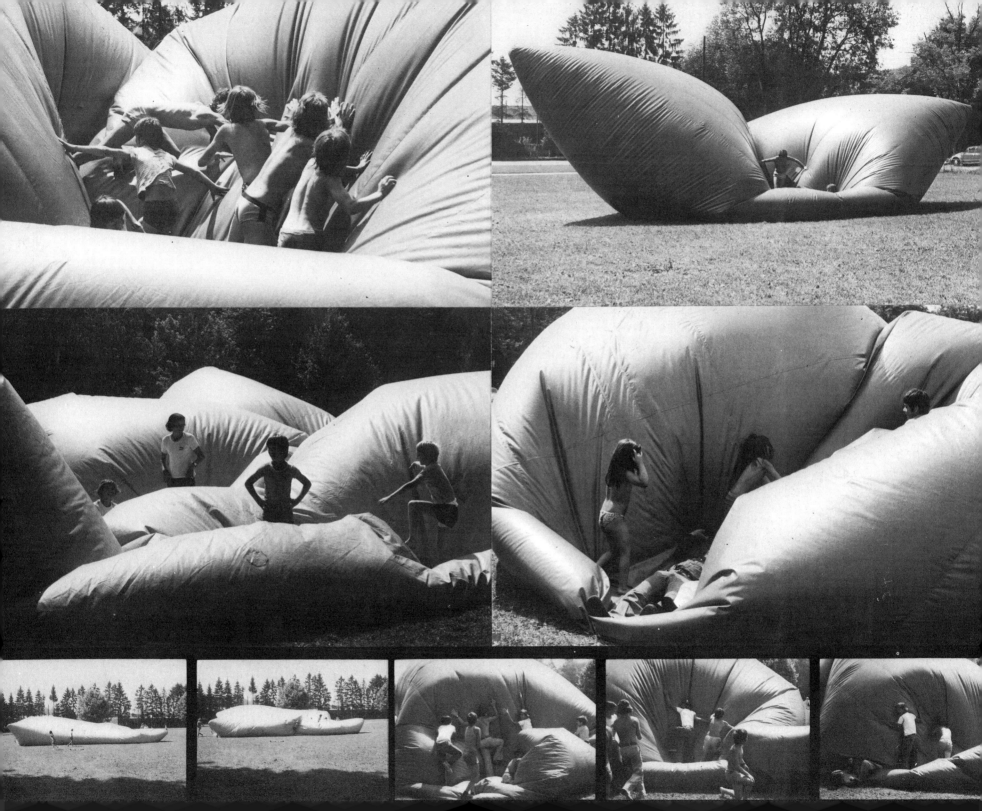

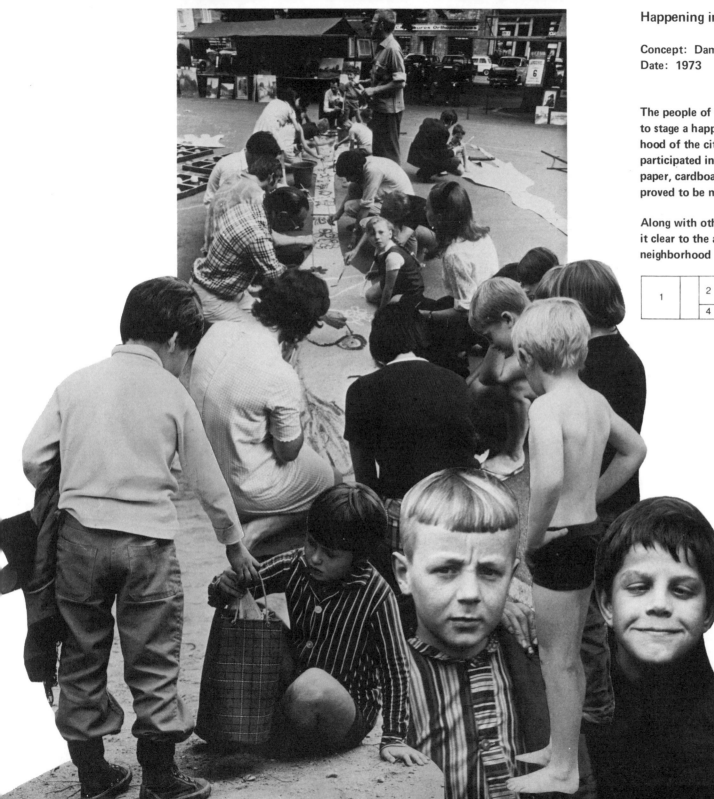

Happening in Brussels, Belgium

Concept: Damien Hambie
Date: 1973

The people of the community took the initiative
to stage a happening in order to save an old neighbor-
hood of the city from urban "renewal." Children
participated in various projects but painting on
paper, cardboard, balloons, and window shades
proved to be most popular.

Along with other street events, this happening made
it clear to the authorities that an old, run-down
neighborhood is not necessarily a dead one.

1		2	3	
		4	5	6

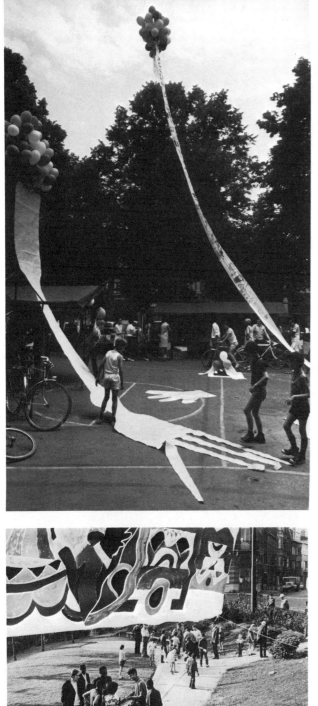

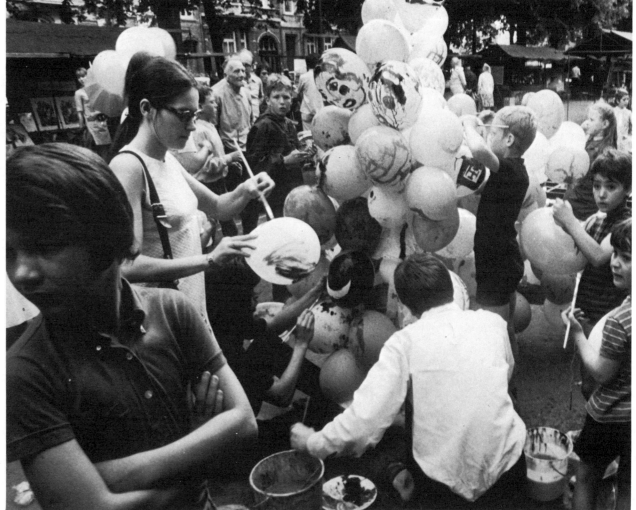

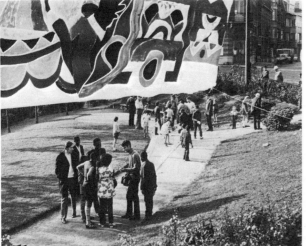

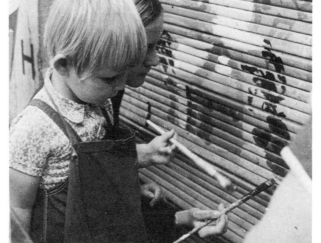

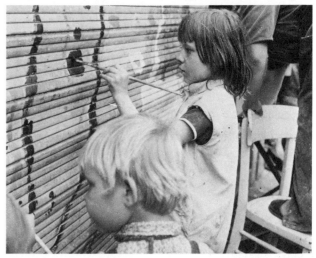

Concept: Jacques Simon, Jean-Louis Bernard and
Jean Dreyfus

This happening was not planned to the last detail in
advance. With remnants (nets, ropes, inflatable
objects) and scraps from industrial plants (paper,
cardboard), it was carried out in the afternoon.
Children themselves unloaded the trucks and were
allowed to do as they pleased. The counselors
only helped fasten the ropes and nets to the trees.
At the end of the day the children cleaned up the
square and sang and danced around a giant fire.

Educators reacted very positively to this experience,
which succeeded at minimal cost.

An afternoon passes quickly when children are oc-
cupied with odds and ends from local supermarkets.
The atmosphere of a happening like this can be
effective and stimulating for children in smaller
areas as well.

1	2	
3	4	7
5	6	

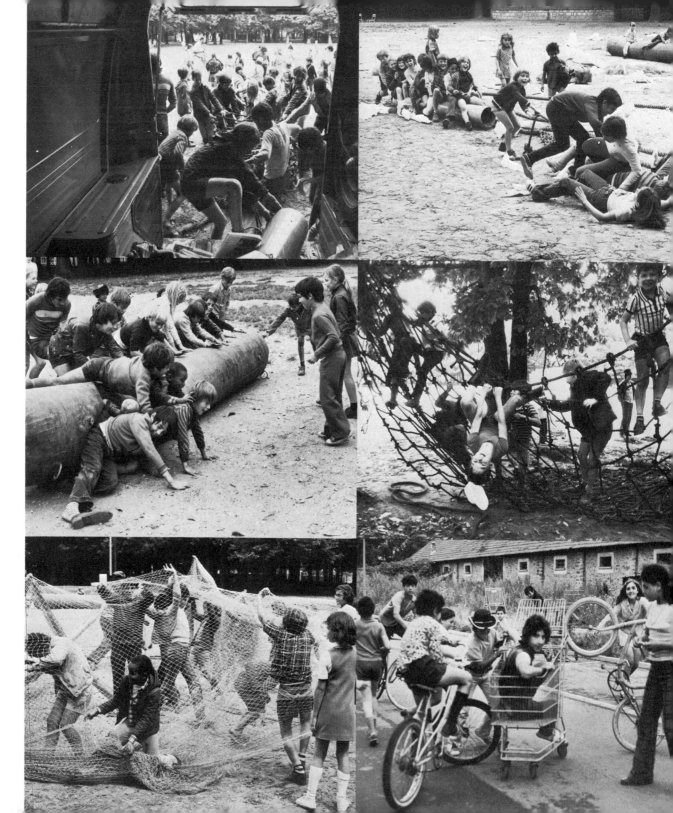

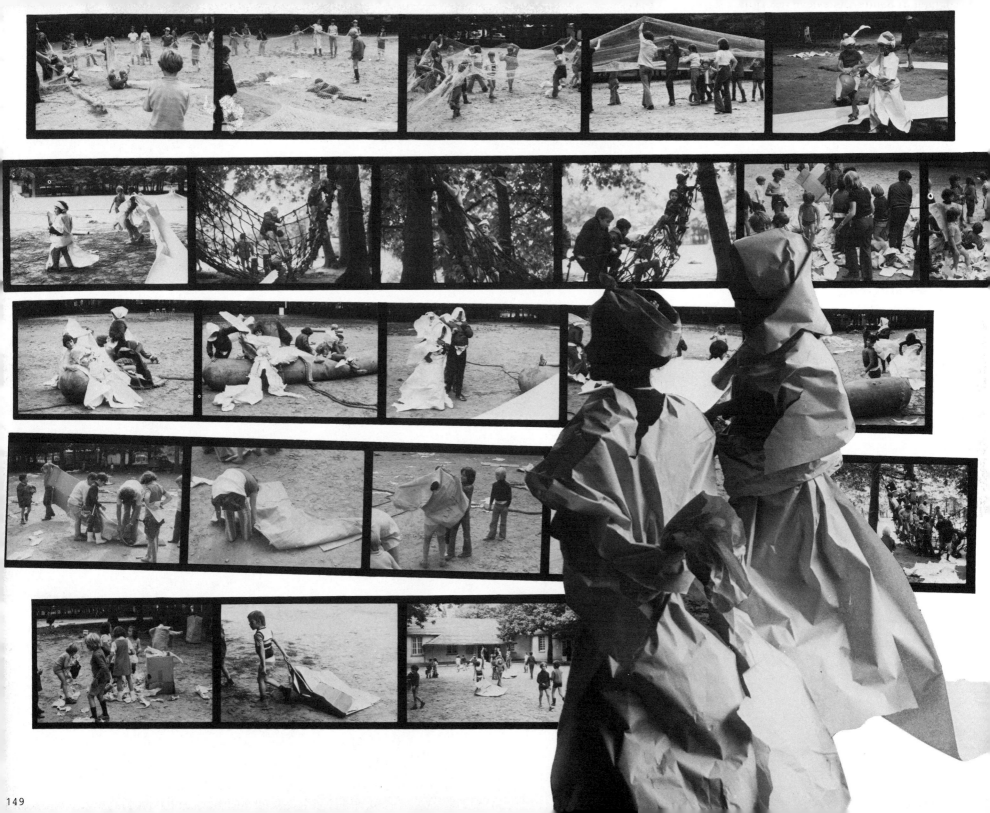

Action Play-Bus, Munich, Germany

Concept: Group for Educational Activities
First action: 1972

The "playground on wheels" is an old London bus.
It always carries a certain amount of basic equipment;
the rest is found on the spot. The happenings are
directed by trained teachers and students.

During the first year, the project was carried out in
three different playgrounds; it was later expanded
to several other districts. Supported by the city, the
organization had all the means necessary to arrange
these children's festivals successfully. Such hap-
penings bring temporary excitement to the parks of
the city, demonstrating to the authorities what can
be done in the future with open spaces and making
them realize the potential of a city block.

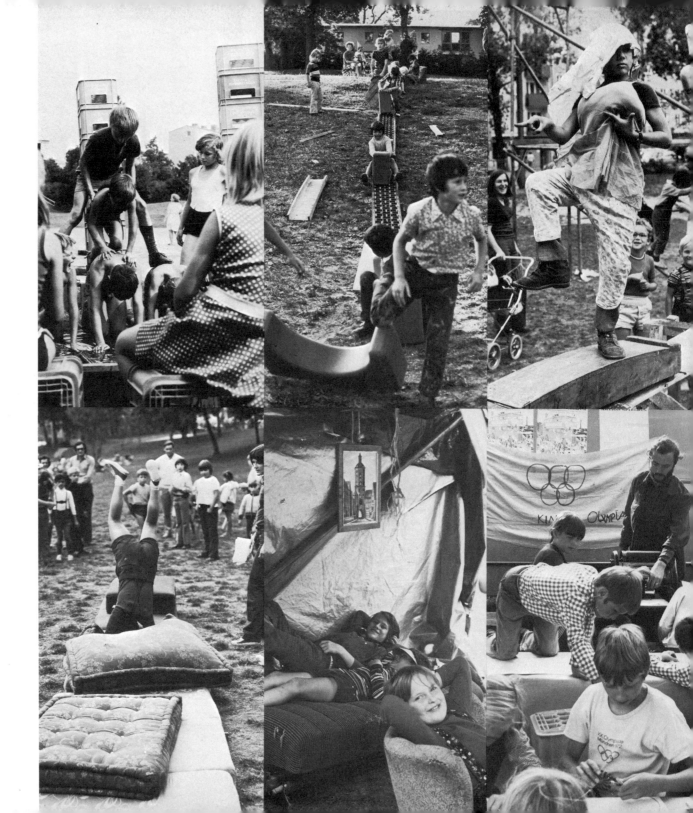

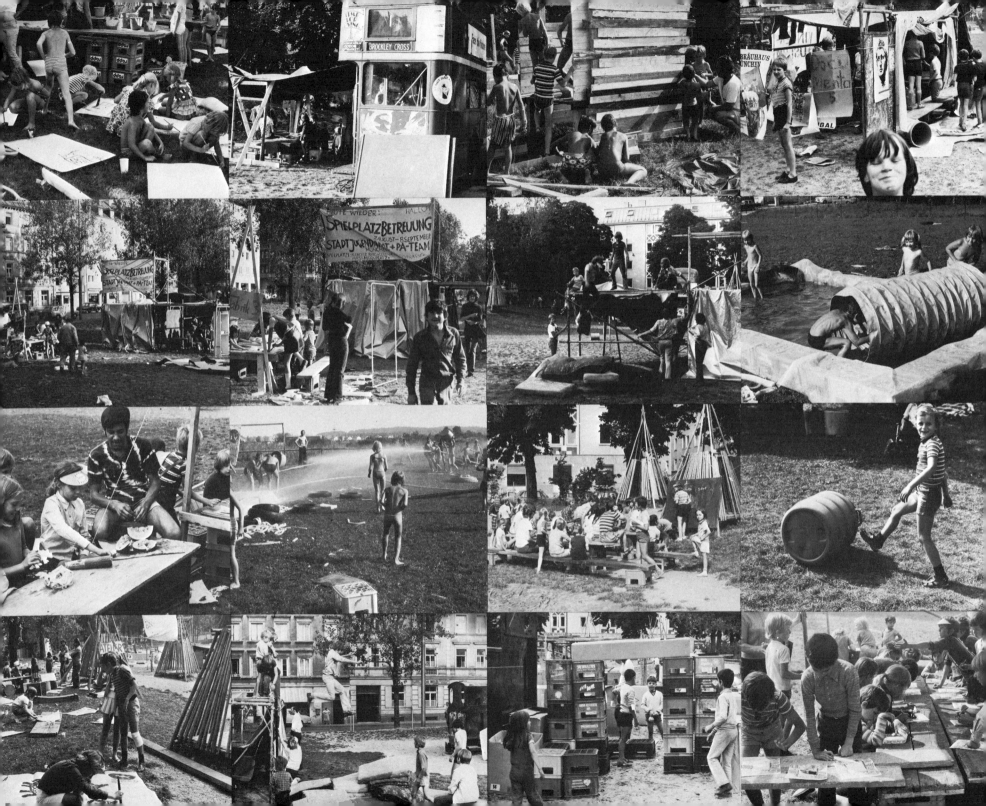

But the last word on modern playgrounds has yet to be written. The old clichés of parents and teachers had it that play is a passive waste of energy. Therefore, as a rule, playgrounds tend to be of a neutral and linear design.

Jumping, climbing, hide-and-seek, swinging, ball games, scuffling, etc. are well-tested and well-known play activities. But play can also lead children to experience earth, fire, water, plant life, smells, light, and colors in their environment. Play helps children extend their fantasy lives, helps them gain a knowledge of the world and other people in it.

We have no perfect solution as yet to satisfy these needs, but progress is being made along many of the lines of the experimental play spaces and play activities mentioned in these pages.

What are the possibilities of developing the creativity of children? What opportunities should they have? Is there such a thing as a perfect playground? Do play areas have to be programmed? CHILDREN'S PLAY SPACES would like to be a sort of recipe book for playgrounds, to serve as an inspiration to designers, to help them come up with an increasing number of satisfactory solutions.

But solutions are of no use if they are not put into practice. The most important question is: are parents, teachers, designers, architects, recreational counselors, and city planners willing to take the real needs of children into consideration in the cities of the future or in urban renewal projects preserving the cities of the past?

Children today are often trapped in sterile urban comfort based on an unimaginative high standard of living. And ghetto kids in the inner city have even greater play problems within even more desperate housing and educational situations. We have an obligation to find a way to prevent all of them from suffocating.

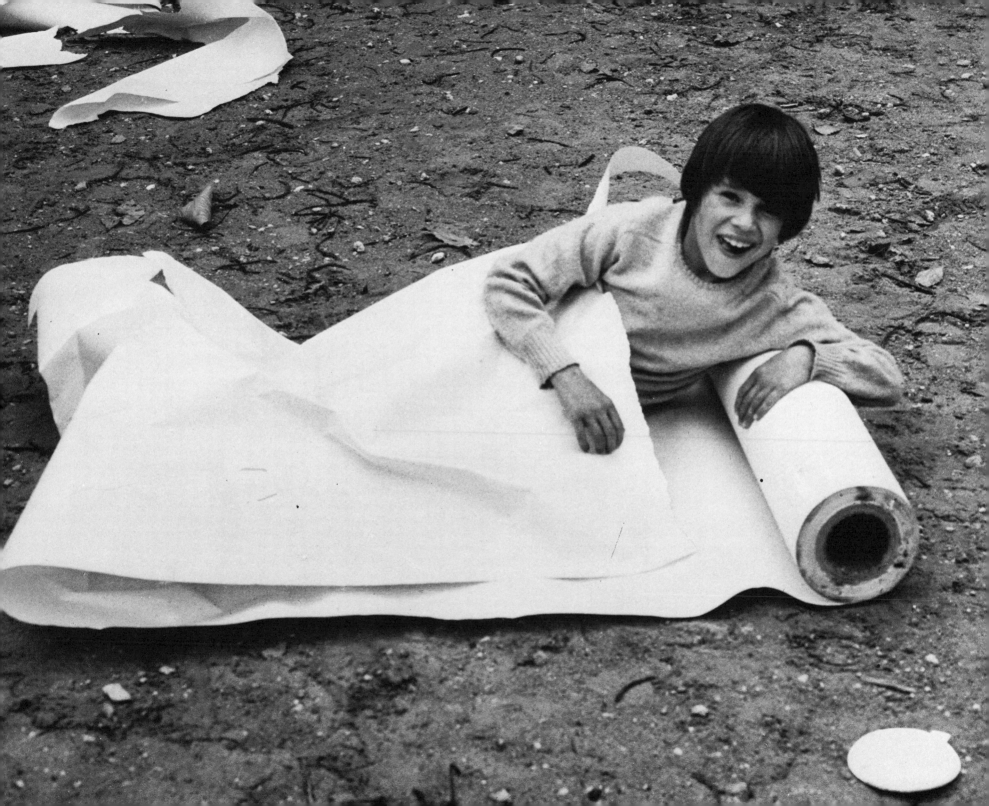

Planners and Designers

Manufacturers

Aarikka
Nokiantie 2
SF 00510 Helsinki 51
Finland

Artur
44 rue Vieille du Temple
F 75 Paris 4
France

Aukam Spielgeräte
Frankfurter Strasse 181
3500 Kassel
Germany

Burri AG Zürich
Sägereistrasse 28
CH 8152 Glattbrugg
Switzerland

Danese Milano
Bruno Danese SNC
Piazza San Fedele 2
I 20121 Milan
Italy

Peter Gätje
Brödermannsweg 53
2000 Hamburg 61
Germany

Sport-Gerlach KG
3561 Hommertshausen-Biedenkopf
Germany

Granit S. A.
Domaine du Bochet
CH 1025 Saint-Sulpice
Switzerland

Grünzig & Co.
Postfach 69
3093 Eystrup/Weser
Germany

Sportgeräte Otto Hinnen
Geissensteinring 26
CH 6005 Lucerne
Switzerland

Oy Yuho Jussila
SF 40100 Jyväskylä 10
Finland

Keramchemie
Postfach 80
5433 Siershahn
Germany

Gebrüder Kesel
Postfach 1822
8960 Kempten Leubas
Germany

Krey Spiel-, Turn- und
Nutzgeräte
3161 Ehlershausen
Germany

Lenika Editions
6 rue du Docteur Zamenhof
F 92 Rueil-Malmaison
France

Nola Industrier
Essingeringen 88
S 11264 Stockholm
Sweden

Hans Oqueka
Postfach 1542
5920 Berleburg
Germany

Playstyle Limited
12 New Bond Street
London W1Y 9PF
England

Hilde Richter Spielgeräte
Susettestrasse 7
2000 Hamburg 50
Germany

Sculptures-jeux
1 rue Véronèse
F 75 Paris 13
France

Timberform
1727 N. E. Eleventh Avenue
Portland, Oregon 97212

Holzverarbeitungswerk Trautwein
Höhefeldstrasse
7504 Weingarten-Karlsruhe
Germany

Illustrations

Architectural Record 41(2, 3)

Christian Baur 58(1, 2)
Jean-Louis Bernard 10(1, 3, 4, 6), 17(7), 29(2), 38(3, 4), 39(3)
Gérald Bloncourt 65(2, 3)
Robert Bollag 19(1)
Brems Foto 56, 57

Roland Chapman 130
Lynn Converse 133
Craig, Zeidler, Strong 8, 106(1, 2), 107, 108, 109

André Danancher 60, 95(3)
Rüdiger Dichtel 38(9)
John Donat 90(1)
Jean Dreyfus 10(5), 28(5), 34, 53(7), 89(5), 148(1, 2, 4, 6)
S. Y. Du Barré 143(8, 13)

Espaces Verts 14, 15, 63(3, 4, 6), 76(2)

Mark Fisher 22, 23

O. Giverne 143(7, 11, 14)
Gösta Glase 38(5), 53(5)
Rob Gnant 58(3)
Peter Gramowski 20

Jim Hallas 104(3), 105
David Hirsch 54
Bart Hofmeester 33(5)

Willi Klingsöhr 38(6)

Greater London Council 50, 135

Foto Maryronne 53(1, 2)

Franco Mello 28(4)
Briane Milne 90(2), 92(9), 93
Mary Mitchell 68, 69, 70(2, 3, 4, 5), 71, 118, 119(1)
Kees Molkenboer 49(3)
Robin Moore 138, 139(3, 4, 5, 6, 7)

Sigrid Neubert 51(2), 59(3, 4)

Tomio Ohashi 116(2), 117(3)

J. Ritz 19(2)
Rotterdamsch Nieuwsblad 49(1), 94(3)
City of Rotterdam 46, 47
Paul Ryan 103

Eike Schmidt 94(6)
Yoshio Shiratori 120(1, 2), 121, 122/123(6)
Jacques Simon 10(2), 12, 26, 28(1), 35, 36, 37, 38(1, 7), 39(1, 5, 7, 8), 42, 43, 53(6), 61(1), 65(4), 66(2), 67(5), 74, 75(4, 5), 77(3, 4, 5, 7), 78, 80(4), 82(1), 83, 89(2, 3, 4, 6, 7, 8, 9), 94(4, 5), 95(1, 2), 111(6, 7), 119(4, 5), 131(4, 5), 134, 141(2), 144, 145, 148(3, 5), 149
Richard Stein and Associates 86(2), 87(3, 5, 7)
City of Stuttgart 84(2, 3), 85
L. Sudre 143(9, 10, 12)
Yo Suzuki 39(2), 126(6), 127

Angela Danadjieva Tzvetin 102

Hugo Uhl 37, 110(1), 111(3, 4, 5, 8)
Gerhard Ullmann 7

Tohru Waki 114(2), 115
Helga Wilde 36
Herb Wong 139(8)

Zacharias 150, 151

15